MW01011719

A NEW LIGHT ON TIFFANY

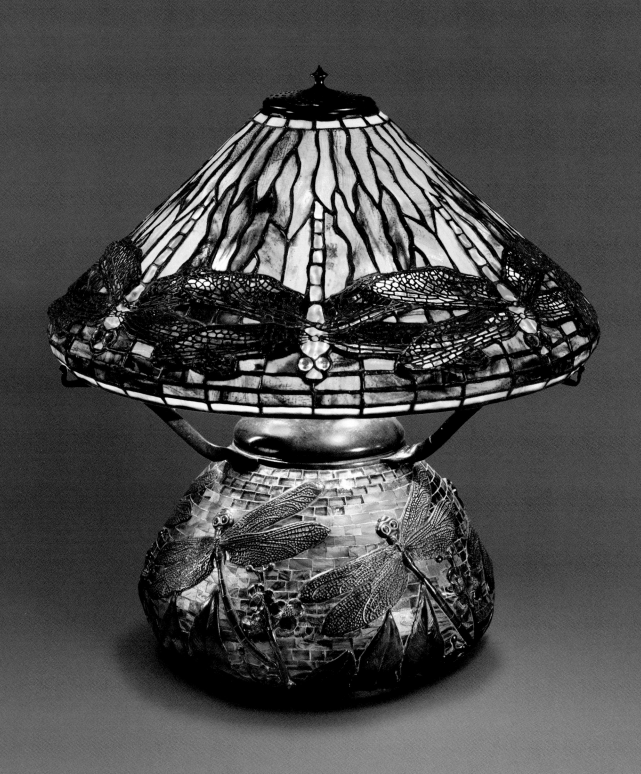

A NEW LIGHT ON TIFFANY

CLARA DRISCOLL AND THE TIFFANY GIRLS

Martin Eidelberg

Nina Gray

Margaret K. Hofer

New-York Historical Society

The New-York Historical Society, New York, in association with D Giles Limited, London

Front cover illustration
Wisteria lamp (detail of shade), designed by
Clara Driscoll c. 1901, NYHS, and detail of
photograph showing "Tiffany Girls" on the
roof of Tiffany Studios c. 1904-05, The
Charles Hosmer Morse Museum of
American Art, Winter Park, FL.

Back cover illustration
Cobweb shade on *Narcissus* mosaic base,
designed by Clara Driscoll pre-1902, NYHS.

Frontispiece
Dragonfly shade designed by Clara
Driscoll 1899, model 1462, 17 in. (43.2cm)
diam.; *Arrowhead* base, designed by
Clara Driscoll 1899, model 145. Courtesy
McClelland + Rachen, New York.

© 2007 New-York Historical Society
First published by the New-York Historical Society in association with
GILES, an imprint of D Giles Limited, on the occasion of the exhibition
A New Light on Tiffany, organized by the New-York Historical Society
and on view February 23-May 28, 2007.

This exhibition and publication were generously supported by Robert G.
Goelet, Barbara and Richard Debs, Mr. and Mrs. John Klingenstein, Donna
and Marvin Schwartz, Barrie and Deedee Wigmore, Sue Ann Weinberg,
the Elizabeth Morse Genius Foundation, and Arlie Sulka.

First published in 2007 by GILES
An imprint of D Giles Limited
Kite Studios, Priory Mews
2B Bassein Park Road
London, W12 9RY, UK
www.gilesltd.com

ISBN: 978-0-916141-07-3 (Softcover edition)
ISBN: 978-1-904832-35-5 (Hardcover edition)

All rights reserved

No part of the contents of this book may be reproduced, stored in a
retrieval system, or transmitted in any form or by any means, electronic,
mechanical, photocopying, recording, or otherwise, without the written
permission of the Board of Trustees, New-York Historical Society, and
D Giles Limited.

FOR THE NEW-YORK HISTORICAL SOCIETY
Project Manager: Debra Schmidt Bach
Project Editor: Anne H. Hoy
Photographs are by Glenn Castellano unless otherwise noted

FOR D GILES LIMITED
Copy-edited and proofread by Moira Johnston
Designed by Anikst Design Ltd, London, www.anikstdesign.com
Produced by the Publisher, an imprint of D Giles Limited, London
Printed and bound in China

NOTE FOR THE READER
The quotations from the Driscoll correspondence in this book preserve
original spelling and punctuation. In the captions, the design dates of
Tiffany Studios works are derived from the firm's marks and brochures of
1904, 1906, and 1910; Clara Driscoll's references; and other contemporary
documentation. In measurements, height precedes width. All Tiffany
lamps from the collection of the New-York Historical Society were gifts of
Dr. Egon Neustadt in 1984.

Contents

Foreword

Peacock shade, probably designed by Clara Driscoll pre-1906, model 1472, 18 ½ in. (47 cm) diam.; *Peacock* base designed pre-1906, model 224. New-York Historical Society (hereafter NYHS).

FROM THE PRESIDENT

The discovery of the Clara Driscoll correspondence, the event that has inspired this book and exhibition, is a landmark in the scholarship on Tiffany Studios as well as an opportunity to revisit the important Tiffany collection at the New-York Historical Society. We are deeply grateful to the scholars who united to create this rich and rewarding program. Dr. Martin Eidelberg, Professor Emeritus of Art History, Rutgers University, is well known for his important studies on Tiffany's glass, ceramics, and lamps. Nina Gray is an independent curator and scholar specializing in nineteenth-century decorative arts and architecture who is also the author of a book on Tiffany lamps. Margaret K. Hofer, Curator of Decorative Arts at the New-York Historical Society, has worked with the Society's Neustadt collection of Tiffany lamps since 1993.

I am also pleased to acknowledge the enlightened support that has enabled us to move forward with this project. Critical support has been provided by Robert G. Goelet, Barbara and Richard Debs, Mr. and Mrs. John Klingenstein, Donna and Marvin Schwartz, Barrie and Deedee Wigmore, Sue Ann Weinberg, the Elizabeth Morse Genius Foundation, and Arlie Sulka.

Louise Mirrer
President and CEO
The New-York Historical Society

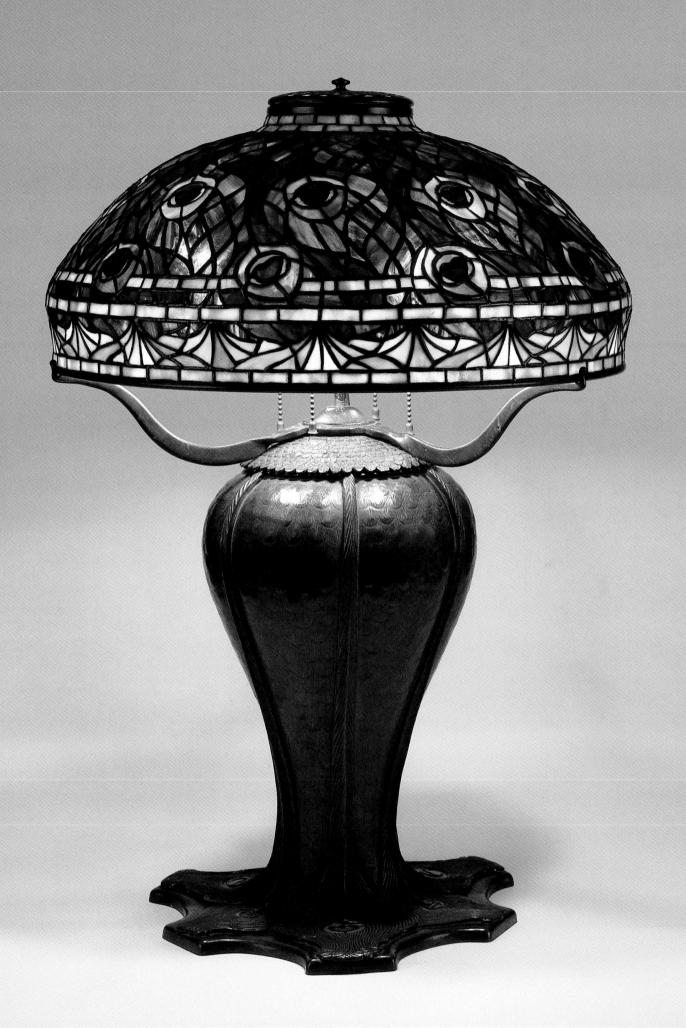

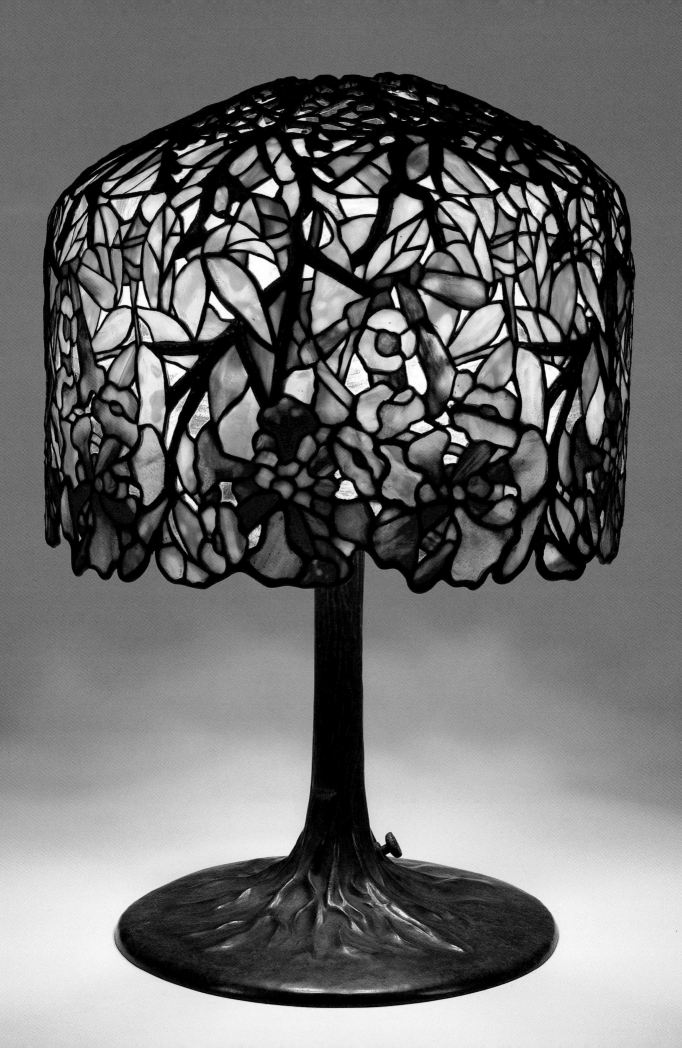

Trumpet Creeper lamp, probably designed by Clara Driscoll pre-1906, model 346, 18 in. (45.7 cm) diam. NYHS.

FROM THE DIRECTOR

This volume and exhibition provide an entirely new context for understanding and interpreting the Society's great Tiffany collection, one of the world's largest holdings of Tiffany lamps. In 1984 the pioneering Tiffany collector Dr. Egon Neustadt donated 132 lamps to the New-York Historical Society. Since then the Tiffany collection has been a magnet for visitors and a resource for scholars. This volume, we believe, extends this dual tradition. Based on the information contained here, we have now been able to attribute many of our Tiffany lamps to a single designer: Clara Driscoll. We have also gained a far greater understanding of the context in which all of Tiffany's lamps were produced.

Clara Driscoll's vivid descriptions of her work and her colleagues constitute the only known first-person account of the day-to-day activities of Tiffany Studios. This goldmine of information, contained in her letters to her family, has transformed our understanding of the design and manufacture of Tiffany objects, including lamps, windows, and mosaics. Equally important, her account has revealed the crucial role played by women at the firm, identifying many women employees whose significant contributions as artists have gone unacknowledged until now.

Linda S. Ferber
Vice President and Museum Director
The New-York Historical Society

Acknowledgments

Clara Driscoll is a scholar's dream. A gifted unsung artist, an eyewitness to the making of some of the twentieth century's most beautiful and beloved designs, a pithy writer about both these roles. Almost as astonishing as the discovery of Clara is the fact that two of us found her within days of one another, and the third of our triumvirate added to our findings and enabled their swift presentation in the ideal museum.

We three had long been separately engrossed in the history of Louis C. Tiffany. But serendipity and the generosity of colleagues, archivists, and Driscoll relatives brought us together. In October 2005 Nina Gray learned that some of Clara's letters were at the Queens Historical Society, a tip from the Tiffany scholar Elizabeth De Rosa, who had it from Catherine Tamis. Also in October, Martin Eidelberg heard through David Powers, a collateral descendant of Clara, that much of her correspondence resided in the Kent State University Library. Nina too heard about the Kent State trove, when Richard Hourahan, Collections Manager at Queens, alerted her to a website about Clara's sister Emily, and then the website's author, Professor Emeritus Edgar McCormick, told her about the Driscoll letters in Ohio. By chance, Nina and Martin learned of each other's discovery. Quite naturally, they decided to join forces. Moreover, through her previous position at the New-York Historical Society and her association with Margaret Hofer, Curator of Decorative Arts there, Nina knew that the institution, with its imposing collection of Tiffany lamps, was the perfect place to introduce this exciting material to the public. For these three authors, all working on the Upper West Side of New York, the circle was closed, all within the perimeter of a few city blocks.

Of course after these initial contacts there were many steps to this book and exhibition. We are indebted to our institutional colleagues: Richard Hourahan and James Driscoll at the Queens Historical Society went out of their way to make their collection accessible, as did Craig Simpson at the Kent State University Library. Our museum colleagues were also quite generous: we would single out Alice Cooney Frelinghuysen at the Metropolitan Museum of Art, Jennifer Thalheimer and Donna Climenhage at the Charles Hosmer Morse Museum of American Art, Lindsy Parrott at the Neustadt Collection of Tiffany Glass, and Dean Zimmerman at the Western Reserve Historical Society. At the auction houses, Jeni

Sandberg of Christie's and Christina Japp of Sotheby's were instrumental in helping us track down Driscoll-related objects. Michael Burlingham generously shared important aspects of his research on his great-grandfather, Louis C. Tiffany. Christopher Gray of the Office for Metropolitan History kindly helped with information about Tiffany's sites in New York City. We are also indebted to Nancy A. McClelland of McClelland + Rachen, and Eric Silver at Lillian Nassau LLC. Arlie Sulka deserves special mention for sharing her comprehensive knowledge of Tiffany lamps and objects. Linda Alexander, Clara Driscoll's fourth cousin, was a gracious host during a visit to Tallmadge, Ohio. Thomas P. Kugelman tracked down elusive genealogical records documenting the "Tiffany Girls." Volunteers and interns, including Marilyn Lutzker, Helen Polychronis, Kaitlin Shinnick, and Laurel Waycott, also conducted painstaking research. Jack Gray, Seth A. Gopin, and Andrew Hofer provided much support.

We are grateful to the following lenders to this exhibition, whose objects helped us provide a rich representation of Clara Driscoll's career: James and Julie Alexandre; American Decorative Art 1900 Foundation; anonymous lenders; David and Catherine Bellis; Nancylee Dikeman; the Ellman Family; Cameel and Hoda Halim; Lillian Nassau LLC; the Metropolitan Museum of Art, New York; the Charles Hosmer Morse Museum of American Art, Winter Park, FL; Museum of the City of New York; the Museum of Modern Art, New York; the Neustadt Collection of Tiffany Glass, Long Island City, NY; the New York State Museum, Albany, NY; Queens Historical Society, Flushing, NY; and Mr. and Mrs. Robert Sage. We owe deep gratitude to President Louise Mirrer and Museum Director Linda S. Ferber, whose enthusiastic support led to the New-York Historical Society's commitment to this important exhibition and publication, and to Debra Schmidt Bach and Roy Eddey for keeping us on track despite a whirlwind production schedule.

The swift pen and wit of our editor, Anne H. Hoy, vastly improved our manuscript; her patience and perseverance are much appreciated. Glenn Castellano's sensitive photography endowed this book with special brilliance. Our London publisher, Giles Limited, brought it to press with both miraculous speed and attention to detail. Sarah McLaughlin diligently supervised production, and Anikst Design provided the exceptional design.

Martin Eidelberg
Nina Gray
Margaret K. Hofer

Introduction

"I was met by a new official who asked who I was. I looked at him with an—I—was—here—before—you were born expression and told him I was Mrs. Driscoll from the New York, Tiffany Studios...."

Clara Driscoll, January 9, 1902

Clara Pierce Wolcott Driscoll was one of the many creative artists employed by Louis Comfort Tiffany (figs. 1-2). From the late 1880s until about 1909 Clara supervised the execution of many of his most celebrated leaded windows and mosaics. More important, she designed most of his leaded-glass lamps and many of his *objets d'art*. Yet her name was unknown at the turn of the century since she, like most Tiffany employees, worked anonymously. Although he occasionally credited the designers of his firm's windows and mosaics, Tiffany preferred that his name alone appear before the public. His advertisements proclaimed that all work was made under his personal supervision and emphasized how he himself had labored to perfect the richly colored, iridescent glass that was his invention. At the Paris World's Fair of 1900, he exhibited his wares not under his companies' names but under his own. It was a brilliant and typical display of showmanship.

Despite all the brochures and books that Tiffany's firms issued over a period of more than three decades, never once was Clara Driscoll's work acknowledged publicly. But, then, neither were the contributions of Arthur J. Nash (1849-1934), who served as the head of Tiffany's glassworks.[1] When the firm was obliged to disclose the names of individual workers to juries, as at the Paris World's Fair of 1900, it complied and, in fact, both Clara and Arthur Nash as well as others received prizes. Nonetheless, their individual awards were never publicized, but Tiffany's were.[2] Clara's achievements might have gone unnoticed by modern historians had it not been for a short discussion of her work in a 1904 article on highly paid women in the *New York Daily News* (fig. 3),[3] and, much more important, the recent discovery of hundreds of pages of her correspondence from the turn of the century.

fig. 1
Clara Driscoll (1861-1944), c. 1904-05. Detail of
fig. 65. The Charles Hosmer Morse Museum
of American Art, Winter Park, FL.

fig. 2
Louis C. Tiffany (1848-1933), photographed by Pach
Brothers c. 1890. NYHS, Gift of Philip M. Plant.

CLARA PIERCE WOLCOTT

On December 15, 1861, Clara Pierce Wolcott was born
in Tallmadge, Ohio, a small town between Akron and
Cleveland. She was the eldest of four daughters of
Fannie L. Pierce Wolcott (1834–1906) and Elizur V.
Wolcott (1833–1873).[4] Clara was only twelve years
old when her father died and thus she was raised in
a largely matriarchal society, one in which her
mother's sister—Aunt Josephine—was also a
dominant force.[5] Her sisters Kate Eloise (1863–1903),
Emily Porter (1866–1953), and Josephine Minor (1871–
1896) rounded out this close family circle.

Clara's mother, a graduate of Willoughby
Female Seminary in Willoughby, Ohio, valued
education highly and saw to it that her daughters
were instilled with the same ideals. Clara attended

fig. 3
"Mrs. Driscoll's Prize Dragon Fly Lamp," from
New York Daily News, April 17, 1904. General
Research Division, The New York Public Library,
Astor, Lenox and Tilden Foundations.

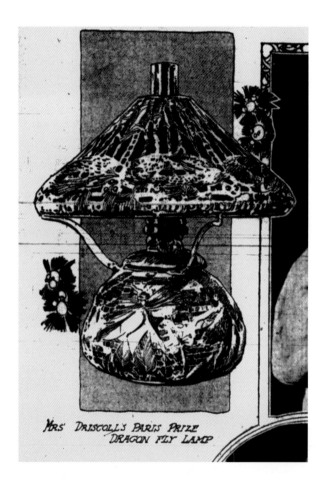

MRS. DRISCOLL'S PARIS PRIZE
DRAGON FLY LAMP

Central High School in Cleveland and briefly tried her hand at teaching but did not enjoy it.[6] Only her sister Emily, an aspiring author, made teaching her lifetime career. Clara chose to pursue the visual arts, as did her sisters Josephine and Kate. To this end, Clara enrolled in the relatively new Western Reserve School of Design for Women. After graduation, she worked as a designer for the Cleveland furniture maker C. S. Ransom & Co., a firm specializing in furnishings with Moorish-style fretwork.[7] By 1888 she had moved to New York City, where she studied at the recently founded Metropolitan Museum Art School.[8] Despite its affiliation with the museum, the school focused on industrial design and the instruction of "artist artisans." When Clara studied there, two-thirds of the almost four hundred students enrolled were women. She specialized in architectural decoration and, despite being the only woman in that department, was one of the foremost students and held her place "as easily as any of the young men."[9] While Clara attended the Metropolitan Museum Art School, she and her sister Josephine, who had also come to New York to study art, lived in the boardinghouse of a Miss Todd at 32 South Oxford Street in the Fort Greene section of Brooklyn, just half a block from the bucolic, recently completed Fort Greene Park.[10] The turning point in her career came when she and her sister found employment at the Tiffany Glass Company in Manhattan.[11] Both women were employed there by June of 1888. This would be the first of Clara's three tenures at Tiffany, each of which was delimited by engagement and marriage.

When Clara began working with the Tiffany firm, it was located at 333-35 Fourth Avenue (now Park Avenue South), at Twenty-fifth Street (fig. 63).[12] By that time, Tiffany's earlier firms, Louis C. Tiffany and Associated Artists, and Louis C. Tiffany

fig. 4
Detail of *Arrowhead* base, designed by
Clara Driscoll 1899, model 145. Courtesy
McClelland + Rachen, New York.

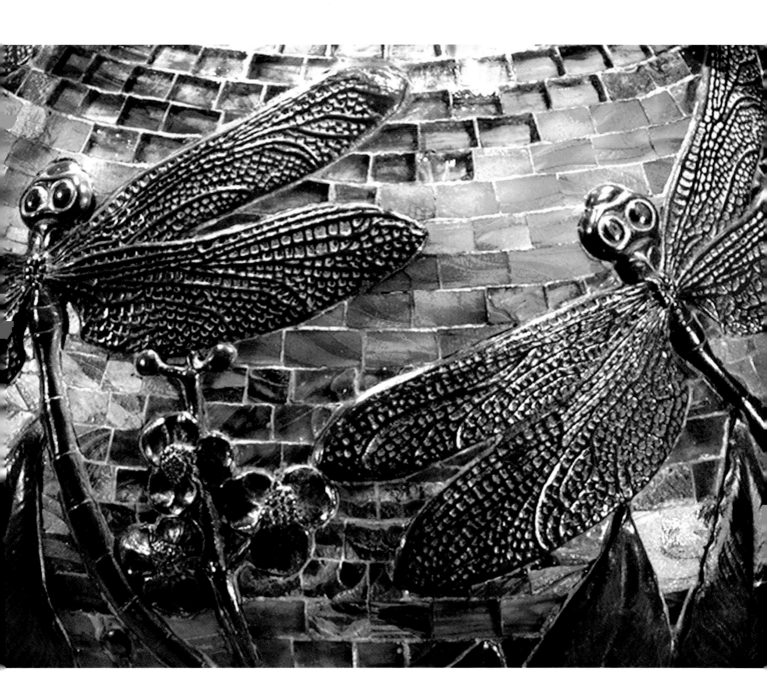

& Co., had been superseded by the Tiffany Glass Company.[13] As that name suggests, the company focused largely on leaded-glass windows but it also received commissions for interior decoration. Little is known about Clara's first tenure there, but presumably she worked in the window and mosaic department. Unfortunately there are few company records and her correspondence from this period has not survived.

CLARA DRISCOLL

Clara's employment with Tiffany was soon interrupted because of her engagement to Francis S. Driscoll (c. 1831–1892), a fellow boarder at Miss Todd's.[14] As was customary at the time, Tiffany employed only unmarried or widowed women and Clara accordingly left the firm.[15] Her fiancé, a widower thirty years her senior, employed in real estate, was described as "very well off" and "a marvel of generosity."[16] Clara and Francis Driscoll married in Manhattan on Thanksgiving Day, 1889, and after their honeymoon returned to Miss Todd's boardinghouse.[17] Her brief marriage came to an end on February 21, 1892, when her husband died, leaving Clara a thirty-one-year-old widow with apparently meager financial resources.[18]

Soon after Driscoll's death, Clara resumed working at the Tiffany Glass Company. Her return corresponds to a critical turn in the development of Tiffany's own firm, which was expanding the sphere of its commercial activities. Still located at 333-35 Fourth Avenue, it had built an adjacent factory/studio around the corner at 102 East Twenty-fifth Street in 1891 (fig. 63).[19] In 1892, the firm was reincorporated as the Tiffany Glass and Decorating Company, and the following year Tiffany created the Stourbridge Glass Company to supply it.[20] A glass factory was set up in Corona, Queens, under the direction of Arthur J. Nash.

Still in 1892, in the midst of these many changes, a small Women's Glass Cutting Department with six female employees was established under the direction of Clara Driscoll at the Manhattan site. Just two years after the inauguration of her department, she had thirty-five young women working under her.[21]

Little is known about Clara's personal life during these same years, especially because her surviving correspondence begins only in the fall of 1896. By January 1897 she had moved into Manhattan to shorten her commute to work, and she was living in a flat at 468 West Fifty-seventh Street (near Tenth Avenue) leased to Alice Gouvy, an aspiring artist friend from Ohio who was studying at the nearby Art Students League. They shared household duties with a third partner, Louise Minnick, also employed by Tiffany Studios.

In 1896, Clara accepted a marriage proposal from Edwin Waldo (1863-1930), who worked at the University Settlement, a charitable institution for the poor on the Lower East Side. He was reported to be intellectual, artistically gifted as a painter

and a musician, and "an all-around genius."[22] Because of her pending marital status, she left Tiffany's employ for a second time, probably by late 1896. She seems not to have had any specific plans, although her mother suggested that she should resume art studies to further her career.[23]

Clara and Edwin contemplated moving to Mexico so that he could pursue a business opportunity as manager of a coffee plantation.[24] The couple was in Ohio by June 1897 on a celebratory pre-wedding trip,[25] where they spent time with family and friends, and Edwin lectured on the activities of the settlement house. They left for Chicago in early July, but then things went awry.[26] Edwin fell ill, disappeared from Lake Geneva, Wisconsin, and, despite intense search efforts, could not be found. Clara sought refuge back in Tallmadge and then returned to New York City in September.[27] Six years later, upon learning that Edwin had turned up in San Francisco, claiming temporary amnesia, Clara wrote: "My feeling in the matter is wholly, one of sympathy for George [her fiancé's brother and her good friend]. Anything other than that ended for me years ago. My personal feeling could not be anything but that of deepest gratitude for an escape."[28]

By November 1897, Clara was back at Tiffany Studios for the third time. This tenure with the firm was undoubtedly the most creative of her entire career. During this period, her so-called "Tiffany Girls" executed many of Tiffany's most prestigious commissions for leaded windows and mosaics. Clara came into her own as a designer of leaded-glass lampshades, creating some of Tiffany's most iconic models such as the *Dragonfly, Wisteria,* and *Poppy* (frontispiece, figs. 19, 25). Her expertise extended to the designing of lamp bases and desk sets in bronze, often inlaid with small mosaics of brilliantly colored glass. Her personal success and that of her staff can be measured by the attempt in 1903 by the unionized male workers at Corona to close her department. They failed and a compromise was ultimately reached: she was obliged to limit the number of her staff but she won the right to design all the lampshades and many of the small luxury goods, and to execute most of them. If anything, the rivalry between the departments suggests the singular eminence she had attained.

Clara's personal life was equally lively in this period, and it is well documented. After a brief stay at 5 West Sixty-third Street, just off Central Park, with roommates she knew from Tiffany's and Ohio,[29] she moved in 1898 to a boardinghouse run by Miss Mary Owens at 44 Irving Place, not far from the Tiffany firm. This house became an important anchor in her New York life. Over the next twelve years her days revolved around her work and her activities with a wide circle of friends, including Tiffany colleagues, artists, fellow boarders, and acquaintances from Ohio. Although her social circle was dominated by unmarried men

and women in the arts, their interactions were not uninhibited. Much of the propriety of the late Victorian world still ruled in Clara's circle.

Edward A. Booth (1868-1953) became one of Clara's most important companions.[30] An Englishman, he emigrated to America in 1893 and worked as a manager for the import firm of John G. Rollins & Co. She admired his intellect, first referring to him as "Mr. Book Booth" to distinguish him from his younger brother, an amateur butterfly collector she called "Mr. Butterfly Booth" who was her constant bicycling partner. Clara and Edward lived in the same boardinghouse for a decade, where he helped her with her accounting, read to her aloud, and participated in the lively social life of the residence. When their landlady bought a new house in 1907, both of them and other boarders followed her to 70 Irving Place (fig. 73).

Clara summered at the seashore in Point Pleasant, New Jersey, and made trips home to visit her family at "the house on the hill" in Tallmadge. But with the deaths of her sisters Josephine in 1896 and Kate in 1903, and her mother in 1906, her ties with Ohio loosened. Like many in her circle, Clara longed to travel to Europe, and finally in the summer of 1906 she made the trip. Then the next summer Tiffany took her and another designer, Agnes Northrop, on a sketching vacation to Brittany (figs. 84-86).

CLARA BOOTH

Because little family correspondence survives from the second half of 1907 onward, Clara's life cannot be followed as closely. Perhaps the most significant event was her decision to leave Tiffany's employ in 1908 or 1909. Once again, this was sparked by a change in her marital status. At age forty-seven, she married Edward Booth, her junior by six years, on September 1, 1909, in Montclair, New Jersey.[31] The couple continued to live at the Owens boardinghouse, Clara still avoiding the obligations of cooking and cleaning. She built a modest new career painting scarves with flowers and colorful sunset landscapes, but these have not survived and there are few other details of her creative pursuits. The Booths continued to divide their time between New York City and a house in Point Pleasant, the same arrangement they had enjoyed as friends.

In the fall of 1930, Edward Booth retired, the import business having been adversely affected by the Stock Market Crash. Retirement brought about a dramatic change in the pattern of their life, because they withdrew completely from New York City. That fall they moved to Ormond Beach, Florida, where they remained until the early spring;[32] then they returned north to their home in Point Pleasant for the summer, establishing a pattern for their later years. The letters that Clara and Edward exchanged with Emily give occasional glimpses into Clara's private life. She learned to drive a car, although her husband did not fully

trust her at the wheel. Her health evidently suffered in later years and finally on November 6, 1944, Clara succumbed at the age of eighty-two. She was cremated and her ashes interred with those of her parents and sisters in the cemetery at Tallmadge. Her sister Emily wrote a moving tribute to her that was printed and circulated, but by then her halcyon days at Tiffany Studios were long past.[33] Indeed, the United States was in the last year of World War II, Tiffany had died more than a decade earlier, the world of her youth had disappeared, her designs were long out of style, and her achievements had been totally forgotten.

THE WOLCOTT ROUND ROBIN LETTERS
What saved Clara Driscoll from undeserved obscurity was her passion for writing letters. In 1907, when Tiffany took Clara and Agnes Northrop on a trip to Europe, he watched Clara writing a letter to her sister Emily and observed in his diary: "Mrs. Driscoll's to her sister is the longest thing I ever saw. Had a curiosity to see what she could find to say so much about, when nothing has happened. Asked to see it. Very interesting. Curious to see how much some people write in a letter."[34] Fortunately, this passion (or sense of obligation) was shared by Clara's mother and her three sisters. They delighted in long, chatty correspondence filled with the minutiae of daily life and work. Clara gleefully reported: "The Round Robin is so very fat this week that I hardly know

where to begin. Emily's thirty eight pages, breaks our record and Kate and Aunt Josephine and Grandma have as good material.... "[35] While various circumstances—the pressure of business, visitors, migraine headaches—often prevented Clara from writing letters as lengthy as she might have wished, she was nonetheless a voluminous correspondent.

In the late nineteenth century, the distance between family members was easily bridged by letter writing, especially for the Wolcotts. Not unlike the fictional characters in Louisa May Alcott's *Little Women,* the fiercely independent Wolcott women formed a tight matriarchal clan and aspired to careers as artists and writers. After the sisters one by one left their family home in Tallmadge to gain their education and forge careers, they kept in touch through letters that were circulated among the scattered family members. Ultimately this developed into their formal Round Robin correspondence—the documents upon which this publication is founded.

Although this correspondence offers insights into Clara's professional life and sheds enormously valuable light on Louis C. Tiffany's artistic empire, these subjects occupy only a small part of the exchanges. Clara's letters are filled with news of social and cultural events in New York and offer a fascinating window onto the world of an urban professional woman. They are, in effect, a time capsule of middle-class daily life at the turn of the

fig. 5
Bound volumes of Wolcott Family Round
Robin letters. Queens Historical Society,
Flushing, NY.

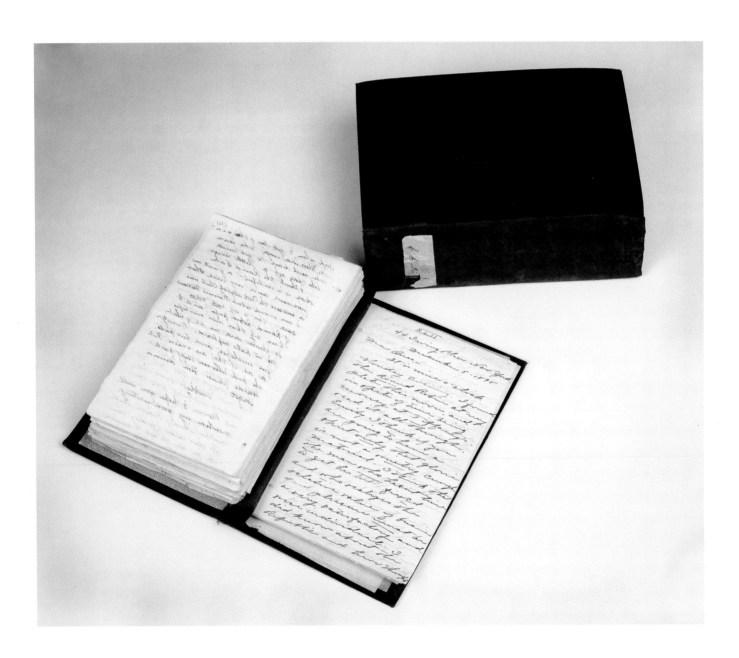

century.[36] Just as the writings of Samuel Pepys, Horace Walpole, and Alexis de Tocqueville allow readers to recapture the essence of those societies, so too the Wolcott Round Robin letters allow us to imagine life a century ago more accurately.

The origins of the Round Robin are suggested in a letter from their mother, written in the spring of 1891 and addressed "Dear Children at the East," an appellation that was meant to include Clara, Emily, and Josephine, all of whom were there.[37] As their mother explained, she had already sent on previous letters from them, had written to daughter Kate, and was now addressing a communal letter to save time. From 1894 forward, each week's letters were assigned Roman numerals, and after they had circulated they were gathered together and bound (fig. 5).[38] Even though Josephine and Kate died, the institutionalized system of Round Robin letters continued, but the momentum for binding them came to an end.[39] After their mother's death in 1906, Clara and Emily were left alone. Still, the two sisters went on writing for the next three decades, with Edward Booth taking part, especially as Clara's strength waned.

The volumes of the Round Robin letters ended up with Emily, who survived her older sister by almost a decade. Emily kept most of them in a summer house she maintained on Lake Canandaigua in upstate New York. They were found in a desk by Todd Fenn, her first cousin and executor of her estate; he and his wife gave the letters to their cousin Elizabeth A. Jones Yeargin, and in 1995 she donated them to the Kent State University Library in Kent, Ohio. Two of the bound volumes and much of the later correspondence were stored by Emily in the attic of her house in Richmond Hill, Queens, and although she left instructions with the new owner that she would send for them, she never did. When Mrs. Ruth Seifert sold the house in 1997, she donated them to the Queens Historical Society in nearby Flushing.

An extensive portion of the Round Robin correspondence has been preserved, but there also are major gaps. Most disturbing of all is the disappearance of most of the letters prior to 1897 and the volumes from 1900 and 1901. Other gaps include the letters that Clara wrote when she was traveling in Europe in 1906, and there is very little surviving from the years after 1907. Thus we do not have a complete picture of Clara's career, but what has survived is a remarkable body of evidence.

Borrowing from John Keats's famous ode, Clara once reported that "reading the Round Robin is a joy forever."[40] That same joy extends to readers today, as we become intimate observers of her life and society, and the creative world of Louis C. Tiffany and his talented employees.

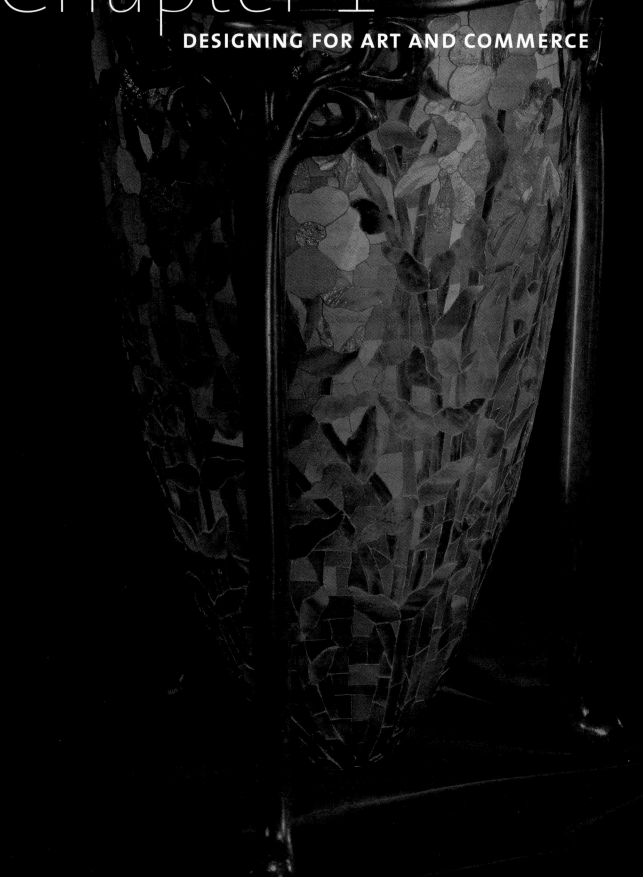

Chapter 1
DESIGNING FOR ART AND COMMERCE

THE BUTTERFLY LAMP

June 29, 1898: "Last and most important ... is a big beautiful lamp made of the evening primrose. Like that field of them on Mr. Root's land [in Tallmadge, Ohio]. This in mosaic will be the lamp, and a cloud of little yellow butterflies which you know look exactly like the primrose blossom, in a net work of gold wire made in beautiful lines like the lines of smoke—is to be the shade. I described this to Mr. Tiffany while he was in Mr. Mitchell's office sitting in front of the electric fan in Mr. Mitchell's chair waiting for him to come in, and looking as if life were a burden that he could not support much longer. But when he heard about the primroses, he braced up at once, seized a pencil and began to make pictures all over Mr. Mitchell's clean blotter and talking to himself and to me, while the fan made his thick curls stand up around his beaded brow like a halo, after this fashion—'The lamp mutht be tall and chlim' (the words tall and slim being unnaturally lengthened while he drew long up and down lines to illustrate) 'like the flowerth, and the thade—' but every time he came to that he wavered off into such vague lines that you could scarcely distinguish them from the gray of the blotter and then he would say—'well, work out your own idea.'"

"I told him [the supervisor of lamp production at the Corona factory] I would give my mind to it and get him out some good designs if he would keep it before the public that I designed them.... He has agreed to do it and to blow my trumpet whenever opportunity offers. I feel that I must get up a commercial reputation as well as an artistic one."

Clara Driscoll, January 9, 1902

Clara Driscoll's lasting legacy at Tiffany Studios is her design of ravishing objects. Not only did she directly oversee the execution of some of Tiffany's most important windows and mosaics but she invented most of the leaded-glass shades and mosaic-clad bases. She also designed many of the bronze and mosaic candlesticks, inkstands, and other *objets de luxe* that brought Tiffany fame at the turn of the century. Clara Driscoll was, in effect, the hidden genius behind many of Louis C. Tiffany's designs.

None of these claims is meant to take glory away from Tiffany, the undeniable maestro. It was his artistic vision and inspiration that guided Tiffany Studios and fueled his employee's ideas. Had there not been a Tiffany, there would not have been a Clara Driscoll. Her situation was very much like that of Arthur J. Nash, who was responsible for

the production of Tiffany's *favrile* glass (the name he invented to describe his blown glass). His many contributions were almost never acknowledged publicly, yet he too ceaselessly worked for the firm's success, inventing new color formulas and glass-working techniques, as well as overseeing the many workmen who fabricated the glass. Nash's work was done anonymously and under Tiffany's shadow. Yet, had there not been a Tiffany, there would have been no Nash.

The secret to such artistic collaboration was the harmony that existed between Tiffany and his workers. His sense of color and texture, his love of nature, and his modern, anti-academic sensibility were evidently admired and shared by those to whom he delegated power. It is significant that when Clara requested a leave of absence in 1906 to go to Europe for half a year, Tiffany ordered her first to find a replacement whose art he approved.[1] One can presume that Tiffany applied that same standard of aesthetic approval when he first hired Clara. Although she did not state this, it is often implied in her correspondence. Clara possessed a sensitivity to Tiffany's *favrile* glass, as when she expressed her awe at some that he had given her to use for a screen. She was impressed not merely by its costliness but also by its special artistic qualities.[2] On the other hand, she wrote that "Miss Francis" (she often used the honorific for her Tiffany Girls) was a good designer but limited in her abilities because "she has not had experience with Tiffany materials."[3] And when Tiffany gave Clara a tour of the studio he maintained in his Seventy-second Street mansion (figs. 71, 72), she correctly intuited that his art was "suggestive of Eastern thought."[4]

Above all, the inspiration she received from nature accorded with Tiffany's own vision. Evocations of spring appear as frequently in her letters as in her designs. Her descriptions of the trees and flowerbeds bursting into bloom are like the lampshades she designed.[5] Her narrative of a bicycle ride reads as though Tiffany might have written it, not only for the coloristic evocations but also for its references to wild grapevines and swaths of wild carrot (or Queen Anne's lace).[6]

While Clara admired botanical forms, she rarely drew or painted them herself. Instead, she

fig. 6
Agnes Northrop, photographed by Davis & Sanford c. 1896. Department of American Decorative Arts, The Metropolitan Museum of Art, New York.

deferred to her good friend Alice Gouvy, whose artistic talents she felt were superior. When Clara was designing the *Deep Sea* lamp (figs. 20-22), she wrote that the shade would be "made of ambers and greens like the tanks at the Fisheries Building at the [Chicago] World's Fair," yet she called in Gouvy who "is going to the aquarium to make some sketches to work from."[7] Indeed, there are many extant nature studies by Gouvy, as well as by Lillian Palmié and Agnes Northrop (figs. 61, 62), but none by Clara.

Like Tiffany, Clara was very much interested in photography, and often expressed the desire to photograph plants. In 1898, when she was contemplating her departure from Tiffany Studios because of her impending marriage to Edwin Waldo, she wrote about spending the summer with her sister Kate in Ohio, "drawing and photographing every flower and weed, with a view to decoration. I should love to be a good photographer."[8] On several occasions, Clara referred to photographs of plants that she and Alice Gouvy used. When she was designing clocks and other items based on the theme of wild

carrot, Clara wrote of a book depicting enlarged microscopic sections.[9]

All this mirrored Tiffany's own inspiration from nature, his interest in photography, and his assembling a large collection of books on nature. A decade before Clara conceived her *Cobweb* lamp (fig. 18), Tiffany had designed a wallpaper with the same theme. Similarly, Clara's idea for a lampshade with swarms of butterflies (fig. 16) was preceded by Tiffany's for a *Butterfly* window for his home on Seventy-second Street.[10] Their love of nature and their harmony of spirit made for an ideal relationship.

CLARA'S FIRST TENURE AT TIFFANY STUDIOS

What did Clara do in her early years at Tiffany Studios? Little is known about the organization of his window department in the late 1870s and 1880s. Work was carried out in the company's building at 333–35 Fourth Avenue (fig. 63) and was primarily, if not solely, executed by men. The creation of a distinct Women's Glass Cutting Department occurred only in 1892 and was probably precipitated by the establishment of a glass factory in Corona, Queens, and the intended transfer of the main window shop there.

The decision to hire women for the window department is not documented, but it can be assumed that much of the work was relatively mundane, such as the preparation of full-scale cartoons and the copying of working drawings. Tiffany was accustomed to working with women, especially because of a prior partnership with Candace Wheeler and the running of a large embroidery shop employing a female staff.[11] Two prominent women designed windows for Tiffany in the 1880s: the painters Lydia Field Emmet and Dora Wheeler, Candace's daughter. By 1888, when Clara and her sister Josephine were working for Tiffany, there were other women in the window department. Agnes Northrop (fig. 6, 97), supposedly already on staff, was a specialist in floral compositions. She became perhaps the best-known female designer there and ranked high enough to merit a private studio in the Fourth Avenue building.[12]

Clara as well may have designed some windows, perhaps ornamental ones. In 1894, the journalist Polly King described her as "for many

fig. 7
Detail of figure of Christ from Jay Gould
Memorial Chapel window, designed by
Frederick Wilson and Agnes Northrop
c. 1893. Jay Gould Memorial Reformed
Church, Roxbury, NY.

Elizabeth Comyns.[14] However, the dominant and
most renowned window designer was a man—
Frederick Wilson (1858–1932).[15] Although there
were gendered roles at Tiffany Studios, male and
female designers even collaborated on some
projects, such as the windows in the Jay Gould
Memorial Chapel: the figures were designed by
Wilson and the floral backgrounds, admittedly a
lesser element, were by Northrop (fig. 7).[16]
Collaboration was an important and practical
aspect of work at Tiffany Studios.

DESIGNING THE CARTOONS FOR WINDOWS
Although Tiffany windows tended to be known as
the work of a single designer, or occasionally as a
collaboration of individuals, many different hands
were involved in their creation. Once the basic
design was set, a presentation drawing was made
for the patron's approval, a task that could well
have fallen to one of Clara's assistants after she
gained managerial status. For example, when
Clara was working up sketches for a project for the
Mutual Life Insurance Company in New York, she
called upon Alice Gouvy to create the watercolor

years an experienced designer," thus suggesting
she was skilled in this area.[13] Other women
designed windows for Tiffany in the 1890s, after
Clara was made the director of the Women's Glass
Cutting Department. In addition to Emmet and
Northrop, there were Mary E. McDowell and

fig. 8
"Making a Cartoon at the Tiffany Studios," from *Art Interchange*, October 1894. Courtesy the Ellman Family.

presentation drawings.[17] Given Gouvy's apparent skills at rendering, she was probably asked to do this on numerous occasions, and presumably other of Clara's Tiffany Girls were assigned this task as well.

Once accepted by the patron, the design had to be developed into a full-sized cartoon for the glass cutters.[18] Color was rendered only cursorily in watercolor. A photograph of the Women's Glass Cutting Department published in 1894 shows a woman painting a full-sized cartoon, her hand braced against the traditional maulstick, an aid to support the hand holding the paintbrush (fig. 8). Clara assumed responsibilities in this area, and presumably Agnes Northrop and other mature members of the department did the same. Unfortunately, Clara did not describe her work in creating the cartoons.

After the cartoon was approved, two linear transcriptions of the design were prepared by placing two sheets of heavy manila paper under it, with carbon paper sandwiched between each of the elements. One of the Tiffany Girls went over the lines of the cartoon with a stylus, thereby transfer-

ring the design to the sheets of manila paper. Then each individual section of the working drawing was numbered. In the case of large windows, the numbers could run into the thousands.

The individual sections of one of the working drawings were cut with double-bladed scissors which created the space needed for leading. These pieces of the working drawing served as templates for the cutting of the glass. The second drawing was placed under a large sheet of glass known as an easel and secured, so that it was visible from above. Next, one of the women, using black paint, traced the design onto the easel itself, and the working drawing was then removed. All these preparatory steps were traditional; however, the colors and textures of Tiffany's glass were innovative, and the active participation of women in the work was novel.

SELECTING AND CUTTING THE GLASS

The inauguration of the Women's Glass Cutting Department in 1892 marked an unprecedented change: henceforward, women could both select and cut the glass, thus breaking a male monopoly.

King's 1894 article (see page 167) alludes to the reasons why Tiffany decided to entrust women with this work. She cited traditional assumptions that women's fingers are more nimble, their eyes are more sensitive to nuances of color, and they possess a special disposition for decoration. Equally important, they were thought to be more easily directed. As King declared: "It has been proved by experiment that success in this work is achieved not so much by an art school training as by natural decorative taste, keen perception of color ... and the power to learn from the work about and from the criticism of the heads of the department."[19]

Significantly, when Clara cut glass, she described it as "mannish" work.[20] Although there were social and political divisions between the women and the men, the actual labor and the procedures that the women followed were just like those practiced by the men. Little else but gender separated the two divisions. One can presume that when Clara advanced from designing cartoons to the selection and cutting of the glass, she did it in small stages, beginning with "simpler small windows of conventional designs" and gradually advancing to "large

fig. 9
Rose window with scenes from the Infancy
of Christ, designed by Louis C. Tiffany c. 1892-
93. The Charles Hosmer Morse Museum of
American Art, Winter Park, FL.

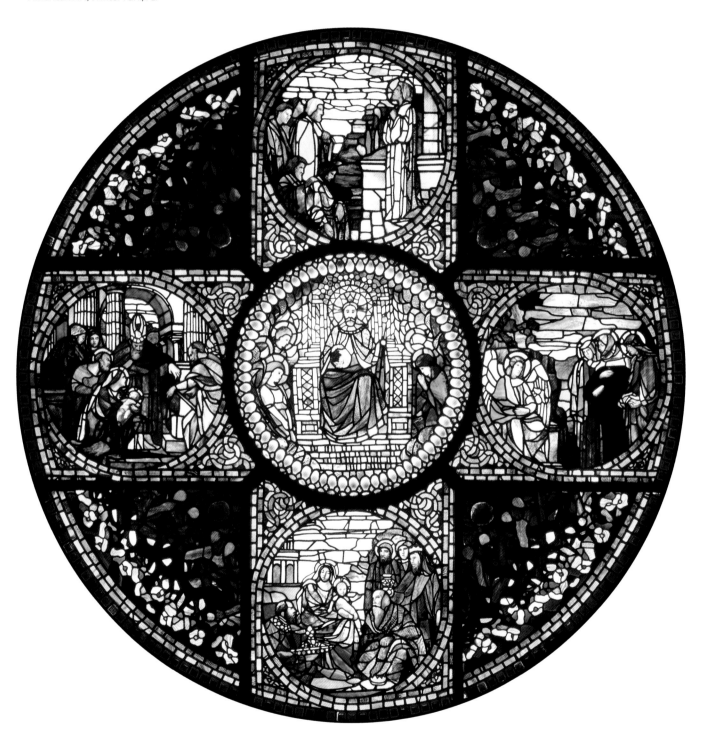

and important figure compositions." Indeed, this progression was the program she laid out for the Tiffany Girls as they learned their trade.[21]

After the glass for the window was cut, each piece had to be "foiled," that is, encased with a strip of copper around the perimeter so that it could be soldered to the adjacent pieces of glass. To accomplish this, sheets of copper with bee's wax applied to one side were cut into thin strips and these strips were wrapped around the edges of the glass (the waxed side facing inward to make the foil adhere to the glass). A small amount of foil was intentionally left to overlap the edge, and was tamped down on both front and back sides of the glass. Once all the foiled glass was reassembled on the easel, the Tiffany Girls' participation came to an end, although the window was still far from finished.

Clara provided a dramatic description of a window leaving the studio to go down to the enameling and leading departments:

> All of the big window, that has been filling up our side of the house for six weeks went down stairs.... The window went to the glass painter, to have the angels heads and feet and hands put in. It took six men to carry one of these easels and there were four of them. The girls who had made the windows followed anxiously in the rear, lest some of the heavy glass, should fall and break.[22]

Once outside the Women's Glass Cutting Department, the soldering of the foiled glass, as well as the final glazing and installation, were carried out by male employees. Such physical labors were not considered appropriate for women.

An outstanding example of the women's figurative work was the rose window with scenes from the Infancy of Christ made for the chapel shown at the World's Columbian Exposition of 1893 in Chicago (fig. 9). Designed by Tiffany himself, "the entire work was carried out by women," according to King.[23] This was an extremely large and important project, with some 10,000 pieces of glass. It may have been one of the first works undertaken by Clara and the Tiffany Girls after the creation of their department.

fig. 10

Winter from the *Four Seasons* window,
designed by Louis C. Tiffany 1899. The Charles
Hosmer Morse Museum of American Art,
Winter Park, FL.

Many of the windows cited by Clara were floral in subject. For example, her department executed the *Four Seasons* window which was exhibited in the Paris World's Fair of 1900. Clara offered some important insights into the *Winter* panel, which she called "the snow window" (fig. 10). Tiffany himself had designed it, but because he was laid up in bed with a cold, she was summoned to his home on Seventy-second Street to discuss the work before she began to execute it.[24] The extraordinary beauty of the glass and the wonderful way in which "twig glass" (glass drizzled with darker glass) is used to render the pine needles suggests that Tiffany and Clara took particular care with the selection of the glass—as befitted a window being submitted to an international jury.

The basis on which windows were assigned to the Men's or Women's Glass Cutting Departments is not clear. With leaded lamps, a clear distinction existed: women were charged with the floral designs while the men made the geometric ones. But such distinctions did not hold true for the windows, since the women were entrusted with both figurative and floral designs.

One might assume that the women were given the projects that involved complex color combinations and demanded greater sensitivity, but this was apparently not the case. When a commission of six landscape windows was refused by the Men's Department because of their busy schedule, it was offered to the Women's Department and Clara gladly accepted the challenge.[25] Apparently, the two work forces were essentially interchangeable.[26]

The production of windows had been the principal activity of the Women's Glass Cutting Department when it was first set up in 1892, but then, during Clara's tenure, the introduction of lampshades and small objects with mosaic incrustations absorbed an ever-increasing amount of their attention. By 1903, when the men's union tried to wrest away the women's right to make windows, Clara, defending her department against the indignity, claimed that it did not matter since most of their work was then in lampshades.[27]

WORK IN MOSAIC

Clara made only occasional references to the large-scale mosaics executed in her department in the 1890s. Yet in 1896, Tiffany Studios published a small brochure, *Glass Mosaic*, which stated that many of the firm's great mosaic projects were the work of women. This is one of the rare instances in which Clara's department was purposely recognized, although she was not named. This same brochure contains a photograph of a young woman working on the figure of Teucros, the leftmost soldier in a mosaic frieze designed by Jacob A. Holzer (1858-1938), commissioned for Alexander Commencement Hall at Princeton University (figs. 11, 12).[28] It was part of a large commission: the three main panels each measure eight and half feet high and more than twenty-seven feet in length. Although such mosaics were made in relatively small sections, the scale of the Princeton University project is larger than one might have thought would be entrusted to women.

The mosaic friezes for the walls of the Wade Memorial Chapel were an equally substantial commission assigned to the Women's Glass Cutting Department (fig. 13). This mortuary chapel was erected in Cleveland to honor Jeptha Wade, founder of the Western Union Telegraph Company. Frederick Wilson designed two allegorical friezes, each twenty-five feet in length, one representing the Old Law and the other the New Law. As Clara wrote in November 1899:

> It is so inspiring to have enough ahead as this new panel is. There is another long procession of shadowy figures typifying the virtues. The other panel, was in general a procession of the Christian religion and this is the Jewish religion or the old law pointing to the new to come. The chief interest that it has for me is that there are three hundred square feet of small pieces of glass to be accomplished. There is nothing like having enough work to do and feeling able to do so.[29]

Clara, like her contemporaries, probably admired Wilson's academic design, but for her the chief fascination of the project was its magnitude.[30] Strangely, her letters to her family mention neither the work's impressive patronage nor the site, even though it was so close to the family home in Tallmadge.

fig. 11
Mosaicist working on mosaic for Alexander
Commencement Hall, Princeton University,
from *Glass Mosaic*, 1896. Courtesy The
Neustadt Collection of Tiffany Glass, Long
Island City, NY.

fig. 12
Detail of *Scenes from Homer,* mosaic frieze
designed by Jacob A. Holzer c. 1894. Alexander
Commencement Hall, Princeton University,
Princeton, NJ.

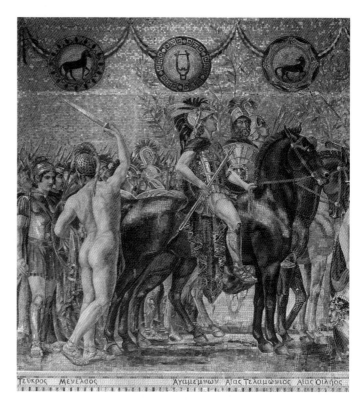

fig. 13
Detail of *An Allegory of the Christian Religion*,
mosaic frieze designed by Frederick Wilson
c. 1899. Wade Memorial Chapel, Lake View
Cemetery, Cleveland, OH.

Clara's letters contain only a few other indications that her department executed such large architectural commissions, but they suffice to suggest that this was an ongoing aspect of their activity. For example, before the turn of the century her department worked on a mosaic depicting the head of Christ.[31] In 1905, her chief assistant Joseph Briggs (1873-1937) and Theresa Baur executed a big mosaic panel of Christ and St. John.[32] Clara wrote of other large projects, such as "a big mosaic panel" of *The Fire Worshipper.*[33] Perhaps it was this or another such commission in 1905 that was so ambitious in scale that she contemplated working on it at the larger but still-unfinished Tiffany quarters uptown at Forty-fifth Street.[34] Mention should also be made of the mosaics that her department began in 1906 for the Madison Square Presbyterian Church (fig. 77), a church that supposedly had "the most complete Tiffany interior" of any ecclesiastical commission and that was, in fact, where Tiffany and his family worshipped.[35]

Even more frustrating than the infrequent mention of specific mosaics is Clara's silence regarding how they were made. On the other hand, a detailed explanation was given in 1901 in an article in the *New-York Daily Tribune*.

The cartoon of the mosaic must be reproduced in every line.... The tracing is made on transparent linen from a full size cartoon, either in color or carefully shaded black and white. The color scheme of the mosaic is determined by a small color sketch from which the glass is also chosen. The tracing is transferred by impression paper to a mounted board, which is the size of the mosaic panel, or in the case of a very large piece of mosaic work, the mosaic is made in sections, each section being mounted on a separate board.... This drawing is then covered thinly with melted wax so that the lines underneath can be distinctly seen.
...The pieces [of glass] are cut with a diamond or steel glass cutter, and worked into the exact shape with iron pliers, and then fitted into the space allowed for them on the waxed surface of the working drawing. This process continues until the entire drawing is covered with the various pieces of glass, reproducing the cartoon

in color. When the cutting of the glass is completed the whole work is laid flat and the surface of the glass is covered with varnish, which is allowed to partly dry. It is then covered with oiled paper pressed down until it adheres firmly to every part. The paper on which the glass has been worked is cut loose from the board, and the whole is laid face down on a marble table which has been covered with a preparation of Venetian turpentine. The original paper is now carefully removed, and the back of the glass, thus exposed, is thoroughly cleaned. Cement in a liquid state is now poured over it, so that it runs into every crack and crevice. In a few hours the cement is hard and the panel is loosened from the marble table, turned over and the oiled paper removed. The surface is then carefully cleaned, so that all foreign substances are removed from the face of the glass....[36]

The specificity of this description is extraordinary, and it reveals that the process for making mosaics was very similar to the one followed in the production of windows.

An uninspired photograph that Tiffany Studios provided to the *Daily Tribune* shows two of the Tiffany Girls posed passively, looking idle, while the man at the center (quite probably Joseph Briggs) misleadingly takes an active role as a draftsman (fig. 14).[37] The picture in Tiffany's 1896 brochure, while appropriately focusing on the role taken by women, is equally artificial. The mosaicist, dubbed a "musivarius," is posed completing a mosaic panel that is positioned vertically, an unlikely situation since most mosaic work was done on a slightly inclined surface. Nonetheless, it is noteworthy that it shows the woman working on the mosaic with the upper surface exposed. Whereas mosaicists traditionally worked with the mosaic lying face down, at Tiffany Studios the opposite was preferred so that the subtleties of color balance could be more carefully controlled.

An interesting insight comes from a situation that arose on one occasion when the cement had to be poured to integrate and solidify the mosaic. Joseph Briggs was away from the studio, as was his substitute. This prompted Clara to take on an obviously unaccustomed role:

fig. 14
"Mosaic Workers at Their Tasks," from *New-York Tribune,* June 23, 1901. Courtesy the Ellman Family.

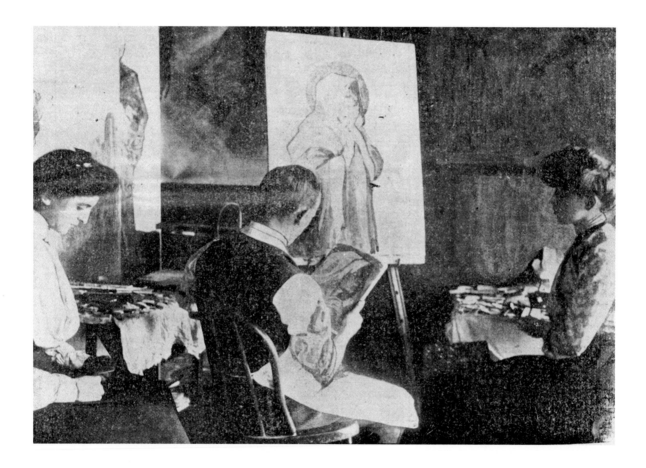

So yesterday I cast the panel myself with fear and trembling. The deaf and dumb boy and one of the girls assisted. This morning when we turned it up, it was all right and we feel very, very set up, we are all working hard on the actual work to get another one ready tonight. There are six more to do. (I mean five) You ought to see me with sleeves rolled up doing plaster work with a trowel. It is really great fun.[38]

Her account reveals that, as in window-making, certain gendered distinctions prevailed in work assignments: more physically demanding labor and messy tasks went to the men. In addition, they installed the finished mosaic panels on site.

Despite Clara's reticence in discussing the mosaics in progress, they evidently absorbed a fair amount of her time. Equally important, her experience with this medium proved crucial in the development of her ideas for lamp bases and small objects adorned with mosaics.

NEW TYPES OF PRODUCTS

When Clara returned to Tiffany Studios in late 1897 after her engagement to Edwin Waldo ended, she continued to guide her department's production of leaded windows and mosaics, and she also inaugurated designs for new types of objects, such as leaded-glass lampshades, mosaic-clad lamp bases, small boxes, inkstands, clocks, and candlesticks. By then, the glass-blowing department under Nash's direction had created new deep colors and textured, iridescent surfaces, and there was a drive to capitalize upon this success by employing the glass in a wide variety of *objets de luxe*. Also, a bronze foundry was established at the Corona plant around 1897–98 and this not only allowed greater artistic freedom but precipitated a need for new designs to keep the furnace active and profitable. Tiffany's artistic empire was rapidly expanding and Clara played a significant role in this evolution.

Clara's surviving letters report on these critical changes. They describe her first leaded shades and explain how they were designed and executed. Likewise, they reveal much about her first mosaic lamp bases. There are also frequent allusions to

the smaller objects she and her colleagues made. Because she was not chronicling the firm's day-to-day business but, rather, penning friendly letters to her family, her narrative leaves much unanswered. Nonetheless, these letters offer the most detailed view inside Tiffany's firm that has yet come to light. In this regard, they are unsurpassed.

LAMPS

After 1897, much of the work in the Women's Glass Cutting Department was devoted to the design and production of lampshades. Tiffany Studios' publicity promoted a general impression that Tiffany himself was the chief designer of the lamps, an idea that he hoped to foster apropos of all products issued by Tiffany Studios. In the company's brochure *Bronze Lamps,* of c. 1904, Tiffany's role in developing *favrile* glass was stated as a simple fact, but the authorship of the lamps was intentionally left vague. It proclaimed: "The bronze lamps, made by the artist-craftsman at the Tiffany Studios to-day, are constructed with the same striving for the artistic and beautiful that has marked the evolution of Tiffany glass...." The

implication is that the lamps were also developed by Tiffany himself. Not surprisingly, the "artist-craftsman" remained anonymous.

The single crack in this corporate armor occurred in 1904 when an article in the *New York Daily News* stated in explicit terms that Clara Driscoll had designed the *Dragonfly* lamp (figs. 28 and 31).[39] In fact, she designed most of Tiffany's lampshades and mosaic bases. Her correspondence provides a firsthand account of them and a more precise understanding of how her ideas were developed. Although not specifically stated in her letters, it was possibly Clara who hit upon the idea of making leaded shades with nature-based themes, a natural outgrowth of her work in making monumental windows. Tiffany and his designers had occasionally experimented in the 1880s and early 1890s with wall sconces and table lamps that employed leaded glass,[40] but it was not until about 1898 that the first leaded shades appeared—in other words, coincident with Clara's return to Tiffany Studios. In June 1898 she reported with a certain excitement that three of her leaded shade designs had already been put into

fig. 15
Peony shade, probably designed by Clara
Driscoll c. 1900-02, model 1543, 10 ½ in.
(26.7 cm) diam. The Neustadt Collection of
Tiffany Glass, Long Island City, NY.

fig. 16
Butterfly shade and *Primrose* mosaic base,
designed by Clara Driscoll with Alice Gouvy
1898, model 148, 18 in. (45.7 cm) diam.
Collection of David and Catherine Bellis.

production. Given the length of time between the
first sketch and actual execution, this would date
these shades to the very first months of 1898 or
perhaps still earlier.[41]

THE DESIGNING OF LAMPSHADES

Clara made occasional references to lamps in
production, invariably implying that these were
models she and her Girls designed. These early
shades reveal the experimental nature of her
ideas. The small *Peony* shade (fig. 15) shares the
same globe shape as the blown-glass shades on
fuel lamps that predominated in Tiffany produc-
tion in the late 1890s.[42] On the other hand, the
Butterfly and *Cobweb* shades are extravagantly
sculptural shapes (figs. 16, 18). Even the cylindrical
form of the *Wisteria* shade, with its open bronze
work of branches at the top and irregular fringe of
blossoms below, suggests the firm's exuberant
approach to design around the turn of the century
(fig. 19). While the great expense of manufacture
seems almost to have delighted Clara, ultimately
it was simpler conical shades, such as the *Arrow-
head, Dragonfly,* and *Poppy* (figs. 23, 28, 25), and

domed shades, such as the *Peacock* and *Peony*
(page 7 and fig. 17), that became Tiffany Studios'
most widely marketed forms. Clara's insistent
desire to design expensive lamps and her frequent
reports of complaints about costs from "the
Powers that Be" (her term for the firm's adminis-
trators) suggest something of the management
conflicts within the company.

While she was always subject to Tiffany's
criticisms and those of his lieutenants, never did
Clara write that she was instructed on what motif
she was to work up into a shade. Rather, she often
described her direct inspiration. In an 1898 letter
she wrote: "[F]or the last four days, I have been
devoting my energies to the butterfly idea that I
had before I went to Unionville."[43] In 1899 she
similarly declared: "This Dragon fly lamp is an idea
that I had last Summer."[44] Again in 1902, she
wrote: "I mean to try one more new and original
lamp of the expensive class this year, but so far it
is vague and worrisome."[45]

In her correspondence, Clara frequently
identified herself as the designer of lamps, but it
must also be understood that she always had

▼ **fig. 17**
Peony shade, designed by Clara Driscoll
c. 1900-04, model 1505, 22 in. (55.9 cm)
diam.; base designed pre-1906, model
397. NYHS.

► **fig. 18**
Cobweb shade on *Narcissus* mosaic base,
designed by Clara Driscoll
pre-1902, model 146, 20 in. (50.8 cm) diam.
NYHS.

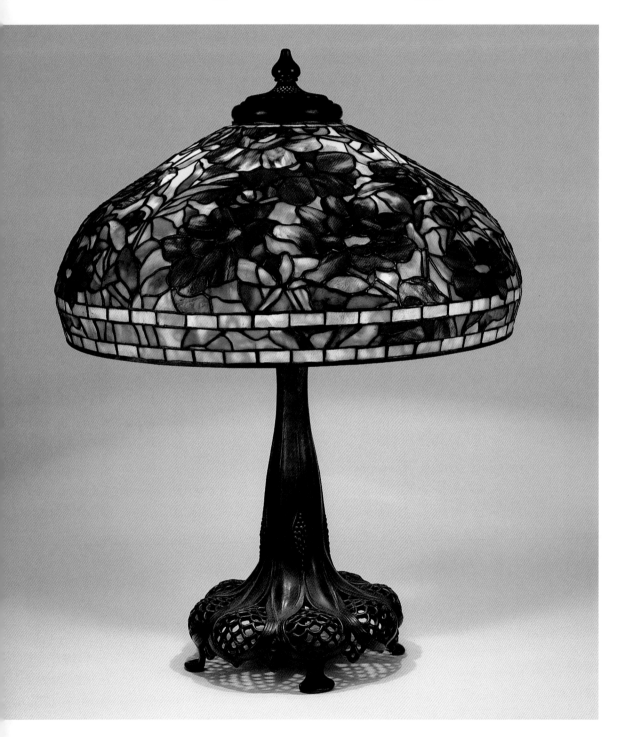

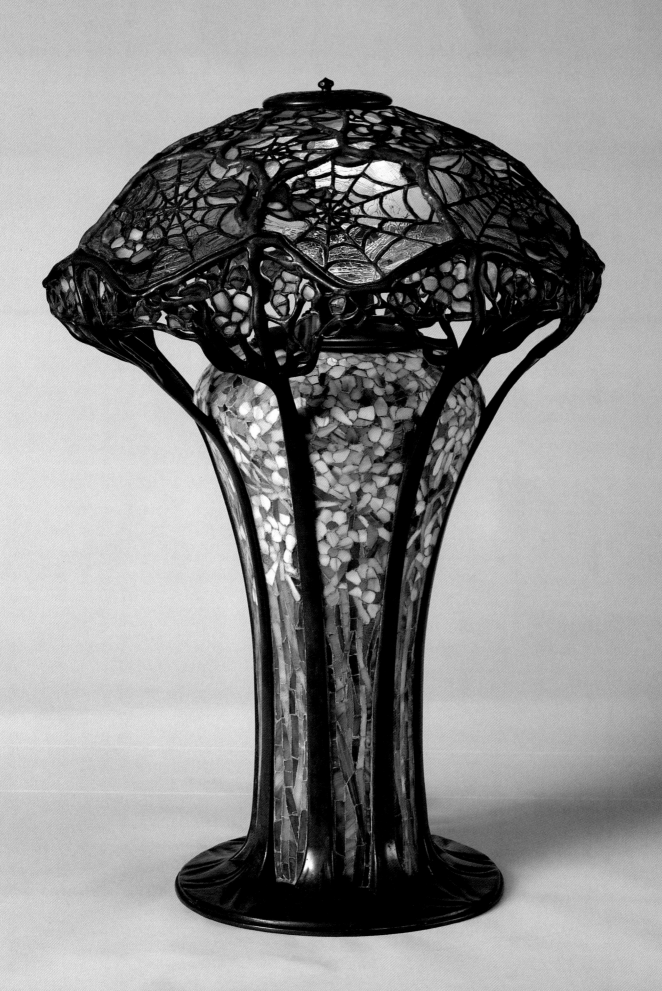

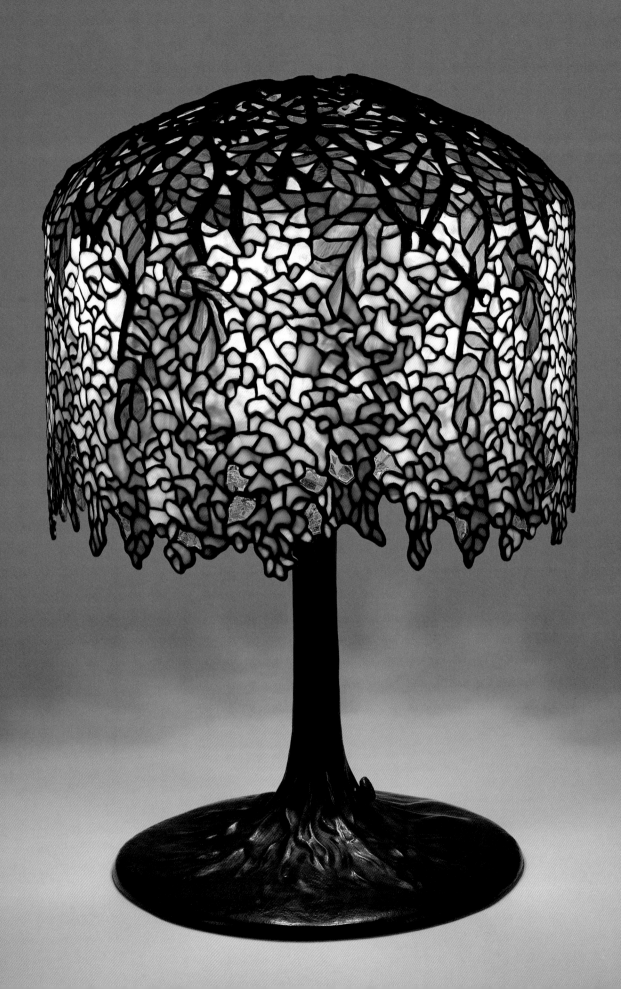

fig. 19
Wisteria lamp, designed by Clara Driscoll
c. 1901, model 342, 18 in. (45.7 cm) diam. NYHS.

assistance from the Tiffany Girls, and that the work was collaborative in nature. When the threat against her department by the unionized Men's Department in Corona was resolved in 1903, and Clara was granted the right to design all new shades, a challenge she proudly accepted, she added a telling proviso: "I have the chance now to make all the designs if I am equal to it. So I think I shall be on the lookout for assistance in that direction."[46] Likewise, in 1906, when she was estimating her work for the following year, she acknowledged: "Also I must take two new girls, a designer and a sort of errand girl so as not to waste a moment of any one who can cut glass or anything else."[47] Most probably this new "designer" served only as a draftsman to work out the final aspects of Clara's ideas and did not design on her own initiative.

Because managerial duties absorbed so much of her time, Clara often parceled work out to trusted colleagues. She frequently relied on her close friend and artistic partner Alice Gouvy. For a *Fern* lamp, she and Gouvy jointly worked on its design.[48] Although Northrop was called in to help on the design of the *Deep Sea* lamp, the next month Gouvy took over (figs. 21, 22).[49] Gouvy also worked out the idea for the *Dragonfly* lamp (frontispiece), and shared in the creation of the *Butterfly* lamp (fig. 16).[50]

Modifications in design, such as adjustments addressing problems in production, were sometimes suggested by the Tiffany Girls, although Clara officially instituted them. It has been noted, for example, that the shapes of *Wisteria* shades vary: some are steeper at the top, others more rounded (fig. 19). While making new brass templates to replace worn ones for the *Wisteria* shade, Clara explained: "Each girl comes out with her pet difficulties and I try to change the design so as to do away with them."[51]

Tiffany himself played some role, but only infrequently did he enter directly into the initial design process. Clara related an extraordinary tale about his involvement with the *Butterfly* lamp and its mosaic base of primroses (fig. 16): "But when he heard about the primroses, he braced up at once, seized a pencil and began to make pictures all over Mr. Mitchell's clean blotter and talking to himself

▼ fig. 20
Flying Fish shade, designed by Clara Driscoll
with Agnes Northrop and Alice Gouvy 1898,
model 1442, 16 in. (40.6 cm) diam. Courtesy of
Sotheby's, Inc.

▶ fig. 22
Deep Sea base, designed by Clara Driscoll with
Agnes Northrop and Alice Gouvy 1898, 30 ½ x
11 in. (77.5 x 27.9 cm). Mr. and Mrs. Robert Sage.

▼▼ fig. 21
Sketch of *Deep Sea* base from Clara Driscoll
letter, June 15, 1898. Queens Historical Society,
Flushing, NY.

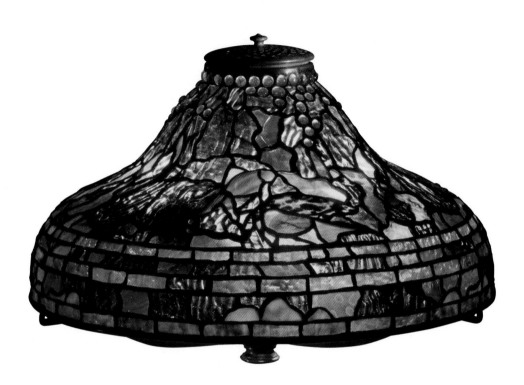

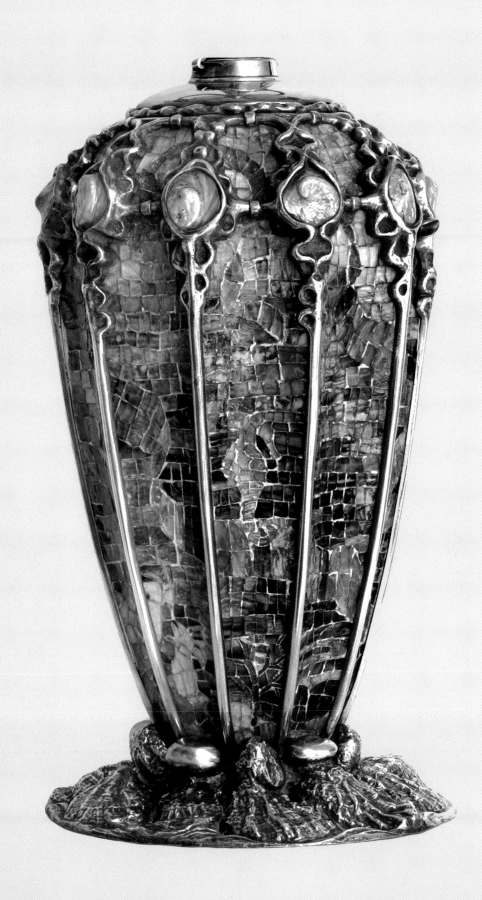

and to me, while the fan made his thick curls stand up around his beaded brow like a halo."[52] This is one of the most memorable eyewitness accounts we have of Tiffany's fervor as an artist.

Tiffany regularly inspected work in progress on Mondays, and his impending reviews loom large in Clara's letters. She was always concerned with getting things ready and was eager for his approval. Only rarely did she report that he modified her designs.[53] He generally favored her ideas.

Tiffany's lieutenants rarely made specific demands regarding her designs. Henry Wyckoff Belknap (1860–1946), one of the managers, suggested that her design for a *Fern* shade should utilize metal filigree to represent the veining of the leaves, just as she had used that material for the dragonfly wings.[54] Yet metal overlays were not employed on the *Fern* shade as produced.[55] Likewise, William Pringle Mitchell, a manager and Tiffany's in-law, wanted her to design inexpensive lampshades but did not specify motifs or designs, just the price range.[56]

THE CREATION OF PROTOTYPES

Clara's correspondence provides close-up descriptions of the process of designing a lampshade. At first, she worked experimentally and tentatively, with no particular formula or routine. In mid-1898, when she was designing a shade with swarming butterflies (fig. 16), she described her approach:

[F]or the last four days, I have been devoting my energies to the butterfly idea By Friday I had made a model of paper and linen so that Mr. Tiffany could see exactly what my idea was.... So I had all this material spread out and Mr. Tiffany was not only pleased but quite enthusiastic. I told him of two other ways I had thought of using them but did not want to spend time and material on them unless he thought it worth while. He said he did think it worth while and that I could work out all those ideas and anything else I thought of along that line. Then I told him that I could not carry them much farther without having special moulds to work on and should I model one in clay for his approval. He said he thought it would hardly pay for me to try what I had no experience in, but that I could have

the men in the plaster room make casts for me from my drawings and instructions. He told Mr. Mitchell about it and he too was very nice about it and said he thought it an original idea and suggested making a transparency to hang on his glass globe in the office. So I am going to do that first.... I have a drawing nearly made for Mr. Mitchell's transparency and shall begin the patterns for it. The one I made the model for is simple after the cast is made. An Italian professional is going to begin it Tuesday. I left the clumsy paper and wire model I made myself, with him and he is to do it in clay first for me to criticize, and then make a plaster cast on which I can make my drawing and glass patterns.[57]

In contrast to this complex process of creating distinctive shades, the firm also encouraged production of standardized, less expensive ones that would be commercially viable. Signs of this were already manifest when Clara was designing the *Fern* lamp: "She [Alice Gouvy] and I are now interested in getting up another lamp shade to take the place of the dragonfly ... which is very

expensive. This is to be exactly the same shape so that the same mould can be used. The base of the lamp will also be the same, so that the same fittings can be used."[58] Such standardization reflects the pressure to rein in costs and generate higher sales.

Leaving behind her fairly complex early projects in paper, linen, and wire (which she herself described as "clumsy"), Clara progressed to a more straightforward system. As she explained to her family:

Perhaps you would like to know how it is done. These particular ones (that I have been doing this week) are for 14 inch lamp shades.... First I draw a precise outline of the full size, rubbing it out and doing it over till it looks like a good shape. Then send it to the factory and have it spun in plaster, so that it is a perfect facsimile finishe[d] shade in plain white plaster. This I divide into three parts so that I can use it for three different shades, making a third of each design. Then with pencil, I sketch the design on one of the thirds, and then with watercolor make it look just as the glass will, tracing in the

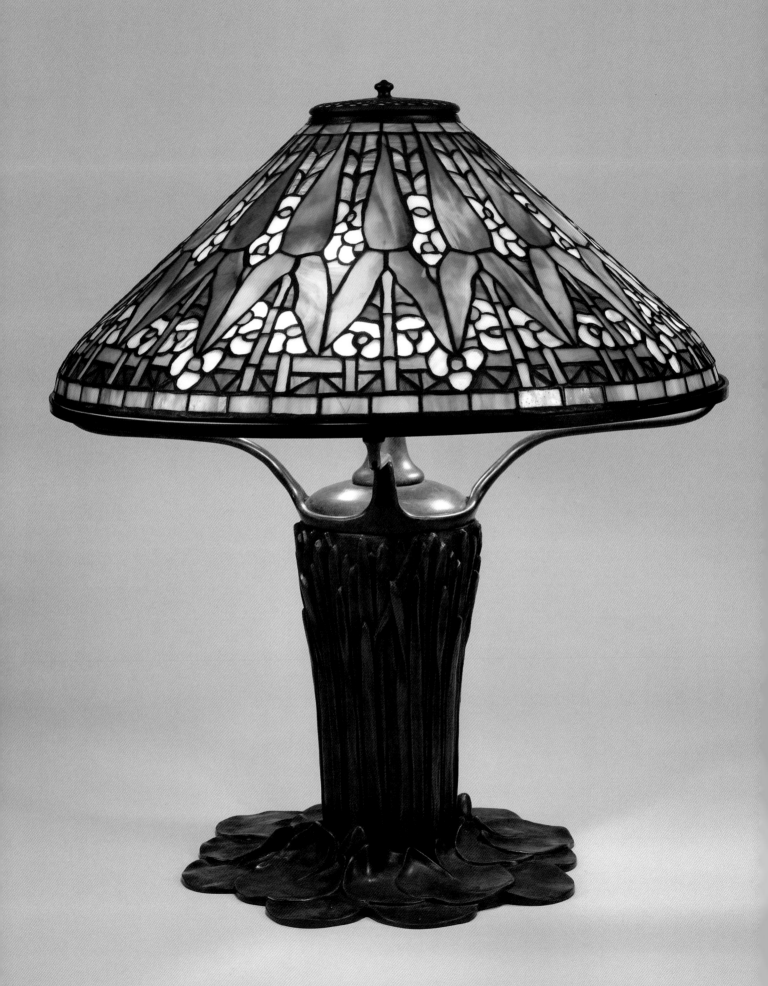

fig. 23
Arrowhead shade, designed by Clara Driscoll
c. 1904, model 1496, 20 in. (50.8 cm) diam.;
Cattail Pond Lily base, designed pre-1905,
model 225. NYHS.

lead lines with dark paint. On this mould—I
have a geranium shade, an arrowhead shade
and a daffodil shade. The girls call them sample
cards when they are done. Mr. Tiffany approves
of all three so the next step will be to have three
wooden blocks spun and then put each design,
very carefully on to its wooden block and then
make little patterns to fit each space. If there are
to be many shades made these patterns have to
be made in brass. Each pattern has a number on
it so that it will be easy to find the place. The
patterns are all laid out on a flat piece of glass
that has had the design traced on it in black
paint and this piece of glass with the patterns
on put in one of the windows against the
light—and the right glass selected and cut for
each pattern and then stuck on the big piece of
glass in place of its patterns. When the shade is
all cut it is sent to the factory (on its piece of
glass) with the wooden mould. There each
piece of glass is taken off and put on its corre-
sponding space on the mould, where they are
all fastened together with metal and the
whole thing drawn off a complete shade. It is

then put in an electric bath and plated with
copper (the metal) and then stained a rich
green. and then its tag is put on it and it comes
back here to be sold.[59]

Because Clara directed this particular part of the
letter to her mother, she may have omitted steps
and simplified processes. For example, she does not
mention making preliminary colored sketches of the
composition, although on other occasions she did
acknowledge them. When she was told that a shade
she was designing had to be completed quickly, she
noted that she had "only just finished the color
sketch...."[60] That preliminary sketches were indeed
made is also demonstrated by an extant example, a
watercolor rendering of the first model of a *Poppy*
shade—probably done under Clara's direction and
perhaps executed by Alice Gouvy (fig. 24).
 The use of plaster forms as models for shades
is unexpected. Equally surprising is that the
designs were drawn and colored directly on the
plaster, allowing the artist and "the Powers" to
judge the design full-scale and in the round. Until
now there had been no intimation whatsoever of

fig. 24
Study for a *Poppy* shade, probably designed by Clara Driscoll and possibly executed by Alice Gouvy c. 1900, watercolor, graphite, black ink on paper, 12 ¼ x 19 ¾ in. (31.1 x 50.2 cm). The Metropolitan Museum of Art, New York, Purchase, Walter Hoving and Julia T. Weld Gifts and Dodge Fund, 1967.

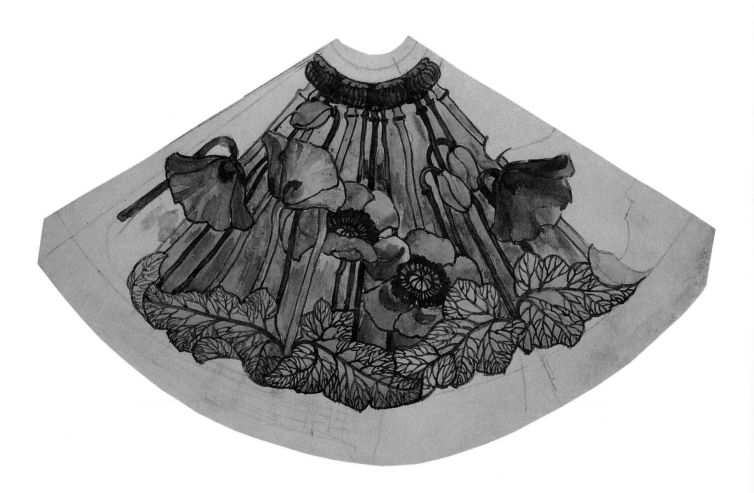

fig. 25
Poppy shade, probably designed by Clara Driscoll pre-1906, model 1467, 17 in. (43.2 cm) diam.; *Cushion* base, designed pre-1903, model 362. NYHS.

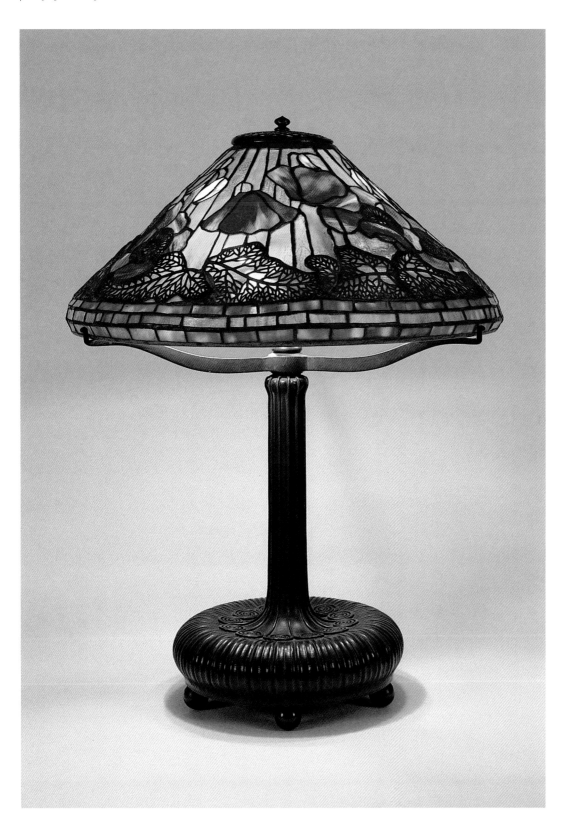

this practice, or that three designs would have been presented simultaneously. Clara's approach to design was economical because all three were intended to have the same shape and the same diameter. Few examples of a fourteen-inch diameter *Arrowhead* shade are known (fig. 26).[61] The model probably enjoyed only a limited production and lost out to a more generous twenty-inch version, almost identical in composition but with more repetitions of the conventionalized design (fig. 23).[62] The fourteen-inch conical *Daffodil* shade went into regular production, but none are known.[63] The fourteen-inch *Geranium* was produced, but with a slight incurvature at the bottom; here, too, few examples survive (fig. 27).[64]

Clara's gambit of presenting a trio of fourteen-inch floral shades was essentially political in nature (she wanted to prove she had the right to work in a size previously controlled by the men at Corona), but it sheds some light on how she designed groups of similar floral shades. In the instance she described in her letter, the three designs had in common the general notion of a floral element dominating most of the area, with a set of three horizontal bands at the bottom. In the *Arrowhead* and the *Geranium*, and probably in the *Daffodil* as well, a blossom or leaf sporadically appears in the middle band, thus helping to bind the two areas together. Curiously, though, the botanical elements are treated quite differently: the *Geranium* is presented in a fairly realistic mode while the *Arrowhead* is highly conventionalized, and the *Daffodil* probably fell somewhere in between.

Clara was evidently a prolific designer, a prerequisite for her position. During her tenure, the firm promoted many different models (in contrast to the scaling back of production around 1910) and she needed to be fast and inventive because she was solely responsible for all new floral and some of the geometric shades.[65] When she was designing the *Butterfly* lamp, she wrote that she had at least four other versions "in the works."[66] This concept of making variants on a theme runs throughout the shades. Although she reiterated that she was the designer of the *Wisteria*, for example, she did not mention the closely related

▼ fig. 26
Arrowhead shade, designed by Clara Driscoll
1904, model 1418, 13 ¾ in. (34.9 cm) diam.
Christie's Images Ltd., 2002.

▼ ▼ fig. 27
Geranium shade, designed by Clara Driscoll
1904, model 1562, 14 in. (35.6 cm) diam. Lillian
Nassau LLC, New York.

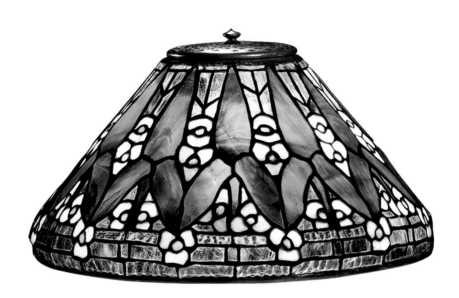

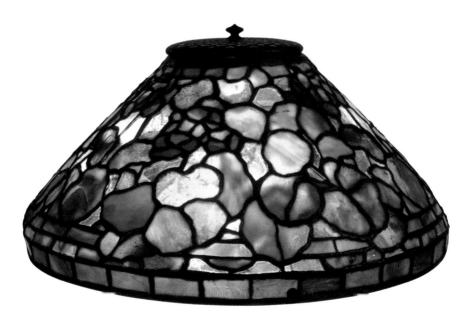

Trumpet Creeper and *Grape* shades (page 8), both of which follow the basic shape of the *Wisteria* but employ different floral motifs. It seems likely that she was responsible for these designs as well. Likewise, although she is documented as having designed one version of the *Dragonfly* shade, countless other versions with the same insect were introduced during her tenure, some with cabochon air bubbles in the background, others with the dragonflies swirling around diagonally (figs. 28, 29). Presumably Clara conceived these also, although she may have left it to Gouvy or others to work out details. While Clara never specified that she designed the *Poppy* shade (fig. 25), it too was introduced during her tenure, and its metal filigree echoes that on the *Dragonfly*. The vast number of models introduced in the first eight years of the century, although rarely documented in her correspondence, indicate how talented and resourceful she was.

In addition to this large repertoire of models in standard production, there were "special order" commissions. For instance, a difficult client wanted a special *Poppy* shade:

A woman ... began having samples made a year ago and has refused one thing after another till November last when they came to me for a sample of poppies used in a big shade. Knowing that she never accepted anything I made a very rough drawing of one section and had it made in glass. She was to have decided in two weeks, but finally said it would not do, which suited me exactly, but four days ago she came in greatly pleased with her self and said she must have that shade in three weeks.[67]

Unfortunately, Clara did not describe the variant offered to this client. On the other hand, some Tiffany Studios presentation drawings for other special order lamps have survived, such as one for a Miss H. W. Perkins showing a variant on the *Dogwood* shade and a unique base (fig. 30). Presumably such a presentation drawing would have been offered to the client for the *Poppy* for her approval.

Curiously, Clara barely described the processes that she knew best and supervised daily: the selection and cutting of glass. Perhaps she felt her family had heard enough about these tasks. When she was

working on the *Butterfly* lamp, the Tiffany Girls began collecting pieces "with suggestive markings" for her, but this was an exceptional moment when they first began making shades.[68] Typically, sheet glass was stored in the basement of the Manhattan building, and in one letter she referred to the problem of getting the glass from there: "Albert came up from the basement ... and gave me a long harangue about the difficulty of 'gittn the coolers loike the sample.'"[69] It is most likely that she normally went to the basement and selected the glass herself, even though the men carted it up to her studio. In one letter she recorded such a visit and digressed to an anecdote about how she weighed herself on the nearby scale, only to discover she had put on two pounds in the last two weeks.[70] Within her tale are important clues as to how the glass was selected. The scale was there because all the glass that she chose was first weighed and charged to her account.[71] That she had weighed herself on that scale two weeks earlier suggests the frequency with which she went to select the glass.

Templates snipped from sheet brass were used to guide in the cutting of the glass. Surprisingly,

Clara herself took on the responsibility of making them for all the models. As she reported in 1903: "I have nearly finished the patterns for my new conventional shade and tomorrow I have to duplicate them in brass."[72] For more popular lamps, sets of duplicate templates were made so that several shades could be produced at once. For example, there were three sets for the *Wisteria*. Yet even these metal templates wore out with use, and new ones had to be cut. Again, Clara took on this duty. As she noted in 1905, 123 *Wisteria* shades had been made, causing the templates to wear out, and she had to cut new ones.[73]

A lampshade was not fabricated by a single artisan. Occasionally Clara wrote of a selector and cutter working together on an individual shade. In 1905 she described the workers in her workspace and noted: "At my back is Miss Gober standing back and squinting to get the effect of a big red peony lamp shade she is selecti ng the glass for. Her cutter Anna Ring, the blonde jewess with enormous pompadour is cutting the pieces, with her usual deftness and skill."[74] As with the windows, teams of women worked together, especially when there

fig. 28
Dragonfly shade, probably designed by Clara
Driscoll pre-1906, model 1507, 22 in. (55.9 cm)
diam. NYHS.

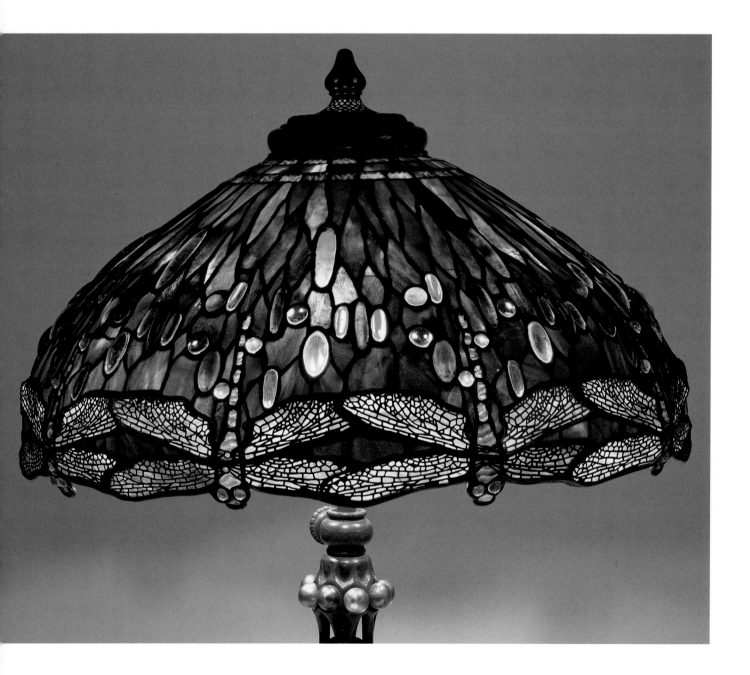

fig. 29
Dragonfly hanging shade, probably designed
by Clara Driscoll c. 1900-08, 21 in. (53.3 cm)
diam. The Neustadt Collection of Tiffany
Glass, Long Island City, NY.

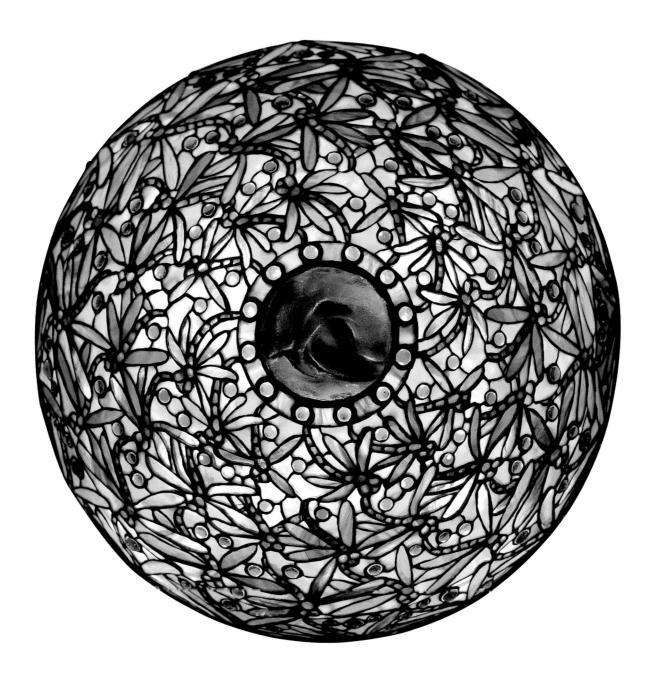

fig. 30
"Suggestion for Lamp for Miss H.W. Perkins
by the Tiffany Studios," probably designed by
Clara Driscoll c. 1900, watercolor and graphite
on paper, 15 1/16 x 11 9/16 in. (38.3 x 29.4 cm).
The Metropolitan Museum of Art, New York,
Purchase, Walter Hoving and Julia T. Weld
Gifts and Dodge Fund, 1967.

were rush orders. On occasion different groups of women worked on a single shade, each taking one repetition of the design.

In another letter, Clara referred to the copper foil used to wrap the cut pieces of glass for a lampshade.[75] The foiled pieces were set on the large glass easel in accord with the black-painted guidelines traced from the cartoon, just as in the making of windows. While on the easel, the pieces were not affixed to each other or to the surface and thus the slightest bump could easily scatter the assembled glass. Clara recounted a disastrous event that occurred while the Tiffany Girls were working on a rush order of *Wisteria* shades:

> The wisteria lamps were in an awful rush and the girls were going to work over time in the afternoon. At three o'clock a most tragic thing happened. The scrub woman was cleaning the floor under the easel when she suddenly decided to get up. Of course she took the whole … easel with her and immediately the work of for [sic] girls for six days was in about nine thousand pieces over the floor in an undistin-guishable heap. The catastrophe was so great that there was not even a word of regret. About six of us fell to work without a word to repair damages. As for the scrubwoman, she looked around in a dazed way for a minute and then calmly went on scrubbing[,] the only untrou-bled and care free person in the room. It was possible to save most of it but an awful piece of work to find the place of each little piece.[76]

The easels on which the foiled glass pieces were arranged also served as pallets on which the cut glass was transported out of the Women's Depart-ment. As with the windows, male employees soldered the foiled pieces together and electro-plated the leaded surfaces with copper. In her letter, Clara glossed over the men's roles. It is a significant lapse: she was writing soon after the combat with the men's union and she was crowing over her newly gained right (taken away from the men) to make fourteen-inch shades. As she described the various production stages, it was as though men had no part in making *her* lampshades.

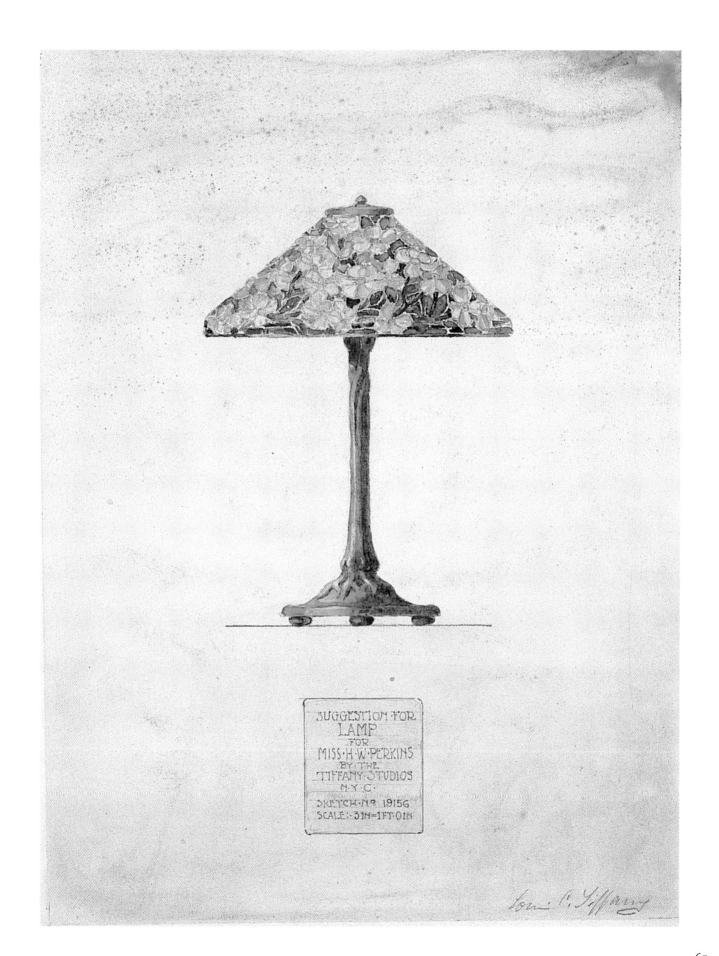

SUGGESTION FOR
LAMP
FOR
MISS·H·W·PERKINS
BY THE
TIFFANY·STUDIOS
N·Y·C·
SKETCH·Nº·1915G
SCALE·3IN=1FT·0IN

Louis C. Tiffany

fig. 31
Dragonfly lamp, probably designed by Clara Driscoll pre-1903, model 356, 14 in. (35.6 cm) diam. The Neustadt Collection of Tiffany Glass, Long Island City, NY.

MOSAIC LAMP BASES

When Clara returned to Tiffany Studios in 1897, lamp bases were bronze with either blown glass or metal fuel containers. Then, a critical event occurred in mid-1898: "Today I thought how nice it would be to make a lamp with a mosaic base instead of a metal or glass vase that is usually taken for the base."[77] Given her experience with monumental mosaics, this was a natural evolution. Like her innovative leaded shades, Clara's introduction of mosaic bases was a major turning point in the development of Tiffany's lamps.

The methods used to fashion these first bases were awkward. Normally the form would have been modeled in plaster or wax, but Clara, who apparently had no training as a modeler, improvised. When planning the base of the *Deep Sea* lamp (fig. 22), she proposed a rather clumsy way of forming it in clay over a small pail, and if Tiffany approved, she planned to model it more carefully and draw and color the design on that. Then she foresaw copying it in cement on the real lamp base and adding the glass mosaic.[78]

By the time she began work on the *Dragonfly* lamp (figs. 28 and 31), Clara was intending to use modeler's wax. Writing from her boardinghouse room, she reported:

George [Waldo] is coming to help me on a design that I want to model in wax. I don't know how to use the wax so he is going to show me. It is for an electric light and is going to be dragon flies with gauze wings ... I want to submit the idea to Mr. Tiffany in the shape it will actually be so have taken a vase that was nearly the right form inverted—and had a coating of wax put all over it. Then with a lump of wax I can build up all the raised work and with pieces of paper indicate the glass wings—sticking the real beads in the holes where the eyes would come.[79]

Her use of an inverted glass vase to establish the basic form and split glass beads for the insect's eyes suggests the still experimental mode of her work. Clara, after all, was not a professional in the same sense as the modelers whom Tiffany employed; her training was in design and was perhaps less impressive than the position she occupied. But what she lacked in expertise, she made up for in inventiveness.

The bronze bases were cast in Corona, one of the few professional foundries in the United States, but were brought back into Manhattan for their mosaic inlays. Each section of inlay would

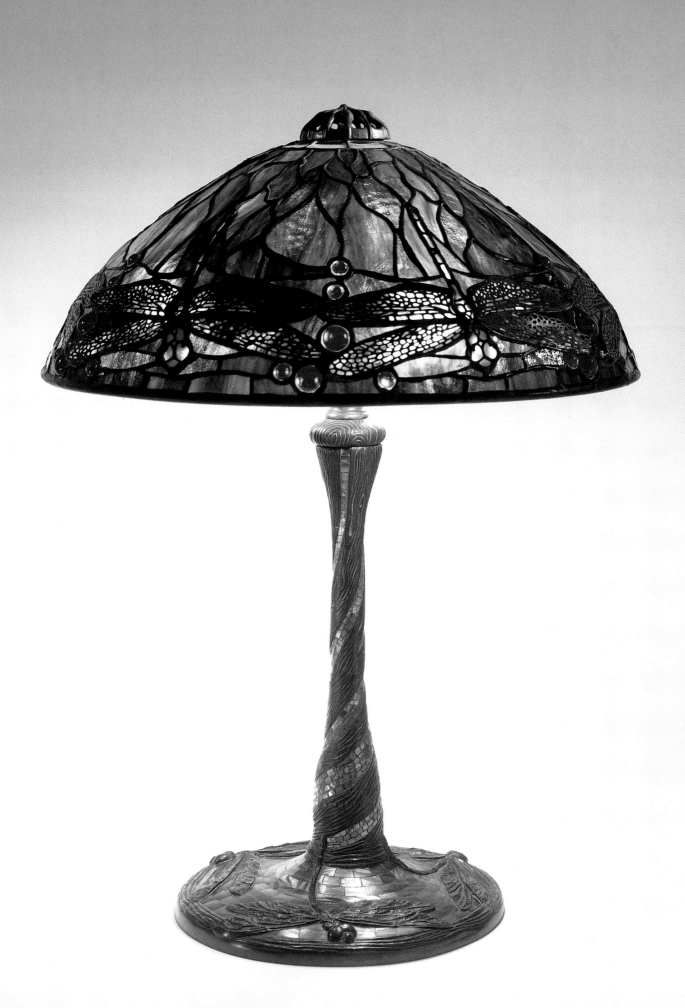

fig. 32
Nasturtium shade, probably designed by
Clara Driscoll pre-1906, model 1506, 23 in.
(58.4 cm) diam.; mosaic base designed pre-
1906, model 355. NYHS.

have required a full-scale cartoon worked up from Clara's (or Gouvy's) design, and then the glass would have been cut to that pattern. It is likely that templates were made to aid the cutters, just as they were for the lampshades, but this is not discussed in Clara's letters. On the other hand, the mode of assembling the cut tesserae was explained. The individual pieces were not cemented directly into the recesses of the base. Rather, they were assembled on easels. Then each panel was inserted as a whole into the waiting recess.

The Tiffany Girls executed these mosaics. Gouvy, for example, made the mosaics for the first eight bases of the *Butterfly* lamp.[80] Interestingly, several workers might be assigned different mosaic panels on one lamp, just as group participation occasionally prevailed in the making of leaded shades. Clara referred to one such collaborative effort apropos of a *Cobweb* base made as a rush order:

We had an order for one of the big cobweb and apple blossom lamps. The base is made in eight sections of mosaic, which are afterward put together. The design is narcissus flowers growing up around it. In order to hurry it through, Miss McVickar and Theressa who have had lots of experience each took one and then I gave one to him [the deaf and dumb boy], to his great delight. They each had their little easels propped up on the table and two or three flowers in apiece, when I came around in the afternoon.[81]

Not all the mosaic bases were pictorial. For example, the mosaic used for the *Dragonfly* lamp shown in Paris in 1900 (frontispiece) and also the base made for the electric version (fig. 31) have no imagery—just gradations and contrasts of colors. Similarly, a very large base intended for general usage with large shades, such as the *Nasturtium*, also has only gradations of color in the mosaic (fig. 32). In the later years of Clara's tenure, few if any new mosaic bases were introduced, as production centered on less costly all-bronze bases. In fact, almost all the bases with mosaic inlay were phased out before 1910.[82]

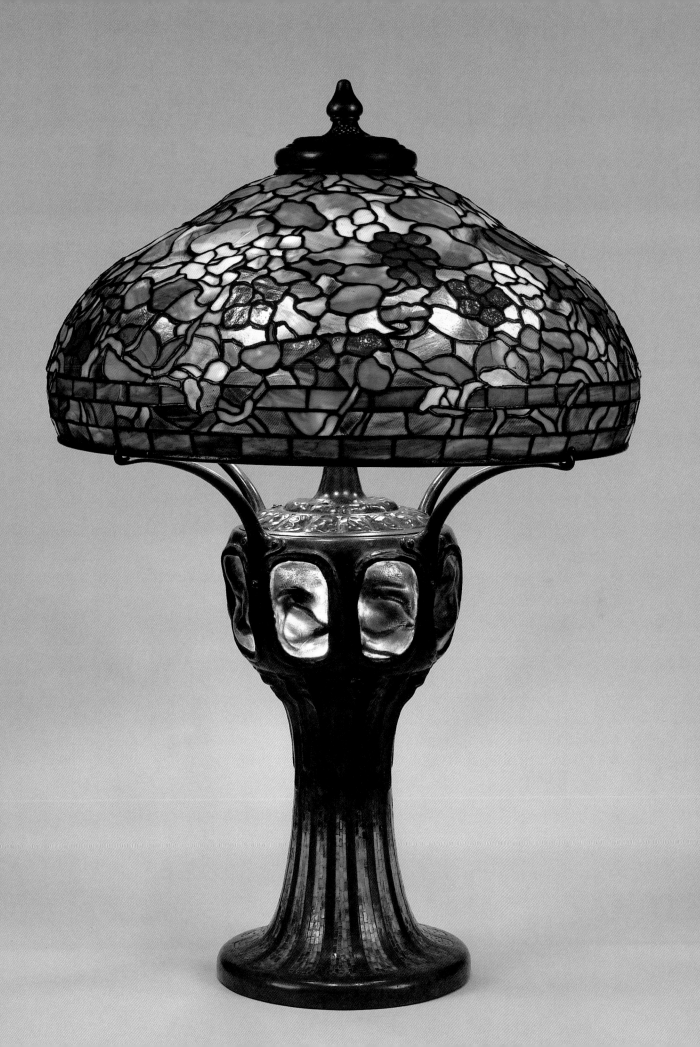

FANCY GOODS

Clara was also responsible for a wide range of what she termed "novelty items" and which Tiffany Studios marketed as "fancy goods": inkstands, candlesticks, boxes, "tea screens," and many other decorative but functional objects. These too evolved from her work with leaded glass and mosaic. In most cases, though, these objects were far less expensive because their small scale required relatively few hours for the cutting and assembling of the glass. Although Clara always welcomed the challenge of large projects, these smaller items helped to keep the Tiffany Girls fully employed.

Small tea screens, intended to protect the spirit burner under a teakettle, were composed as three hinged leaves inset with glass. The simplest screens were made from carefully chosen sheets of glass with novel coloration and veining (fig. 33). The more complex ones, made of leaded glass, have floral designs and resemble miniature Tiffany windows or lampshades. For example, one with iris is closely related to certain monumental Tiffany landscape windows that depict these stately flowers in the foreground (fig. 34). Another

popular design, of spider webs and apple blossoms, very much resembles the *Cobweb* lamp, and uses the same crackle glass as the shades to simulate the cobwebs (fig. 35). Although Clara did not mention these tea screens in her correspondence, the parallels between them and her larger projects are evident.

Small objects with mosaic inlays, such as inkstands and pen trays, were other types of fancy goods offered by Tiffany Studios. Soon after creating some new inkstand designs, Clara wrote: "Last week I took down the first ones of my cheap novelties for this year all ready to go to the factory. A small ink well to be of cast metal with a little place for a rich medallion of inlaid glass, and the other a pen tray to go with it. The cost, counting in the metal work, will enable them to sell them for ten dollars apiece."[83] The range of prices for these works with mosaics was wide and depended on the size, the complexity of the inlay, and the size and richness of the bronze casting. The firm's 1906 Price List records a range from $7 for a simple inkstand to $90 for the *Arrowheads* "fern dish" or planter (figs. 36–38). The design of the latter recalls the base of

Clara's *Dragonfly* lamp (figs. 28 and 31), illustrating the way in which she cleverly adapted her designs as was needed. By 1910, however, all fancy goods with mosaic inlay, except for the *Arrowheads* fern dish, were taken out of production because of their intensive handwork and expense, and Tiffany Studios increasingly promoted bronze objects requiring little handwork.[84]

Some idea of the sorts of inkstands Clara designed can be gleaned from her correspondence and from the 1901 photograph of her studio, which shows a number of her designs on the worktable (fig. 66). In the foreground is a pyramidal inkstand with bronze fish along the outer edges, and the sides inlaid with mosaic.[85] Slightly behind and to the left is a cylindrically shaped inkstand with modeled poppy leaves in bronze, and a molded glass poppy blossom as the cover (fig. 37). This inkstand was a work in progress, and a few months later Clara showed it to John Cheney Platt, the Tiffany treasurer, for his approval. He agreed that it should be put into production.[86]

It is tempting to speculate that the *Swirl* desk sets are Clara's invention (figs. 39, 40).[87] The curved surfaces of the inkstands were invariably set with mosaic, while the flat surfaces of the pen trays and paperweights could receive either tesserae or whole pieces of glass, such as the richly veined and textured Cypriote glass seen here. Suitably, a brown-toned glass was chosen for a paperweight with a brown patina, while glass more green in tone was selected for one with a greenish patina. Although produced serially, even small items such as these paperweights were fabricated with great care. The fluent, undulant design of this desk set is quite remarkable and comes close to the Art Nouveau idiom of Edward Colonna (1862–1948), then being promoted by Tiffany's European representative, Siegfried Bing.[88] In early 1898, Clara's sister Emily recalled having just seen "some little brass boxes covered with wavering lines which Clara called a design and said she made."[89] Emily was looking at brass (perhaps unpatinated bronze?) boxes, yet her comments suggest the type of linear design that Clara was experimenting with in the *Swirl* desk set, and they register the bewilderment that such avant-garde patterns might have caused.

▾ **fig. 33**
Tea screen, designed pre-1906, bronze and glass, 7 ½ x 13 9/16 in. (19.1 x 34.4 cm). The Ellman Family.

▾▾ **fig. 34**
Iris tea screen, probably designed by Clara Driscoll pre-1906, bronze and glass, 7 ¾ x 12 ½ in. (19.7 x 31.8 cm). Virginia Museum of Fine Arts, Richmond, VA, Gift of Furman Hebb.

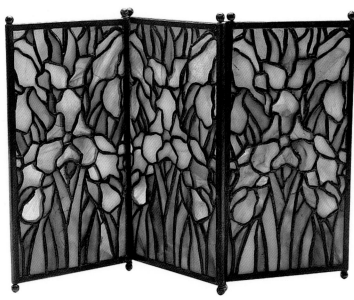

fig. 35
Cobweb and Apple Blossom tea screen,
probably designed by Clara Driscoll pre-1906,
bronze and glass, 7 ¹⁄₁₆ x 12 ¼ in. (17.9 x 31.1
cm). Christie's Images Ltd., 1994.

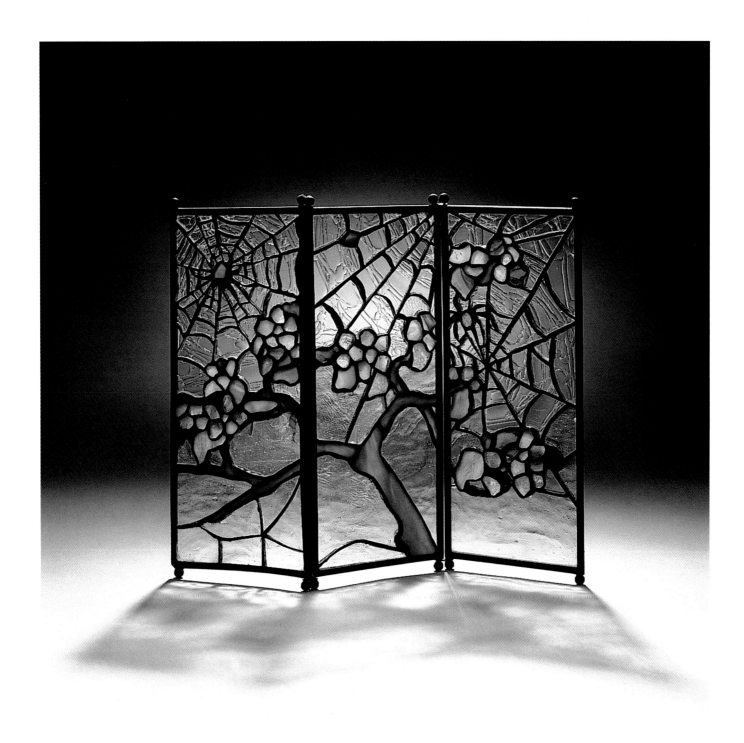

▼ fig. 36
Inkstand, probably designed by Clara Driscoll
pre-1903, bronze and glass, model 865, 3 5/16 x
4 ½ in. (8.4 x 11.4 cm). The Ellman Family.

▼▼ fig. 37
Poppy inkstand, designed by Clara Driscoll
1901, bronze and glass, model 867, 3 3/8 x 3 5/8
in. (8.6 x 9.2 cm). The Ellman Family.

► fig. 38
Arrowheads fern dish, probably designed
by Clara Driscoll pre-1903, bronze and glass,
model 835, 3 ¾ x 12 ¼ in. (9.5 x 31.1 cm).
American Decorative Art 1900 Foundation.

Clara alluded only in passing to how she designed such items, but she seems to have worked largely by carving directly in plaster. She may have modeled in wax as well.[90] While carving the plaster model of an inkstand, she mentioned that "the space for glass [was] filled in with wax."[91] Steel molds were made once the item was approved so that it could be cast in sufficient quantity. Decisions about the size of the run were left to higher authorities. Regarding two of her proposals, she explained: "Mr. Platt liked them and without waiting for a sample to be made up, gave an order for two hundred of the ink bottles and one hundred trays." But concerning another inkstand design: "Mr. Platt thought it very nice and worth doing but was going to talk over the quantity with Mr. Tiffany."[92]

Trivets or "tea stands," as they were labeled by the company, were another way of coupling qualities prized in that era: the Beautiful and the Useful. A tea stand with a mosaic of a single dragonfly artfully placed against a background of concentric circles was shown at the 1902 International Exposition of Decorative Arts in Turin and put

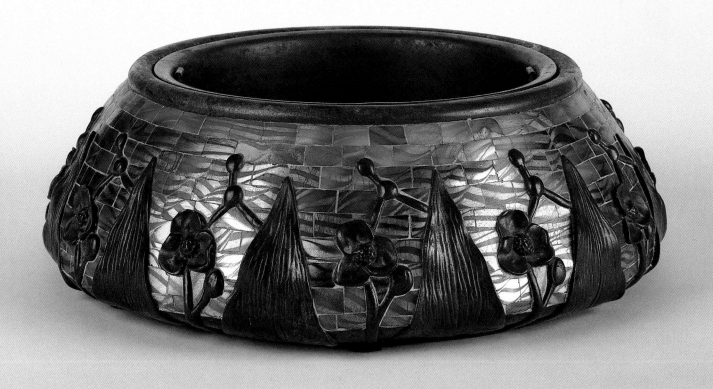

fig. 39
Swirl pen tray and inkstand, probably designed by
Clara Driscoll pre-1903, bronze and glass; tray model
1001, 7 ¾ x 2 ¹⁵/₁₆ in. (19.7 x 7.5 cm); inkstand model
868, 2 x 3 ⅛ in. (5.1 x 7.9 cm). The Ellman Family.

fig. 40
Swirl paperweights, probably designed by Clara
Driscoll pre-1903, bronze and glass, model 932, each
3 ½ x 2 ¾ in. (8.9 x 7 cm). The Ellman Family.

▼ **fig. 41**
Paperweight, probably designed by Clara
Driscoll c. 1900-09, marble, bronze, glass,
2 ¹¹⁄₁₆ x 2 ¾ in. (6.8 x 7 cm). The Ellman Family.

fig. 42
Carp and dragonfly tea stand, probably designed by Clara Driscoll c. 1900-02, bronze and glass, 6 ¼ x 6 ¼ x ⅞ in. (15.9 x 15.9 x 2.2 cm). The Museum of Modern Art, New York, Gift of Joseph H. Heil.

into general production (fig. 43). Other mosaic trivets, equally early but much less common, have more complex designs.[93] An especially beautiful square example, with richly textured Cypriote glass, features both a fish and a dragonfly (fig. 42).[94] These motifs, of course, also appear in Clara's early lamps. Gradually, production seems to have centered primarily on the single dragonfly or a plain design of just colored tesserae. There was no price distinction between the two types (termed "fancy" and "geometrical") since both involved the same amount of materials and labor. The numbers that have survived attest to their popularity, even though production stopped by 1910.

A closely related form employing mosaic is the small pictorial plaque set within a bronze frame. One,

fig. 43
Dragonfly tea stand, probably designed by
Clara Driscoll c. 1901, bronze and glass, model
972, 7 ¼ in. (18.4 cm) diam. The Charles
Hosmer Morse Museum of American Art,
Winter Park, FL.

fig. 44
Carp mosaic plaque, probably designed
by Clara Driscoll c. 1899, bronze and glass,
18 ⅛ x 13 in. (46 x 33 cm). Hessisches
Landesmuseum, Darmstadt, Germany.

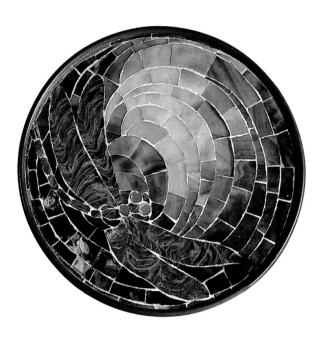

sold in 1900 by Siegfried Bing, features two large
carp and it too has richly textured glass (fig. 44).

Table clocks were also decorated with a variety
of designs in mosaic. Clara's correspondence
reveals that she was busily designing timepieces
in the late 1890s and that she was using imported
European clockworks. A Tiffany Studios clock with
French works, richly covered with glass mosaic,

fig. 45
Desk set with moths and cicadas, probably
designed by Clara Driscoll pre-1903, bronze;
inkstand 3 ½ x 5 ¾ x 5 ⅞ in. (8.9 x 14.6 x 14.9
cm). Private Collection.

fig. 46
Table clock, probably designed by Clara
Driscoll c. 1900, bronze, glass, and mother-of-
pearl, 9 ¾ h. in. (24.8 cm). Christie's Images
Ltd., 1997.

fig. 47
Inkstand, probably designed by Clara Driscoll
c. 1900-07, bronze and glass, 2 ½ x 4 ¼ x 4 ⅛
in. (6.4 x 10.8 x 10.5 cm). Private Collection.

could well be one of Clara's designs (fig. 46).[95] The
attribution is especially tempting because the
clock has rows of mother-of-pearl beads, a mate-
rial that interested Clara at the time she was
designing the *Deep Sea* lamp. Other bronze and
wood clocks, similarly inlaid with mosaic, illustrate
the wide variety of work that Tiffany Studios was
offering at the turn of the century.[96]

WORK IN BRONZE AND OTHER METALS

While Clara's smaller objects in leaded glass and
mosaic were logical extensions of her larger works
in the same materials, her designs for objects to
be cast in bronze are more surprising. Bronze is an
unlikely medium for an artist with little prior
training as a modeler, and, moreover, this might
have seemed more the province of the men out at
Corona, where the Tiffany foundry was located.[97]
Yet designs for bronze objects, even lamp bases,
fell within Clara's domain.

fig. 48
Seaweed photograph frame, designed
c. 1900-07, bronze and glass, 6 ¼ x 7 ¼ in.
(15.9 x 18.4 cm). Private Collection.

The Round Robin letters record many projects that were three-dimensional tributes to nature. An 1898 letter from Clara recorded: "I am still plodding along on that butter fly calendar," a work in bronze.[98] A few years later she wrote that "Alice [Gouvy] had a beautiful clock, made of dragon flies and arrow head (flowers)."[99] An early and rare Tiffany desk set comes close to these

descriptions of nature rendered in bronze (fig. 45). The letter rack and blotter ends are decorated with moths, while the letter opener is formed of cicadas. Parts of two such desk sets are known, suggesting that it was put into relatively limited production and discontinued soon thereafter. Other designs are known only from single examples, although these too may have been made in small series. One is a charming mosaic-covered inkstand with a leafy cover and base (fig. 47). Another is a bronze picture frame of rippling seaweed, with panes of striated blue glass to suggest the sea (fig. 48). The modeling in these works is quite accomplished.

More common are a number of all-bronze inkstands that were put into general production. One is a model with butterflies (fig. 49), whose densely packed surface of diagonally swarming insects recalls the arrangement on the *Butterfly* shade (fig. 16). The cover is a molded *favrile* glass poppy flower, the same as used for the *Poppy* inkstand (fig. 37).

Clara also designed a number of objects featuring the wild carrot (or Queen Anne's lace) plant. In

fig. 49
Butterfly inkstand, probably designed by
Clara Driscoll pre-1906, bronze and glass,
model 852, 2 ½ x 5 in. (6.4 x 12.7 cm). Private
Collection.

fig. 50
Wild Carrot inkstand, probably designed by
Clara Driscoll c. 1900-02, bronze, model 855,
3 ⅝ x 5 ¼ in. (9.2 x 13.3 cm). The Ellman Family.

1898, she described her plan to make boxes and clocks based on this flower.[100] Northrop was called upon to help with the boxes, which were supposed to be completed right away. Whether they were actually put into production is not certain, especially since several delays then occurred.[101] Another design with the wild carrot motif is an inkstand shaped like the unopened floret (fig. 50).[102] It was probably this model that was exhibited at the Grafton Galleries in 1899.[103] Others in Clara's artistic circle used the same floral motif. As she noted in 1902: "Lilian Palmié was making a candlestick out of the wild carrot in wax which is afterward to be hammered in metal."[104] Wild carrot candlesticks were offered in a variety of forms and sizes.[105] Most often the candle holders are relatively simple cups or ones inset with blown glass (fig. 51), but some extraordinary examples have candle cups fashioned like the flower bud and are rendered in such fine detail that they were probably cast from live specimens (fig. 52).[106]

fig. 51
Wild Carrot candlestick, probably designed by
Lillian Palmié c. 1902, bronze and glass, model
1306(?), 18 ½ x 8 ¼ in. (47 x 21 cm). Lillian
Nassau LLC, New York.

fig. 52
Wild Carrot candlestick, probably designed
by Lillian Palmié c. 1902, gilt bronze, model
1319, 19 ½ x 8½ in. (49.5 x 21.6 cm). The Ellman
Family.

BRONZE LAMP BASES AND CLOCKS

One might have thought that Clara did not design bronze lamp bases (except, of course, those with mosaic inlay), yet her correspondence proves the contrary. In 1902, she wrote of having prepared the designs for four new and less expensive bronze bases.[107] Implicit in her phrasing is the idea that she had already designed others. But which designs might be hers? Are they ones with naturalistic themes like the *Wild Carrot, Fern,* and *Bird Skeleton* bases? Might they be those with inlays of "turtleback" glass tiles? Or are they indistinguishable from the ones conceived by the men at Corona? Unfortunately, her letters fail us.

Clara also designed all-bronze table clocks. Her letters about them were often quite detailed and even included sketches, but none of the clocks are extant. Tiffany had already approved a number of her clock designs by mid-July 1898, when Clara first began discussing new ideas. One project featured an automatic calendar around the clock face and had an elaborate decoration of interlaced strapwork (fig. 53), a Celtic-inspired decoration that Tiffany had already used in the ceiling of the Veterans' Room in the Seventh Regiment Armory in New York (1879–80). Especially intriguing is the parallel between Clara's clock design and the one for the *Zodiac* desk set issued by Tiffany Studios (fig. 54). Was Clara responsible for the *Zodiac* set as well, or were both manifestations of a popular decorative motif favored by Tiffany's design staff? A clock decorated with signs of the zodiac bore the legend "Tempus Fugit" (fig. 55), recalling the tendency in British Arts and Crafts to add instructive maxims. Clara's descriptions, though, emphasized not their decorative aspects but the clocks' mechanical surprises.

For her "Tree-of-Life" clock (fig. 56), Clara planned ornament that "contained all the symbolism known to art, and some that I invented my self." She asked her friends' opinions about it and Henry McBride told her quite frankly that "there are too many ideas in it. Eight feet of ideas and not a quiet spot to rest your eye on." Clara responded: "I am afraid it is true and isn't it sad? I have grown so fond of each idea that I don't know what to discard."[108]

"THE IDEAL FUTURE"

Clara approached her work at Tiffany Studios with

fig. 53
Sketch of table clock with Celtic interlace from Clara Driscoll letter, July 26, 1898. Queens Historical Society, Flushing, NY.

fig. 54
Signs of Zodiac calendar frame, designed pre-1906, gilt bronze, model 943, 7 x 8 in. (17.8 x 20.3 cm). Dee and Mike Michaelis.

fig. 55
Sketch of "Tempus Fugit" table clock from Clara Driscoll letter, August 11, 1898. Queens Historical Society, Flushing, NY.

fig. 56
Sketch of "Tree-of-Life" table clock from Clara Driscoll letter, July 26, 1898. Queens Historical Society, Flushing, NY.

fig. 57
Four covered boxes and bowl with berries,
grapes, apple blossoms, and eggplant,
designed c. 1898-1907, enamel on copper,
largest 4 ⅞ x 6 ¼ in. (12.4 x 15.9 cm). Private
Collection.

great enthusiasm. As she wrote in 1902: "The Tiffany work goes well. There is plenty to do. My ideas are coming on slowly and I think will be really commercial."[109] Yet despite her emphasis on professional success and her enjoyment of life in a great metropolitan center, her letters also show another, more retiring side. She frequently sought respite from the pressures of business, particularly the large-scale ones of Tiffany's. It is significant that when she went out to the Corona property in 1905, she found the factory workplace unsettling—especially because there had been rumors that her department might be transferred there. The heat, din, and bleakness of the factory were oppressive.[110]

Clara much preferred the enamel and pottery departments installed in a small building there, and occupied by Alice Gouvy, Lillian Palmié, Miss Lantrup, and a small staff of women. Clara admired both the environment and the beautiful wares that were made in these workshops, which she called "a little Arcadia" (figs. 57–60).[111] This genteel, feminine environment was tastefully decorated with "beautiful studies on the walls and vases of seed pods and dried leaves and every kind of lovely thing both in Nature and Art" (figs. 61, 62).[112] The non-commercial way in which the women worked in Corona was something Clara found even more attractive: "No one ever comes and asks them when they will finish a thing or how much it will cost to execute their designs. They never hear the word cost, and are quite untouched by the hurry and worry of the commercial world. Mr. Tiffany whose only idea is Art comes to see them two or three times a week."[113] Clara wished that she could indulge in such luxury. Two months later she expressed the very same thoughts: "Their work is practically the private enterprise of a rich man, and they never consider anything but the question of beauty while I have to consider the cost of production at every step—beside being interrupted in my work by all manner of things relating to business rather than Art...."[114] Her many responsibilities—the pressure of constantly creating new, commercially viable designs, the problems of managing a large staff, the persistent opposition of the union—all contributed to the stress and fatigue she constantly felt.

fig. 58
Plaque with oysters and seaweed, designed
c. 1898-1907, enamel on copper, 12 ½ in. (31.8
cm) diam. Private Collection.

Clara often expressed a desire to retreat back to the Ohio countryside. In part it was nostalgia for her family, but even after the death of two of her sisters and her mother, she still longed for the simplicity of Tallmadge. Her idea was to start a small-scale Arts and Crafts venture back there. At the core of this scheme, often referred to as "the Ideal Future," was the idea that Clara would organize members of her family and friends to work in a handicraft cooperative, and that she would provide designs and manage the undertaking.

Clara entertained thoughts of "the Weaving Scheme." As she wrote to her family: "What you say about the Tallmadge girls having something to do that will sufficiently occupy the time and ability of such bright capable girls and at the same time bring in a little money appeals to my heart and I hereby solemnly swear that it shall be done."[115] True to her word, Clara made inquiries and consulted a weaver working at Tiffany Studios who offered to build a simple loom and teach her to use it. Clara also visited Henry Belknap, who by then had left Tiffany and founded a gallery for modern crafts in New York.[116] He and his partner

were most enthusiastic to handle her textiles: "So tell Flora Jones and Grace Sackett and the rest, to have patience for a few moments longer and there will be plenty of work to do, congenial and interesting and paying. Something they can do at home in their own time. The first meeting of the Western Reserve Tapestry Weavers will take place in the hammocks as soon as I get home."[117]

Clara's project was prompted in part by the union's threat to close the Women's Glass Cutting Department, but her letter reveals something else—a desire to create a congenial and profitable sorority. It was an idyll worthy of William Morris.[118] As late as 1907, well after the threat from the union had abated, Clara was still corresponding with Emily about the scheme, which involved weaving and photography, and she was planning to bring in Gouvy and Edith Griffin (Clara's temporary replacement at Tiffany Studios in 1906).[119]

One persistent idea behind the Ideal Future was the wholesomeness of rural life and family life, compared with the perilous urban environment and the forces of large business. Clara's thoughts exposed the basic dichotomy of art versus industry, a

fig. 59
Three vases with arrowhead, tulip, and wild
carrot, designed c. 1904-10, semi-porcelain,
from left to right 8 x 6 in. (20.3 x 15.2 cm); 7 ¾
x 4 in. (19.7 x 10.2 cm); 8 x 7 in. (20.3 x 17.8 cm).
Private Collection, New York.

fig. 60
Coupe with frogs and water lilies, designed
c. 1904-10, semi-porcelain, 6 ½ x 7 ¾ in.
(16.5 x 19.7 cm). Private Collection, New York.

problem at the very heart of the Arts and Crafts movement as a whole. Tiffany's empire was an art industry with a factory system, and Clara had become more of a businesswoman than an artist.[120]

Clara's dilemma was not resolved until she left Tiffany Studios because of her marriage to Edward Booth, in September 1909. Circumstances still prevented her from realizing her dream of a rural handicrafts organization in Ohio, however. Although she still had cousins and friends in Tallmadge, her ties to her hometown had weakened and her marriage to Booth kept her in Manhattan. Instead, she turned to painting silk scarves, a small private enterprise in which design and art were joined in a congenial environment. While the strain of work on Clara was undoubtedly much reduced, the glory of her days at Tiffany Studios could not be recreated. Tiffany's creative genius and Clara's ability to realize that vision had made for a once-in-a-lifetime partnership.

fig. 61
Watercolor of fiddlehead ferns,
painted by Alice Gouvy pre-1903,
18 ¼ x 14 ⅞ in. (46.4 x 37.8 cm).
The Ellman Family.

fig. 62
Watercolor of hollyhocks, painted by
Lillian Palmié 1902, 14 ¼ x 15 ¼ in.
(36.2 x 38.7 cm). The Ellman Family.

Chapter 2
MANAGING AT TIFFANY STUDIOS

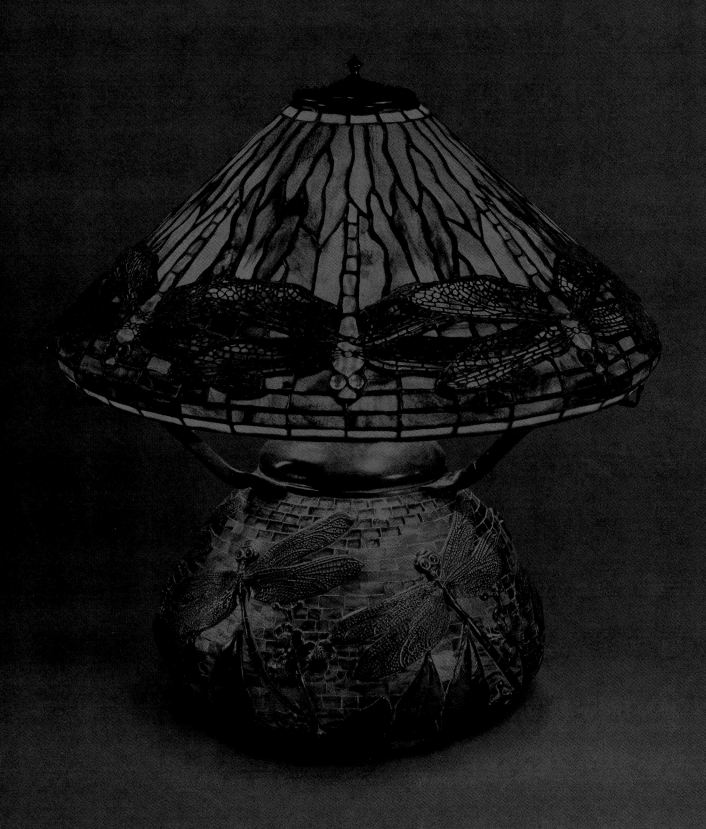

THE DRAGONFLY LAMP

April 6, 1899: "This Dragon fly lamp is an idea that I had last Summer and which Alice [Gouvy] worked out on a plaster mould.... After she had made the drawing on this plaster mould I took it in hand and we worked and worked on it till the cost built up at such a rate that they had to mark it $250.00 when it was finished and every body, even Mr. Belknap, thought it was impractical on account of the cost, but... [t]hen Mr. Mitchell and Mr. Belknap said--It is very original and makes talk, so perhaps it is not a bad investment. Then Mr. Tiffany got well and came down and said it was the most interesting lamp in the place and then a rich woman bought it and then Mr. Tiffany said she couldn't have it, he wanted it to go to London and have another one made for her and one to go to Paris. So they asked me to estimate on four more... 'on condition that we can have one of them in a week.I told him that I should have to step very lively if I did and... that of course it would make a difference to make so large a number but that I could let him know in half an hour. Then I rushed up stairs and [spoke to the] men who have a part in it, the one who puts the glass together with solder, the one who does the metal work—burner base &c and the one who does the etching on the wings after we have made the pattern for him to work by. We found that among us we could come down $5.00 a lamp or $20.00 on the entire estimate, with safety and even profit (we hope) so it was settled and now comes a race. We are to work early and late and I hope it will be done. The girls have entered into the spirit of it and two of them are coming early (an hour) this morning."

"Today has been a field day at Tiffany's when things have swum along and a great deal accomplished, when I have had my fill of Major Generalling, making every one dovetail onto every one else so that no time is lost and none of the tools get cold."

Clara Driscoll, November 10, 1897

While Clara Driscoll was a skilled designer, her managerial skills also commended her to Louis C. Tiffany, and during her three tenures at his firm she rose to a position of significant responsibility. Her letters profile a department chief who cheerfully negotiated the bureaucratic and interpersonal complexities of Tiffany Studios as it evolved between the late 1880s and 1909. A personification of the era's New Woman, she was both an effective middle manager and a gifted artist-artisan.

Clara's career was determined by the job she got with Louis C. Tiffany by 1888, although it remains unknown what specific position she was hired for. As was noted in Chapter 1, given her early training and work experience, she was hired as a designer, but perhaps with a managerial role as well.[1] She certainly became a manager by 1892 when she returned to the firm after the death of her husband, Francis Driscoll, and was placed in charge of the newly created Women's Glass Cutting Department. Moreover, this was in addition to her work as a

fig. 63

Tiffany Studios buildings at 333-35 Fourth Avenue and 102 East 25th Street, New York, from *King's Photographic Views of New York*, 1895. NYHS.

designer, a responsibility that increased considerably in the late 1890s when Clara was charged with designing lamps and so-called fancy goods. Her dual roles as both manager and designer required different sets of skills, and balancing these duties was a challenge. She also had to be skillful in her interactions with the "Tiffany Girls," as she called her staff, as well as "the Powers that Be," the Tiffany partners and managers to whom she reported. It made for a full life.

Tiffany established the Women's Glass Cutting Department in 1892 in his factory/studio building at 102 East Twenty-fifth Street, which he had built in 1891 adjacent to the facility at 333-35 Fourth Avenue (figs. 63, 64).[2] He may have been motivated in part by a city-wide strike in 1892 of the Lead Glaziers and Glass Cutters' Union, which was demanding a reduction of working hours as well an increase in wages.[3] His men were all union workers, but his women were not. A women's department would have minimized the disruptions caused by such strikes. At first Clara directed a small staff of only six women, but by 1894 she had thirty-five workers. Supervising so many glass selectors and cutters was

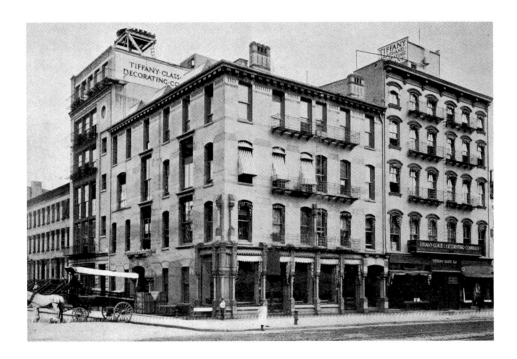

fig. 64
"View of the Glass Room, with Women at Work," from *Art Interchange*, October 1894. Courtesy the Ellman Family.

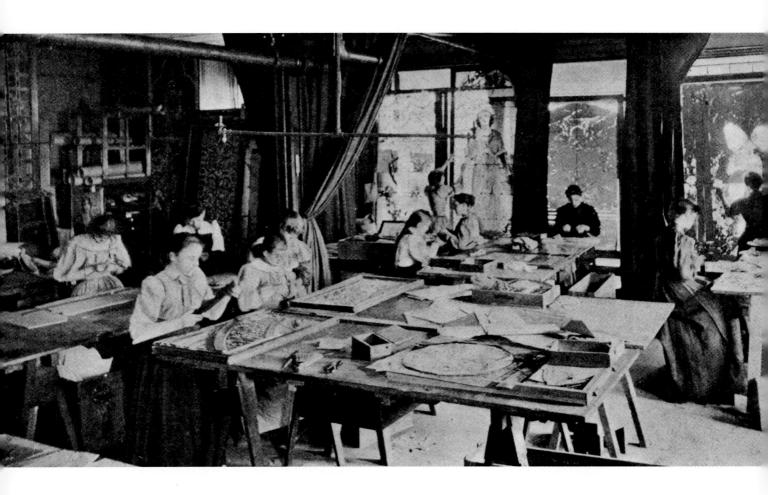

a major role for her. And the company expected much of her department, which was officially recognized with company publicity.[4]

The existence of this women's division should be seen in relation to the men's division, from which it was segregated according to the custom of the period. In part, the growing number of workers Tiffany employed probably reflected his increasing business. But perhaps there were artistic aims as well. His female artisans lacked professional training in stained glass, and Tiffany could probably impress his artistic vision and that of his chosen supervisors upon them more easily.[5]

CLARA'S WORKSPACE

Clara's workroom and the Women's Glass Cutting Department were located in one of the upper two stories of the new building at 102 East Twenty-fifth Street (fig. 64). The space was well suited for glass work because it had windows on three sides, allowing for a great deal of natural light.[6] It was flexible in layout, with curtains used as space dividers, and it could be rearranged according to the needs of current projects. Clara remarked

about one commission: "The next window which is to take up the whole North side of the room was in place all but one section by half past four. The curtains were rearranged and the tables differently placed so as to throw the three alcoves together. The cartoons, after some discussion, [were] where all could see them and we are ready to begin tomorrow."[7]

Glass selection was done in natural light whenever possible. Clara routinely described the weather in her letters and how it affected her work. In 1897 she wrote: "It is dark and rainy and not at all the kind of day I wanted. It will be hard to see the glass and we shall have to work with nasty little electric bulbs."[8] When working on a mosaic in November, she commented: "The days are short now so that the last hour is practically in the dark, which is very bad for mosaic work. Color being quite different by artificial light."[9]

THE TIFFANY GIRLS

Clara was a gifted manager. Not only could she see the larger issues involved in the efficient running of her department, but she could also understand

the seemingly trivial feelings of her Girls. As a middle manager, she was expected to fulfill the objectives of the firm's upper management, facilitating the work of her department in order to maximize the production of Tiffany windows, mosaics, lamps and other objects. "One would think that I did nothing but design, but the usual routine goes on and I jump up to look at samples of glass and have conversations with the various divinities from the basement up, assign the work and then keep an eye upon it from time to time."[10]

Her primary task at the Women's Glass Cutting Department was the supervision of the glass cutting for windows, lamps, and mosaics—all of which was accomplished by her Girls. There was perpetual employment fluctuation among these women: they came and went according to the amount of work, often dictated by seasonal pressures such as the Christmas rush. Furthermore, as noted before, once a woman was engaged or married, she had to leave Tiffany's. An article in the *New-York Daily Tribune* noted that this was the greatest obstacle for the department: "There is one great and apparently insuperable objection to women here. They can't be prevented from marrying. There seems to be something in the work of placing the dainty 'tesserae' that has an irresistible attraction for Cupid, for he is continually hovering around the mosaic artiste, and has worked such havoc at Tiffany's that the department has been nicknamed 'the Matrimonial Bureau.'"[11] Clara often expressed annoyance when the Girls became engaged or married, not only because replacing them meant more work for her but also because she thought the employee was not doing as well for herself as she could:

I was interrupted this noon by a poor little fool of a girl who left here last week to move.... She is barely eighteen and she came to announce her marriage last Sunday to her beau who is a few weeks younger than she and who earns two dollars a week. Think what is before them. Of course she gives up her work here and her salary of $7.50. She was one of the best of the new ones and would have been getting nine dollars a week in a few months. It makes me sick to think of it. In contrast to that I got a letter, at the same time, from Miss Hawthorn,

Nathaniel's granddaughter, announcing her marriage August 2nd to a charming literary man, twelve years her senior and well able to take care of her.[12]

Clara even referred to a farewell gathering given for an engaged Girl as "one of those poison wedding lunches."[13] In sum, her workforce was in continual flux and she had the never-ending task of hiring and training new staff.

The Girls were of a variety of nationalities: they were Swedish, Danish, Irish, and Cuban, as well as American, and came from varying backgrounds: some were from art schools, but many were completely untrained. Clara delivered a lecture in October 1902 to the Women's Industrial and Educational Union in Boston, a progressive organization that was an advocacy group for women's labor and celebrated women's craft. The local newspaper reported her observations on glass cutting as an occupation:

> A comparatively new and wholly fascinating field for women who have the right qualifications has opened at the Tiffany Studios, New York where the making of stained glass windows, mosaics, and many forms of art work in glass which have hitherto been produced by men are now being taught them. The women are proving themselves apt pupils, and although they are doing the work extremely well, they are supplementing not crowding out men. From the beginning their keener sensitiveness and acute artistic sense has atoned for the lack of mechanical skill, natural or acquired, which has been a prevailing characteristic with men.[14]

The Tiffany Girls were photographed on the roof of the Tiffany Studios in 1904/05 with the tower of Madison Square Garden visible in the distance (fig. 65).[15] The women's poses suggest their mutual affection. Indeed, as they lean on one another with their heads tilted, one senses the overall unity of the group. Clara Driscoll is seen standing at the far left in an appropriately managerial posture.[16]

THE CONTRACT SYSTEM
Clara's Girls in the Glass Cutting Department included selectors, cutters, modelers, and designers.

fig. 65
Tiffany Girls on roof of Tiffany Studios c. 1904-05.
From left to right, back row, standing: Clara Driscoll, Mary
Voorhis Schofield Williams, Marion Losey, Edith Pearsall,
Emma Stanley, Annie Tierney, Annie Boax, Carrie McNicholl,
Edna Book, Ella Egbert Van Derlip, Nellie Warner, Alice
Wilson, Roberta Hodgins, Agnes Northrop; **middle row:**
Minnie Henderson, Marion Palmié, May Tatnell, Irene
Talashea, Julia Zevesky, Anna Arnoth, Anna Ring; **front row,
seated:** Mary McVickar, Miss Phillips, Virginia Demarest,
Beatrix Hawthorne. The Charles Hosmer Morse Museum
of American Art, Winter Park, FL.

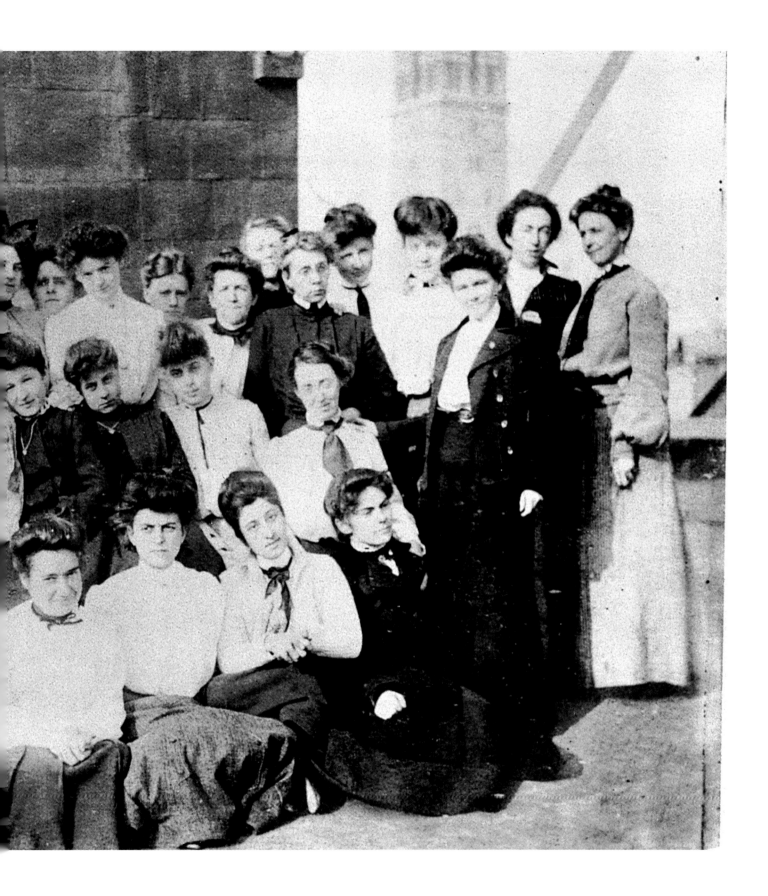

Selectors chose the glass for each individual section of a window or lampshade. As most of the opalescent glass used at Tiffany Studios was variegated in color, texture, and translucence, glass selection was key to rendering naturalistic effects and illusions of depth. Each selector was paired with a glass cutter who was responsible for cutting along the patterns. Modelers and designers worked closely with Clara either in completing a design that she had begun or in executing her ideas.

One of the major economic developments of the business structure at Tiffany Studios was the institution of a contract system in 1898, which caused some consternation among the Tiffany Girls: "[A] price is set on a window before it goes into the works and then if the girl who does it gets through sooner than the average time she makes the difference between her salary and that of her helpers for the time she worked on the window, and, what was allowed." Selectors and cutters had to work in sequence on a given window, and some were faster than others. There were also differences "in the fairness of the estimates" and "the conditions that determine the cost of a window."[17]

Anticipating a litany of grievances from the selectors and cutters, Clara called a meeting and brought two quarts of ice cream, creating a relaxed atmosphere in which her employees could air their concerns and arrive at a majority decision on how to cope with the new system. Clara herself recommended that cutters "be changed around" so that what each selector "gained on one window she would lose on another." She also proposed that the selectors help to rate the cutters for salary purposes.

If one selector should render an incorrect judgment, there would be six other judgments to counter act it and that the average would probably be true. If I found that one cutter was by every selector considered the best, she would have proved herself to stand first and would be entitled to promotion first. This makes an incentive to the cutter. It all ended well and every one seemed to be in the right frame of mind about it.... I felt like a statesman of the first order when it was over.... The selectors are breaking their necks to make money and the cutters to get a good rating by the selectors.[18]

Accounting for the contract system proved a weekly challenge that consumed much of Clara's time and energy. She received help with the bookkeeping from her fellow boarder Edward Booth, a manager at a downtown import firm (and later Clara's husband).

> I am spending my evenings getting up a new system of books for the new emergencies. Last night Mr. Booth helped me. There is so much to keep, not only my present records but estimates of cost and my own account of what is charged me in the office or rather what they credit me which is the amount of the estimates I have in hand and out of which I pay all my labor and certain outside expenses that I have never had anything to do with before.[19]

In 1899, the manager Pringle Mitchell decided to allocate overhead costs to each department and thus began charging Clara's department rent for her space. "Mr. Mitchell has been trying some more thumb-screwing in the shape of rent which we now have to pay—, $50.00 a month for my room."[20]

The bookkeeping also required that Clara balance her accounts with the work carried out by other departments. Once she mastered the system, she enjoyed the responsibility.

> The man [Joe] who manages the kiln, and who speaks the broadest but most stately Irish, never using a small word, if a large one will convey his meaning—brings up his bill, or rather a rough draft of it, about four o'clock Thursday, and informs me that he has come to compare his ledger with mine to be sure that there are no errors in his weekly statement. I refer him to Mamie who paints the inscriptions and she gets out the "firebook" as I have named it—and there ensues a long comparing of items for each day…. When this conference is completed, he goes solemnly downstairs and soon reappears with a neat bill made out in ink—I scrutinize it with as much attention and suspicion as I can call up—and then say—"Mamie is this all right." She looks at it, says it is all right—and then I sign it—he sends it in and it is charged to my account. I go to the office to compare contracts and as I pass

through the metal room, I am stopped by an anxious foreman, in shirt sleeves, with a pencil behind his ear and some papers covered with labored figures, who says—"Got anything against me this week?" "Yes—three dollars and a half for lamp design." He records it mournfully and I say— "Got anything against me?"… I rather like keeping the books now that I have got into it.[21]

Yet another new accounting system was instituted when the firm was incorporated in 1902 as Tiffany Studios. The contract system, which assigned costs by individual commission, was replaced by hourly or weekly pay. "The girls don't like it at all. It brings them into direct responsibility with the firm instead of with me. They have instituted a system of time tickets like any other large manufacturing establishment. In short they consider themselves driven instead of led." Clara used the opportunity however to negotiate for a slightly shorter workday. "We now stop at a quarter of five, making it seven and a half hours…. My personal duties are also changed in some respects but for the better. I am more free to go

and come as I choose. They do not restrict me to hours, but expect a certain definite result."[22]

As time passed, Clara assigned the bookkeeping to one of her assistants, Carrie McNicholl.[23] When Miss McNicholl went on vacation, Clara keenly felt her absence:

My book keeper is having her vacation so I had to make out the pay role, figuring out each person's time for the week and making the aggregate sum come to the same as the pay role. Two and a half hours on 29877- 16" dragon fly shade which at the rate of $16.50 per week would be 36 2/3 cts per hour & c. & c. & c.… [I] had a renewed respect and appreciation for Carrie, whom I have always somewhat looked down upon as fussy and uninteresting. I realize how much Carrie contributes to my calmness and ability to design by taking all this little detail entirely off my shoulders.[24]

To carry out all of her responsibilities, Clara had to delegate many other tasks. "I am trying to cultivate the art of making other people carry out my ideas. I

always feel as if another person would spoil it and that I want to do it myself. Instead of which I ought to be able to train others to finish things I start while I start something else."[25] Clara's perpetual eye trouble, which was compounded by what were probably migraine headaches, motivated her to streamline the process for making objects.[26]

I make the design and then it has to be put on to metal with a thick black paint very carefully, parts of the design being scratched out with a needle something like engraving. All of this part of it is simply impossible to me, but to save the time of tracing the designs on, I have been making them on the metal directly with pencil—having these girls go over it with paint, thus eliminating one step in the process but I have concluded it is too much for my eyes, brass being shiny. So I have secured a girl fifteen years old, for $3.00 a [word missing] and she can draw it on the metal, working it out as I do now.[27]

Clara always felt that modeling the prototypes for three-dimensional objects was not her strength and she happily passed on such jobs to able assistants. "I took a new girl today at Tiff's to do modelling…. Mr. Tiffany says he wants her to work out my ideas, and I am very glad to have her, for I don't know how to model and it is a great assistance."[28] Four and a half years later, Clara was still relieved to have a competent modeler on her team: "My new modeller [Virginia Demarest] is very satisfactory so far and will be a great relief to me I think…. She seems very willing to be criticised and to do things over so I think we shall get on. I am going to start things, working them out very carefully in part and have her finish them."[29]

Not least, Clara entrusted some of the most experienced and talented women with designing. "[Miss Francis] is able to do the kind of thing I do myself and I am resting my eyes…. She is a good designer and can plan things well. She knows nothing about the technical part but I tell her about that as she goes along and between us we shall get up some fine new lamps."[30]

Clara's employees tried hard to please when given important assignments:

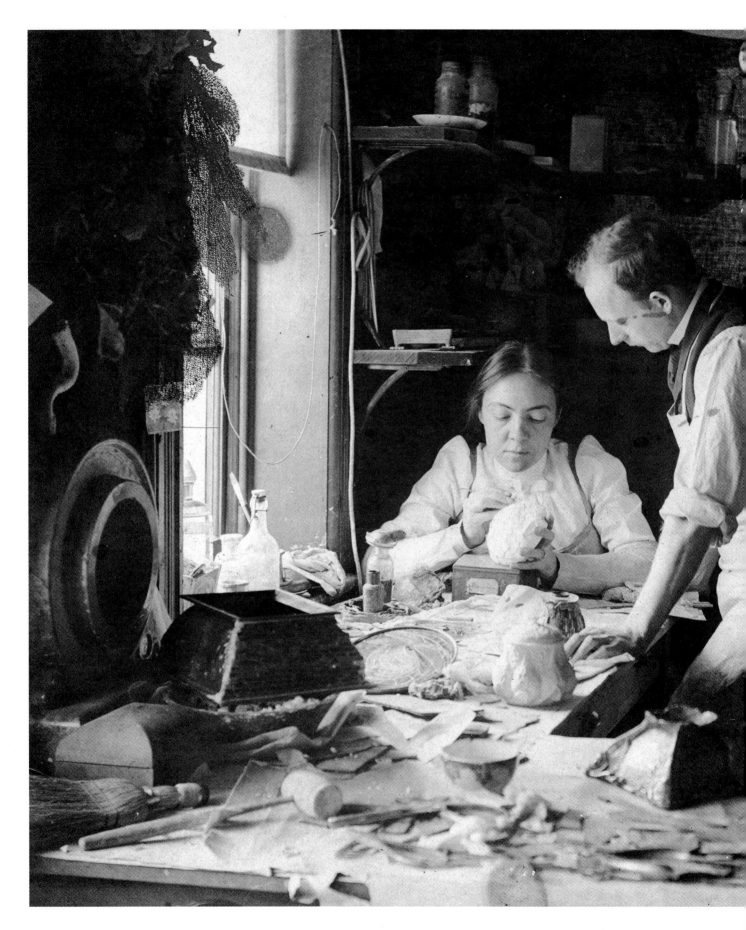

This week I am having two of the girls help me. There is a good deal of repetition in the design and after getting one worked out, I have some one else do the repeating which is fine close work. There are two apprentices who are naturally accurate and careful and I am getting them trained to assist me. They are so anxious to do it and think it such a big thing to be designing or doing anything to a design, that they nearly break their necks to get it right and to please me, each one secretly hoping that she will be the one to be permanently retained in that department.[31]

Clara seems to have particularly enjoyed the idea of overseeing a design studio. "The designing I had intended to do, I have given to Miss Palmié, Miss Henderson and Miss Gober. They are getting on quite well. It makes the front part of the room look quite like a studio and of course they are delighted to have the change."[32]

Clara was not always pleased with the work by some of the women, particularly those lacking a strong work ethic. As she reported in February 1903:

The new girls are nearly all beginning to accomplish things. Only two seem to be stupid and not greatly interested and they may pick up. I am thinking of scolding them this after-noon and telling them I will keep them on trial for one month and then if they have not made decided improvement they will have to go.... I hate to put their noses on the grind stone but if they weren't here they would probably be much worse off, longer hours and harder work. It is so pleasant here that they enjoy the general good time and variety and forget that it is a place in which to labor....[33]

More than willing to help her Girls, Clara tried to get them to do their best work. "I went around and had heart to heart talks with the youngsters who have not learned the meaning of work.... They looked solemn and oppressed, which I discoursed, but they seem to be making an effort today, so probably some of it sunk in."[34]

If anything, Clara showed a quasi-maternal approach to management, especially with the women whom she supervised. Thus it was

particularly difficult to fire one of the older women, a widow who had also lost her baby:

> [T]he strain of discharging poor Mrs. Van Derlip who has been here years and years and expected to end her days here, had reduced me to dust and ashes. She has been gradually falling behind and her work has been a trial to Mr. Tiffany, till he finally couldn't stand it any longer. The worst of it was that she herself does not see any difference between her work and that of the others... besides this she has one of those dreadful dispositions which makes it necessary for her to be at variance with some one in the room.[35]

In spite of occasional frustrations, the Tiffany Girls enjoyed a sorority-like bond among themselves. A series of photographs of them at Midland Beach on Staten Island in June 1905 and another of them at the beach at New Rochelle shows that the women made merry group excursions (figs. 92, 93, 96), just as the men at the Corona plant had similar collegial outings.[36] Significantly, though, these events were carefully separated by gender.

Clara also had a bond with most of the women in her department. For example, they celebrated Christmas together, setting up an illuminated Christmas tree in the studio and contributing decorations. Clara judged it "gay and pretty," and reported that even Mr. Tiffany "seemed very much amused, sat down by it and smiled wider and wider till his eyes were nearly shut."[37]

THE MEN IN THE WOMEN'S GLASS CUTTING DEPARTMENT

Despite the dominance of women in Clara's department, there were also a few men in her domain. The most important was Clara's chief assistant, Joseph Briggs, who was responsible for many of the more physical tasks. When a photograph was made by a traveling photographer of her working in her studio (fig. 66), she had Briggs standing at her side, as if attentively listening to her instruction (not instructing her, according to the prevailing norms of male dominance).[38] Clara sent a copy of this photograph home to her family, explaining: "I thought it would be very nice for you to have a picture of me at work in my apron and sleeves with

my head workman in attendance. It is exactly the way we look every day."[39] That she called him "Joe" suggests the familiar terms of their relationship.

An extraordinary insight into how Clara managed her workers comes from an incident concerning Briggs. One night he arrived at her boardinghouse in an agitated state and revealed his domestic problems. He had married an African-American woman, breaking a major taboo of the day, and they had two children together.[40] His marriage was essentially clandestine, however, and now was on shaky grounds because his wife was jealous of the attentions he had been paying some of the Tiffany Girls. She had been following him on his escapades (which he maintained were innocent) and was threatening violence or, equally damaging, was threatening to reveal the secret of their marriage to those in control at Tiffany Studios. Rather then shying away from these difficult social issues, Clara took control. Accompanied by Edward Booth, she went to the Briggs home, which was in a disreputable area of the city, and waited until his wife returned. Ultimately Clara told Briggs that he had to reform, be more respectful of his

marriage vows, and make a better home for his family.[41] The next day Clara took Marion Palmié and Theresa Baur (the two Tiffany Girls who were involved with Briggs) out to lunch and "tried to make them see the other side," presumably telling them of his clandestine marriage.[42] She also anticipated how the revelation would affect Briggs and wrote: "I didn't want them to crush him with their disapproval."[43] Clearly Clara wielded power when needed.

There were apparently other men under her direction but her letters refer to them only indirectly. Two deaf, mute boys, Frank and Edward, also worked alongside the women, and Clara evidently appreciated Frank's skills.[44] Although they formed part of the team, in 1903 it was decided that Edward could no longer cut glass in the women's department and gender segregation again prevailed.[45]

CLARA'S NEW UPTOWN WORKSHOP

Clara's responsibilities included organization of her department's workspace. In 1905, when Tiffany Studios moved uptown to Madison Avenue and Forty-fifth Street, to a building formerly occupied by

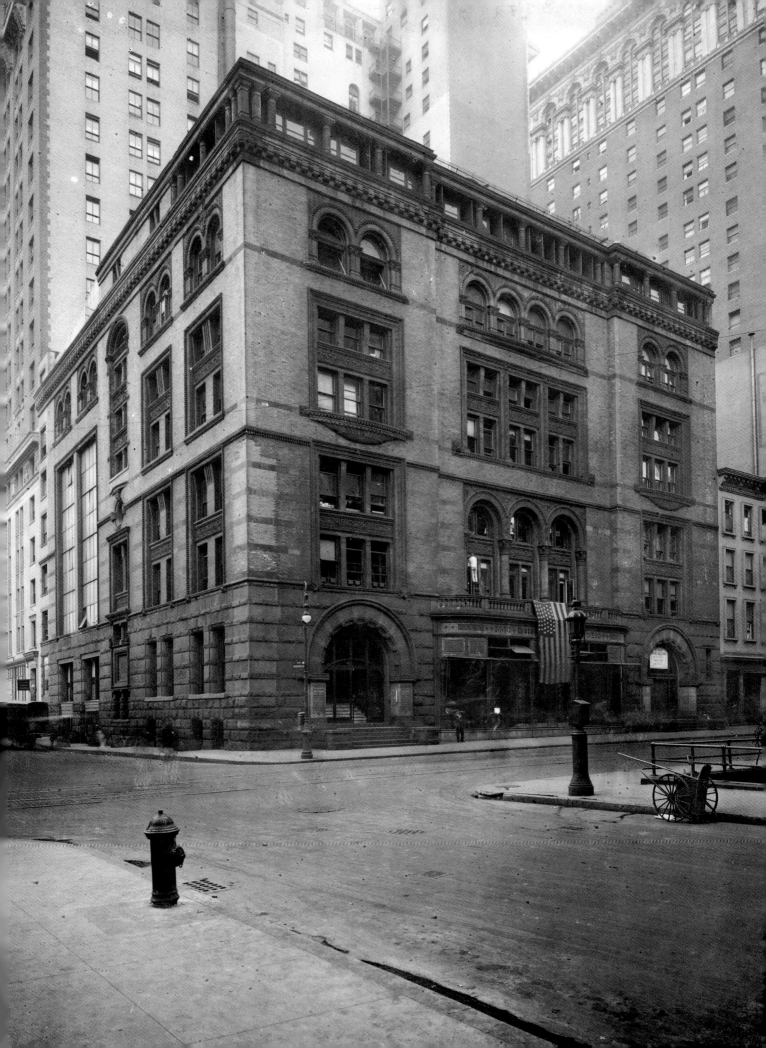

fig. 68
Tiffany Studios showroom, from *Character and Individuality in Decorations and Furnishings*, 1913. NYHS.

the Knickerbocker Athletic Club (fig. 67), she focused her attention on the design and layout of her workroom, which was located on the second floor.[46]

This used to be the dining room of the club and has a beautiful oak wainscotting about ten feet high. This is all panneled and I am having the shelves and glass rack carry out the lines of the panelling, and then shall have it all stained to match the oak. Even the desk which was good enough at the old place, I have had altered at the top so it will continue the line of the old sideboard, a magnificent affair with carved columns and large beveled mirrors, not

to mention, any amount of drawers and cupboard space at the bottom. Just now I am having built the loveliest combination glass and paper rack you ever saw.[47]

It was important that the room would be outfitted to her liking, and she lost no time in making sure it was. Clara equated the amount of space with the amount of work she could get for her department.

[If] I am on the ground I can get the carpenters ahead of some of the others who will still be here and so get my place in shape first and not work under difficulties.... Joe Briggs and I have

fig. 69
Tiffany factories in Corona, Queens, from
Tiffany Favrile Glass, 1905. Courtesy The
Neustadt Collection of Tiffany Glass, Long
Island City, NY.

hourly consultations about the arrangement of the space up there. We want to secure all the mosaic work we possibly can and want the place perfectly suited to it. The Schmitts can't bear to spend money—so it means constant arguing. I am to meet the engineer up there tomorrow and settle the plumbing and dressing room arrangements. It is all very exciting.[48]

The showroom (fig. 68), also located on the second floor, displayed for sale many objects designed or made by Clara and the Tiffany Girls.

THE CORONA FACTORY

Clara had to coordinate her work and that of her department with the factory in Corona, Queens (fig. 69), which she visited every two to three weeks. The main factory contained the furnaces where blown, sheet, and pressed glass was made. After 1897 a bronze foundry was added to undertake the fabrication of metalwork for Tiffany lamp bases and decorative objects. In addition, there were duplicate window, lamp, and mosaic shops at Corona staffed solely by male workers. A major addition to the

factory was built across the road in 1901-02.

Clara coped with the expansion and new male employees with typical self-assurance. She described what was apparently her first trip to the new facility in 1902:

I got off at the Station and there was our new factory looming up only a few steps away. I went around a tall brick wall to a little iron door on which was written "Positively no admittance except on business." I passed through this and

then through the yard to another large iron door similarly labeled where I was met by a new official who asked me who I was and what my business was.... I told him... I had come to see the foremen on business. Where at he stepped aside and I walked in to the familiar sights and sounds of our old metal shop on a much larger scale. My old friends were all there doing their same old tricks with hammers and pinchers and machines.[49]

The main purpose of Clara's visit was to check on the execution of her department's designs and to set priorities.

Mr. Gray the metal foreman came forward and took me around to see all my work going on. I told him I had come out to have a resurrection of the dead, at which he looked a little anxious and guilty —but went over my list of back work and patiently hunted them up. Then we had a sheep and goats time consigning some things to oblivion and replacing others into the ranks of work to be completed at their earliest convenience. After that I saw the other two Mr. Sorg—

(finisher and metal colorist) and Mr. Cantrill— the lamp shade man.

She also conferred about lamp designs for the coming year, observing the move toward larger volume and "cheaper shades." "We discussed next year and picked out proper things to repeat and then talked over what we ought to do in the way of new things. I saw just how they did all the cheap shades (that they make a hundred of instead of three like mine)."[50]

Clara also visited the furnace and watched the glass blowers. "The furnaces were very comfortable looking coming out of the black damp winter weather. They are in an immense brick and stone room very hot and almost unlighted except for the great shafts of golden light pouring from the open doors dark and evil looking men with out many clothes on rushing around with long red hot pokers. I quite enjoy going over there."[51]

Despite her regular visits, Clara was glad not to work in Corona, a possibility that upper management had considered before the decision was made to move to larger quarters on Madison Avenue:

I went to the factory and could hardly restrain my gratitude at being saved from having to move out there. That is what we have always feared. I had some work to do on a big lamp-shade form, that was too big to cart back and forth and as I stood there in the din and the light and heat and bareness of the great room, I decided that it would take me only a few months to break down if I had to work all the time in such surroundings.[52]

The contrast Clara saw between the masculine world of the Corona plant, with its concomitant noise, heat, and industrial bleakness, and the more genteel setting in which she worked in Manhattan (or the secluded, feminine workshop that Alice Gouvy and Lillian Palmié managed to maintain at Corona) goes far to explain why Tiffany's segregation of workers by gender was maintained by both sides.

RIVALRY BETWEEN THE MEN'S AND WOMEN'S DEPARTMENTS

The men making windows, mosaics, and leaded shades at the Corona plant were members of the local Lead Glaziers and Glass Cutters' Union, while the women were not for the simple reason that the union did not admit women. Thus, the men had the protection of the union, while the women continually had to prove themselves to preserve their jobs. Even though collaboration was essential to realize every project, the relationship between the men's and women's departments was competitive and often testy.

Monday forenoon I was called to the office and asked if I could get out six landscape windows by Saturday afternoon. The men had refused to take them saying it was impossible. I knew it would be a great feather in our cap if we could so I said I would take them. The girls rose to the situation nobly... we are working from a quarter to seven till six for all of this week, and you may imagine that it takes a good deal of Generalship to put aside every thing else and turn the whole force capable and incapable into this one thing.[53]

While this was merely the friendly gamesman-ship of business, things turned ugly in early 1903,

when the men threatened to strike if the women did not stop making windows.

> It seems incredible that they can make such a demand and get it but they have. It was decided today and the one window which we happened to be making and upon which five girls were working on, had to be taken down and sent to the men's department. Of course this does not mean that we shall be out of work because most of our business has come to be lamp shades and for some reason lamp shades are not included in leaded glass work, so far as the Union goes. But we hear that they want to do things by degrees and that it is only a matter of time till they can "put the women out business".... I have talked to the General Manager and he says when it comes to shades, the firm will make a big fight, and that he personally would rather see every man in the place out of a job for a year than to see my department disbanded.[54]

The feminist Rheta Childe Dorr called attention to the strike in an article published in the *New York Evening Post*. She noted that it must have particularly galled the Tiffany men that women were paid on the same scale. She praised Tiffany's show of support for his women workers:

> It is difficult to associate trade unionism and art; impossible for the art worker himself to associate them without lowering in some degree his art. That is felt to be the most unfortunate feature of the fight made by stained-glass workers to exclude women from the craft. Their attitude appears the more ungenerous when it is known that the women are attached to a special branch of the art in which they greatly excel the men, and do not seek to invade other departments. Artists and craft workers especially women, have cause to be grateful for the firm stand taken by the Tiffanys against the arbitrary demands of the men glass workers. They did agree not to employ more women, but they refused to dismiss the twenty-seven already at work in the studios, and they reserved the right to fill their places with other women should they leave voluntarily.[55]

Clara wrote home and described her emotional state: "I have been so miserable over this action of the Union Glass Cutters, in preventing any more window work by the women. It was the last straw as it were and I came home day before yesterday and had a crying spell (a thing I do about once in thirty years)."[56] Nonetheless, she maintained a realistic and sober viewpoint about the situation. She was able to see beyond her own frustration to understand the actions taken by the management of Tiffany Studios. "It would have been a great loss to the firm not to make this concession to the Union and no particular gain for we make only a very few windows— nearly all the business of the department being in lamp shades."[57]

The production of lampshades assured the viability of the women's department. An agreement with the union was finally reached in September 1903:

Mr. Thomas came up and told me that the war with the Union about our department is over at last. They have agreed to let us make win-dows, shades and mosaic just as we have done, if we do not increase our present number [of employees]. I am disappointed in one way. I should like to have had an enormous affair but on the other hand—it may be just as well to keep it—for the very best quality of work and excel that way. They have decided that the other shade department out at Corona can not make designs or get up samples any more, so I can perhaps manage to do enough of that to employ other people in that way. I have the chance now to make all the designs if I am equal to it. So I think I shall be on the look out for assistance in that direction.[58]

Thus in the end Clara got more responsibility in spite of the restriction on the size of her department. The limit on the number of women employed was still in place in 1905. Even if the men needed work, Tiffany apportioned the commissions according to those who would do the best job. "[T]he work here has been rolling in astonishingly and on top of it all, came an enormous Easter Window which Mr. Tiffany took away from the

men, though they needed the work, because he didn't consider them capable."[59]

If anything, the women were too successful: they had more work than the limited number of women could accomplish. Because the mosaic division was thriving, "the Powers" decided to create a new men's mosaic department within Clara's space with Joseph Briggs in charge of five union men.[60]

Likewise, the shade department continued to flourish, so much so that it was decided to delegate some of the Girls' work to the men's department at Corona. Because it was believed that men had an inferior sense of color, Clara had to prepare color guides for the male selectors to follow:

> Also our work is so far beyond our capacity (in quantity I mean) that we have to give part of it to the factory. It is beyond their capacity in quality so I want to have a sort of supervision over it which as you see will require great tact and diplomacy not to get the Union by the ears and create jealousy generally. They are to begin next week on the Wisteria lamp. I am to make a color scheme for them and send some glass and then

go and criticise. I do hope it will work all right.[61]

The rivalry between the women's and men's departments was never truly resolved. At best there was an uneasy truce during the remaining time of Clara's tenure.

"THE POWERS"

Clara not only supervised the Tiffany Girls and kept the accounting records, but also met with the directors of the company, or "the Powers that Be," as she called them. They included not only Louis C. Tiffany, who served as president, but also William Pringle Mitchell, vice-president and manager, and John Cheney Platt, treasurer.

Clara did not always see eye to eye with the Powers. She seems to have had numerous conflicts with Mitchell, a relative of Tiffany's.[62] Whereas Tiffany always championed her designs, Mitchell was more likely to be negative. For example, she showed them both her design for a new lamp:

> Mr. Tiffany thought it was very fine and Mr. Mitchell thought it was the ugliest thing he ever saw. Mr. Mitchell said that nobody would

buy it. It was peculiar and he thought a very disagreeable color—where at Mr. Tiffany insisted upon having it made, saying the color scheme was both new (for lamp shades) and "interesting"—"he should not think of having it changed." So you see my designs have not pleased everybody.[63]

Clara clashed with Mitchell again when he requested some new designs "on the sly." He was trying to bolster his position with the firm by having Clara design new objects while Tiffany was away to prove "that cheaper things will sell." She wrote "I feel a little uneasy about it, as it would not be pleasant for me to have Mr. Tiffany come home in the fall and say with disapproval 'Who designed these things?'" Then she recounted a touchy exchange:

Mr. Mitchell's eye fell on the (now nearly complete) model of one of my clocks and said—"Do you think any body is going to buy that clock?" "Certainly I do. It is the most interesting and original thing in this place." "Oh yes, very nice clock—for a museum but the public wants common, white and gold french clocks...." "I think, Mr. Mitchell, that you have only to put the clock on the market to find that it will sell."... "Mr. Mitchell, what about Mr. Tiffany—He likes these things and insists upon having them done." "... Now when he [Mr. Tiffany] is gone will you make me some designs for candlesticks, ink bottles and inexpensive lamps? Those are things we can't have too many of. If you make them to suit me, I will have them made, while Mr. Tiffany is in Europe and I will guarantee that they will sell." Now this isn't a nice predicament to be in.[64]

Mitchell's negativity was balanced by positive reactions from Henry Wyckoff Belknap, who seems to have acted as an artistic director although he was not a partner in the firm. Indeed, Clara had a good relationship with Belknap, both professionally and socially, and she was often his guest at social events.

We used to call him prissy Belknap before we knew him at all, but I find that he knows so much more than I ever shall that I feel quite honored by his attentions. He visits at Mr. Tiffany's house and seems to be the gentleman

of society there and also a patron of the Arts, is a member of this Philharmonic Society and also the Egyptology Society and the Museum of Natural History.... He is about half a head shorter than I am and when I went bicycling with him I felt disagreeably certain that his feet were smaller than mine. In the Tiffany Glass Co—he is a very important man, coming next to Mr. Tiffany artistically. All these things I have been making are to be finally placed and prices put on them by him. It depends somewhat upon him whether I work or survive as a designer. So I am overlooking such details as I have just mentioned and am treating him as well as I can.[65]

After Mitchell's death in 1900, William H. Thomas (d. 1913) became the manager of Tiffany Studios.[66] Thomas supported Clara and the Women's Department, especially during the difficult negotiations with the union in 1903.

The hierarchy of the Powers comes alive in Clara's description of a large mosaic she proposed to make on speculation:

The hardest work I have done for a long time, was screwing my courage up to the point of agitating the question of making a large mosaic panel, on speculation.... Of course the reason I want it is to keep the girls busy and not have to lay them off. But that is not a good commercial reason from their point of view.... Today I boldly suggested it to the Powers. Going to Louis Schmitt first as the one least likely to approve. To my surprise he listened to my arguments, admitted that they were sensible and said that for his part, he should approve of such a scheme. Mr. Thomas also approved, though he came up and told me afterward that he considered me a dangerous diplomat. (He is the new manager.) Mr. Platt (who is away fortunately) disapproved cordially of a similar suggestion last winter. It remains to broach Mr. Tiffany who is really the one to decide.[67]

MRS. DRISCOLL AND MR. TIFFANY

Clara's relationship to Louis C. Tiffany was one of unbounded admiration. She greatly revered him

fig. 70
Louis C. Tiffany house, 27 East 72nd Street,
New York, designed by McKim, Mead & White
with Louis C. Tiffany, photographed by John
S. Johnston c. 1887. NYHS, Gift of Eugene
Armbruster.

fig. 71
"Entrance to Studio" in Louis C. Tiffany
house, from *Architectural Record*,
October 1900. NYHS.

and his artistic sensibility. Tiffany met with Clara regularly to look over the work in her department, and their discussions inevitably centered around issues of artistic design and execution. "Mr. Tiffany said the other day that I did the metal designing (lamps—boxes etc.) better than any one else in the building...."[68] Six months later Clara wrote again: Mr. Tiffany "said that I had great creative ability and he was much pleased with my work."[69]

Unlike his officers, Tiffany did not stint with praise nor tax her with economic worries. Clara's comments in 1902 highlight this important distinction:

> The Schmitts and Mr. Platt have requested me to turn my attention toward manufacture, that is, make designs for those things which can be duplicated by the hundred and at a profit to them, instead of these elaborate lamps that they would make three of and take the chance of only coming out even or losing on. Getting fame and reputation on but not money. Mr. Tiffany on the contrary has been in the habit of expecting the unusual of me and without any reference to cost.[70]

fig. 72
"Another View of Studio" in Louis C. Tiffany
house, from *Architectural Record*, October
1900. NYHS.

Nonetheless, Clara tried to balance Mr. Tiffany's artistic standards with the aims of the other managers. "I have nearly completed two lamp shades to be made at the factory that please Mr. Tiffany very much and that can, I feel sure be produced for less than any shade we now have. This kind of designing is so new to me that I don't know how I shall succeed."[71]

Clara was privileged among the employees of Tiffany Studios and was invited as a guest to certain social events at the Tiffany home at Madison Avenue and Seventy-second Street (figs. 70–72). On one such occasion Tiffany himself gave her a private tour of his studio (see p. 131).

CLARA'S ACHIEVEMENT
Clara enjoyed an eminent position at Tiffany's establishment, but it was an all-consuming and stressful job. Not only did she endure rivalry with the men at Corona and the union in general, but there were seasonal fluctuations in business and constant changes in personnel at all levels. Her reward was a relatively good salary, of which she was very proud. Her pride is tellingly revealed in her narration of one

of her trips to the Corona plant and her visit with her colleagues and close friends, Alice Gouvy and Lillian Palmié, both of whom were working in the enameling and pottery departments there:

> I always choose a lovely day so that after my business at the big factory is completed, I can go to the little one across the way, where Alice is and see all her beautiful things. It makes me feel toward my own works as the monkey at the Bronx did about his granite dish of food compared with what he saw through the little window, but I control my feelings by remembering that it is Alice and how glad I am that she can do such exquisite work and also that there are other things I can do that she cannot, things that mean a good deal more money than she can earn, so when I get back to my own shop the next morning, I don't throw my designs into the waste basket but try to improve upon them.[72]

Just how much money did Clara earn? Based on her inclusion in the 1904 article, "Women Who Make $10,000 a Year or More," it has been assumed that Clara earned that princely sum. But a closer reading of the article reveals that it merely suggests she deserved such a salary.[73] In fact, she earned far less. In 1902 her salary was only $35 per week or $1,820 per year.[74] It was certainly a handsome sum, equal to that of many of Tiffany's top male employees, but still hardly enough to allow her to live as comfortably as she wished. It is small wonder, then, that she was constantly redoing dresses and hats to make ends meet. When she attended the Opera she bought standing-room tickets unless a generous friend like Henry Belknap offered to take her. And as much as she admired and profited from working with Tiffany, she wrote that she was willing to shift allegiance and work for his rival, J. & R. Lamb Studios, if she were offered a salary of $50 per week.[75] Ultimately, Clara's stature within the firm was more elevated than her pay scale.

Certainly Clara enjoyed her work with Tiffany and was appreciated by her colleagues. When she came back in January 1907 after her extended trip to Europe, she was greeted with warmth and excitement by everyone. She recounted the reunion with her staff:

But when I stepped out into the old familiar hall lined with glass rack, there was Miss Northrop in her long apron walking past the door. She greeted me with great enthusiasm and then two of the little girls came out. They spread the news and I was nearly eaten up by most of the twenty five lambs who rushed out in a body. I was born [*sic*] into the work rooms on this pleasant tide of friendliness, where I found startling changes but on the whole, satisfactory. A shortening of the main room and an addition of another, opening off the big one just back of my desk. It makes a better working space. There were several new comers whom I had never seen, but they looked like nice girls.... We next made a tour of the Show rooms and had a series of greetings and farewell from the Powers. It seemed very nice to see them once more.... Next came Joe Briggs who had to show me his increased department and all the new work he is doing. His men all seemed glad to see me. The deaf and dumb boy nearly had spasms and would have been holding my hand yet if I had not forcibly withdrawn it. Altogether my heart was quite warmed by my welcome back.[76]

Nonetheless, as happy as she was to be with the firm, Clara was weary from the work. Chronically troubled by her headaches and poor eyesight, she was frequently ill. Even as late as 1908 she wrote of possibly returning to Ohio, although the only remaining member of her family, her sister Emily, was teaching in New York. In any event, her marriage to Edward Booth on September 1, 1909, made it mandatory for her to leave her post at the firm.

After leaving Tiffany Studios, Clara never again managed a commercial enterprise as she had for Tiffany. But the fact that she had successfully done so, and for so long a period, was an outstanding achievement. Clara herself was keenly aware of how remarkable her feat was. In 1905, several years before she retired, she noted that she was the only manager at the Manhattan firm left from those present when she began.[77] At a time when a woman's career in the commercial world was beset by so many obstacles, Clara Driscoll's success was truly significant.

Chapter 3
EXPLORING NEW YORK CITY

A VISIT TO TIFFANY'S HOME

December 13, 1898: "The room where Mr. and Mrs. Tiffany and the two daughters were, [was] filled to overflowing with flowers. When I went in Mr. Tiffany was at the far end of the reception room talking busily to a man so I had to greet Mrs. Tiffany and the two daughters alone.... I went rather late, owing to my dress not having come home in time. Finally I was obliged to act so went and rudely interrupted Mr. Tiffany—who immediately dropped the man and talked nicely to me asking me if I had been into the library near the door of which we were standing. It is beautiful lined with books and rich hanging[s]. The lights concealed by soft colored shades which are in such positions as not to stab ones eyes. A big fire on beautiful old andirons helped to make the light in the room—while in there Mr. Tiffany said—'Have you ever seen my studio?' I said I had not but I hoped to some time, but he said—'I will take you up there now if you would like to go—' And he did. It is up a queer little winding stair and you come into an entrance which is a real Indian house which he had taken down, decorations, furniture and everything and brought here from India. Out of this room you go into the studio—which appears to be miles long and is wholly unlike anything I ever saw. I will describe it next summer. It is like a dream of poetry and harmony that might have come out of the East. It is somewhat oriental in effect but not in detail. As if Mr. Tiffany had gone to the same sources of inspiration but had evolved his own conception of their great principles. I told him that I felt that his work was in some ways suggestive of Eastern thought, which seemed to please him— and he said 'Yes I have always been influenced by the oriental idea of form and color.' He said he thought that I was gaining in my work and that I was thinking in the right direction. Where at I deprecated my lack of technical knowledge of what was radical and necessary to expression—where at he said that lack of facility was a small matter, that the really great and original things had been accomplished by having an ideal and a great desire to attain it. Then we went downstairs, I said my adieus, put on my wraps."

"The people who come to New York to seek their fortunes! What volumes could be written about them!"

Clara Driscoll, April 15, 1903

Clara Driscoll found time in her demanding six-day workweek to seize the opportunities available in the booming metropolis of New York City, which at the turn of the century stood as the nation's commercial and cultural capital. By the time of the consolidation of Greater New York in 1898, this urban conglomerate of five boroughs with well over three million residents had become the country's largest and most densely populated city. Turn-of-the-century Gotham was a city of extremes, noted both for the material excesses of the Gilded Age robber barons as well as the plight of the "Other Half"—the city's newly arrived immigrants concentrated on the teeming Lower East Side. As a career woman earning a modest living, Clara Driscoll fits squarely between these extremes, and her experiences, so vividly captured in the letters she wrote to her family, offer telling insights into the life of the middle class, the backbone of the city's population. Clara brushed shoulders with the full diversity of the city's inhabitants. She designed objects for extravagantly wealthy clients and visited some of the city's most opulent mansions, but she also supervised young women who were struggling to support their families and experienced first-hand the squalid conditions of the slums.

Clara was one of a steadily increasing number of New York City women who were pursuing respectable careers in artistic professions. In fact, she exemplifies a new urban type of the 1890s that was remodeling the paradigm of Victorian

fig. 73
East side of Irving Place from 18th Street
to Gramercy Park South, New York,
photographed by Brown Brothers, March
1909. NYHS, Gift of New York Public Library.

womanhood. The "New Woman" was marked by her independence, earning power, engagement in the urban experience, and ability to carve out a meaningful life beyond the traditional family home.[1] As a well-educated, middle-class working woman, Clara lived in modest comfort in the heart of the city for most of her career and took full advantage of New York's unique cultural offerings.

BOARDINGHOUSE LIFE

Clara Driscoll was part of a growing demographic in the United States of young, single women living and working in urban areas. Her housing options were limited, given her modest wages. During her first years in the city, in the late 1880s, she boarded in the home of a Miss Todd at 32 South Oxford Street in Fort Greene, Brooklyn, and commuted to work at Tiffany Studios in New York City. After the death of her first husband, Francis S. Driscoll, in 1892, she returned to work at Tiffany Studios and this time sought suitable housing in Manhattan. By January 1897, she was living with friends in a flat at 468 West Fifty-seventh Street (near Tenth Avenue),[2] and later that year she found new quarters with

roommates at 5 West Sixty-third Street, just off Central Park.[3] Clara's move from Brooklyn to Manhattan had simple motives: to shorten her commute and gain some additional hours of sleep.[4]

Clara's letters betray a persistent longing for her family and her home in Tallmadge, Ohio. At her next lodging, the boardinghouse of Miss Mary Owens on 44 Irving Place, Clara surrounded herself with a surrogate family who filled the void she experienced by leaving Tallmadge and by becoming a widow less than three years after marriage. By June 1898, she had settled into a

room in the four-story brick house located on the east side of Irving Place, between Sixteenth and Seventeenth Streets (now the site of Washington Irving High School) (figs. 73, 74). The building was one of many handsome Greek Revival and Italianate homes built near Gramercy Park in the 1840s and early 1850s, when the area was among the city's finest neighborhoods. Typical of Manhattan's relentlessly shifting demography, however, the area not immediately adjacent to the gated park went quickly out of fashion, and many single-family homes became boardinghouses within a

fig. 74
Southwest corner of Irving Place and 16th
Street, New York, c. 1909. NYHS, Gift of Estate
of Hopper Striker Mott.

single generation.[5] In 1857, 44 Irving Place was
advertised for rent as a "first-class" house, and in
1858, another ad claimed that the house had "all
the modern improvements, gas fixtures hot and
cold water, baths, furnaces & c."[6] Yet by 1893, the
house's owner was advertising for boarders.

For $50 a month, Clara occupied a small room
on an upper floor and received three hearty meals
a day.[7] Meals at 44 Irving Place were enjoyed in the
company of Miss Owens's artistic and literary
tenants, including industrial designers, artists,
actors and actresses, schoolteachers, and at least
one businessman (Clara's future husband, Edward
A. Booth).[8] Interaction among the boarders extend-
ed well beyond dinner conversation. There were
charades, performances of plays, cards, and reading
aloud—including Plato's *Apology of Socrates* and
Jane Austen's *Emma*.[9] In 1904, a co-ed group of
boardinghouse friends undertook to enact George
Bernard Shaw's newly published comedy *Man and
Superman*, an interesting selection given the play's
overt theme of sexual attraction.[10]

The boarding population at the Owens house
remained remarkably stable over the decade in
which Clara chronicled its activities. Two male
boarders, "Mr. Booth" (her future husband) and
"Mr. York," became close confidants and the Bacon
sisters, Miss Griffin, Alice Gouvy, Mr. Eveleth, and
Mr. Tennant, were also important members of
Clara's circle. Men and women mingled freely in
Miss Owens's boardinghouse and frequently
visited in each other's rooms, though Clara
revealed nothing in her letters about romances or
unwelcome advances. This socializing extended
beyond their home: Clara often noted going to the
theater, art galleries, and other entertainments
with her housemates. A number of her boarding-
house friends even pooled their resources to rent
a summer cottage in 1902 in Point Pleasant, New
Jersey—a house they kept for many summers.[11]

In addition to this circle of confidants, Clara was
a close friend to several young artists attempting to
establish themselves in New York's competitive art
world and she frequently noted their visits to 44
Irving Place. She maintained close ties with the
painter, illustrator, and decorator George B. Waldo
(1867-1904), who worked for the decorator Georges
Glaenzer. Waldo kept a studio in Nutley, New Jersey,

fig. 75
Madison Square and Fifth Avenue, New York,
1898. NYHS, Gift of Percy R. Pyne II.

which Clara often visited, and his older brother, Edwin Waldo, was engaged to Clara in 1896. Clara also socialized frequently with the painters Dudley Saltonstall Carpenter (1870-1955) and Henry McBride (1867-1962), who shared a studio in a walk-up building to economize on expenses. A struggling artist during their early friendship, Henry McBride later went on to become one of the leading art critics in America of the modernist movement.

EXPLORING THE NEIGHBORHOOD

Clara's residence on Irving Place was just a short walk from her workplace at Tiffany Studios when it was located on Fourth Avenue and Twenty-fifth Street. She typically commuted on foot, enjoying the sights along the way. After the 1905 move of Tiffany Studios uptown to Madison Avenue and Forty-fifth Street, Clara continued to walk to work, priding herself on the wholesome physical exercise attained by her three miles daily. The subway, after its opening in 1904, offered a speedier commuting choice.

Clara also took advantage of the scenic neighborhood parks on evenings and Sundays: "In the evenings George [Waldo] often comes around and we take a walk around the neighboring squares where there are parks, viz Union, Madison, Gramercy, and Stuyvesant, not all the same evening, though we could, and still not have walked quite three miles."[12] It is tempting to read into Clara's descriptions the artistic inspiration that may have influenced her designs at Tiffany Studios. One gorgeous April day she observed the trees "bursting out in that clean fresh green so delicate and misty," and she enthused over the tulip beds, magnolia trees, and lilac bushes in the nearby parks.[13] Even when observing urban bustle, rather than nature, her descriptions could be striking: the throngs on Broadway reminded her of "a piece of sticky fly paper that has been several days in a summer kitchen in August"[14] (fig. 75).

Clara commented occasionally on her neighborhood's skyline, which was undergoing dramatic changes. In 1903, the Fuller Building, better known as the Flatiron for its distinctive shape, was erected at the southern end of Madison Square Park, on the plot formed by the intersection of Broadway and Fifth Avenue at Twenty-third Street

(fig. 76). Clara reported that during a spell of windy weather "one woman was blown off the sidewalk and into the street by the flat iron building and several had to hold to lampposts and be helped out of the vicinity by policemen. There is something about the height and narrowness of the building that seems to increase the force of the wind."[15] Diagonally across Madison Square Park from the Flatiron was Madison Square Presbyterian Church (fig. 77), designed by Stanford White (1853-1906) in 1906 and decorated with Tiffany mosaics produced in part by Clara's department.[16] Clara and the Tiffany family both attended church there and listened to the sermons of the firebrand minister, Dr. Charles H. Parkhurst (1842-1933).[17]

In addition to being conveniently located near her workplace, the Gramercy Park neighborhood exuded a bohemian atmosphere that must have felt welcoming to a well-educated, single woman working in the arts. It proved a magnet for artistic and intellectual figures throughout the second half of the nineteenth century and well into the twentieth. Next door to the Players Club on Gramercy Park, the former home of the actor Edwin Booth (1833-1893), stood the National Arts Club, founded in 1898. Conceived by the art critic Charles de Kay (1848-1935) as a gathering place for artists, patrons, and audiences of all the arts, the club included many women artists among its members.[18] Clara attended a dinner there in 1905 and noted the "interesting people and such good after dinner speeches."[19]

A DESIGNER'S SOCIAL LIFE

Through her work at Tiffany Studios, Clara forged social ties with some members of the firm's upper management, and her connections with Tiffany afforded her the occasional opportunity to mingle with the city's elite. An annual reception, held during the winter months for employees of the firm, whipped up feverish excitement among Clara's employees and not a little exhilaration from Clara. In January 1897, she attended a Tiffany reception at the "magnificent" Majestic Hotel, newly opened on Central Park West and Seventy-second Street. Awed by the uniformed footmen at every turn, a lengthy receiving line with formal

announcer, and a dining room "so immense that it looked endless," Clara was transported by the luxurious trappings and the sheer numbers of glamorous attendees.[20] Even more exciting for her was a reception held at Tiffany's own home in December 1898, which had her scurrying to find the proper attire. "Of course I have nothing to wear and had to 'fly round' and get a dressmaker to alter my black silk a little." Clara was suitably awed by the mansion, which she found "most beautiful as was to be expected."[21]

As Clara gained seniority at Tiffany Studios, her enthusiasm for these lavish parties diminished somewhat and she assumed a "mother hen" role, focusing on organizing the affairs of the Tiffany Girls. Despite suffering from a headache, Clara rallied herself for the 1904 Tiffany Ball. She "simply must not disappoint the girls, some of whom are allowed to come because I am there...." Clara ultimately enjoyed herself immensely and danced until the wee hours of the morning, dragging her staff away at 1:45 a.m.[22] For the following year's Tiffany Ball, Clara made a special request that it begin at 9:30 rather than 11 p.m. so that the Girls

would not get home too late. Despite her supervisory role, she had a splendid time and confessed to her family that her favorite dance partner was an Irish boy, Francis Dooley, who dusted the lamps in the stockroom. He spun her around the floor "like a piece of thistledown, conversing meanwhile [with] the grace and ease (though not the grammar and pronunciation) of an embassador [sic]."[23]

With Clara's increasing status at Tiffany Studios came more exclusive invitations from Mr. Tiffany. In 1906, he invited a group of senior employees out to the North Shore of Long Island to see his new country estate, Laurelton Hall. Clara wrote about his "delightful plan... of asking ten of us designers & c there at the Studios to go down to Cold Spring Harbor, Saturday noon and spend Sunday with him. His new place is just finished and is a perfect palace so I accepted eagerly." The extravagant Near Eastern-inspired edifice, set in a vast flowering landscape, boasted Tiffany's rich collections of exotic objects, glass and windows after his own designs (some of which had been executed by Clara), as well as some lamps and *objets de luxe*. In addition to the thrill of seeing

Fuller (Flat Iron) Building, New York.
Copyright 1903 by Ambrose Fowler, New York.

fig. 76
Fuller (Flatiron) Building, New York,
photographed by Ambrose Fowler 1903.
NYHS, Gift of E. H. Sauer.

fig. 77
Madison Square Presbyterian Church, New
York, photographed c. 1906. NYHS, Gift of
Lawrence Grant White.

fig. 78
23rd Street west of Sixth Avenue, New York,
photographed summer 1900. NYHS, Gift of
Eugene A. Hoffman.

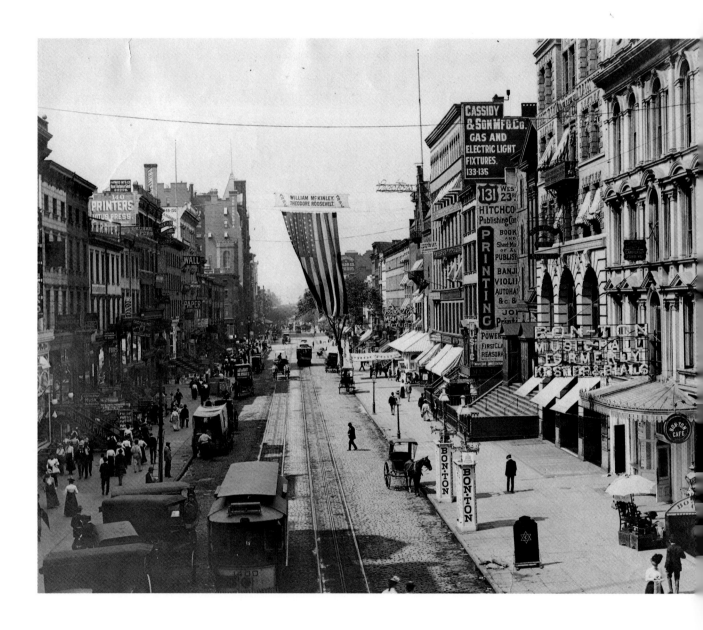

Laurelton Hall, Clara also eagerly anticipated riding in an automobile, "a splendid new touring car all enclosed in glass."[24] Devastated when a last-minute illness forced her to bow out, she had to settle for Alice Gouvy's report: "Alice says it is the most wonderful place she ever saw, that it seems like some enchanted palace, totally unlike anything else, and yet she says you would know at once that it was Mr. Tiffany's own work. It is a pleasure to see artistic ability and money go together for once."[25]

FASHIONING AN IMAGE

Clara lived conveniently near many of Manhattan's leading retail establishments. A few blocks west was the city's prime shopping district, Ladies' Mile, which stretched along Broadway and Sixth Avenue from Fourteenth Street to Twenty-third Street. Between the 1860s and 1880s, many prominent retailers had constructed impressive cast-iron palaces with grand display windows attracting throngs of customers. Clara's letters document her patronage of Stern Brothers Department Store and Best & Company on Twenty-third

Street (fig. 78), as well as Lord and Taylor and Wanamaker's on Broadway. At the turn of the century, as the department stores began to forsake Ladies' Mile and relocate uptown, Clara followed them northward. In 1903, in search of a suitable winter coat, she and Alice Gouvy started at Macy's large new establishment at Thirty-fourth Street and Broadway, and gradually worked their way downtown until they found the right one.

Clara's earnings did not provide much discretionary income, and her letters home reveal an almost Puritanical thriftiness. She wrote countless descriptions of alterations made to her wardrobe in order to extend the life of a dress, skirt, or hat, and she even reported wearing her grandmother's underclothes.[26] The apex of Clara's wardrobe frugality was perhaps her purchase of a bathing suit, on sale for $3.50, and her scheme to charge her sister Emily and her friend Alice Gouvy $1.00 each for the use of it.[27]

The few images that survive of Clara (figs. 65, 66 and 84, 85, 86) and numerous mentions and sketches of clothing in her letters offer a picture of her typical costume, which reflected

fig. 79
Madison Square Garden seen from Madison Square Park, New York, photographed 1900. NYHS, Gift of Mrs. Irving Heidell.

contemporary trends. She had begun her working career just as a revolution was taking place in women's fashion. The shirtwaist, or woman's blouse, worn together with a skirt, liberated women from the corsets, bustles, and hoops that had constrained them in previous decades. The affordable and practical outfit of a dark skirt, belt, and crisp white blouse was considered appropriate attire for the theater, the workplace, and even picnics and bicycle rides. Beginning in 1890, the illustrator Charles Dana Gibson (1867-1944) created the archetype of young feminine beauty known as the "Gibson Girl," often depicted in the waist-and-skirt combination. Clara proudly sported such an outfit at the lecture she gave in Boston in 1902, where she fancied herself "the best dressed person in the room."[28] She wore her "new gray skirt that the tailor made and a fancy shirt waist, that I got at Forsythe's late in the season, very plain and simple but exactly right in the details... my last winter's black and white hat... complemented my costume."[29]

ART AND CULTURE

Between 1897 and 1907, Clara attended many of the city's premier cultural events and came in contact with a wide range of men and women in the arts. In 1898 and 1899, she was often a guest of the Tiffany manager Henry Belknap at New York Philharmonic concerts, opera performances, and lectures on American architecture and German opera. Clara must have been pleased by the wealth of cultural opportunity he offered her, while Belknap clearly took pleasure in educating such a bright and eager student.

Clara attended many cultural events with other Tiffany employees and her boardinghouse friends. In January 1897, she wrote excitedly about going to Madison Square Garden (fig. 79), Stanford White's arcaded palazzo, to view the dazzling "gas tower" created by the Tiffany Glass and Decorating Company. She described an "immense affair with Gas jets innumerable colored steams and water dripping over long strings of chrystal [sic] jewels with an immense torch at the very top." Built as the central feature of an exhibition of gas products and appliances, the soaring sixty-

fig. 80
Detail, Edwin Booth Memorial Window,
designed by John La Farge 1898, Church of the
Transfiguration, New York. Courtesy George
Obremski.

foot Gothic tower was composed of eight sections, each representing a decade in the development of gas illumination. To Clara, the tower was

> ... a wonderful thing and looked like a piece of magic. The Consolidated Gas Company paid the Tiffany Glass Company ten thousand dollars for building it.... This was the opening night and the tickets were complimentary. I think that nearly all of the Tiffany employees

from Mr. Mitchell to Nellie were there. It was such fun to see them all.[30]

The following year, a highlight of Clara's cultural activity was her attendance at the unveiling of John La Farge's stained-glass window memorializing the famous actor Edwin Booth, made possible by an invitation from her friend George Waldo. Donated by members of the Players Club to the Church of the Transfiguration on Twenty-

fig. 81
Loie Fuller in her butterfly gown,
photographed by Reutlinger, Paris, c. 1890.
Jerome Robbins Dance Division, The New York
Public Library for the Performing Arts, Astor,
Lenox and Tilden Foundations.

ninth Street near Fifth Avenue, where Booth was a member, the window portrays Booth in his most famous role, Hamlet (fig. 80). The esteemed American actor Joseph Jefferson (1829-1905) presided over the unveiling ceremony, and Clara undoubtedly noticed the numerous prominent New Yorkers in attendance—including Richard Watson Gilder, Stanford White, and John La Farge himself.[31] Clara described the window: "It represents the young Hamlet (the face being a likeness of Edwin Booth) with the skull in his hands, in deep meditation. The window is fine in design and color...."[32] Clara gave no inkling of the intense rivalry between the window's designer, John La Farge, and her employer.

One of Clara's most exciting artistic collaborations involved the pioneering American dancer Loie Fuller (1862-1928), renowned for her natural movement, flowing silk costumes, and use of colored stage lighting in her performances (fig. 81). In May 1903, Clara reported an exciting visit from Fuller to the Fourth Avenue headquarters of Tiffany Studios:

She is trying experiments with effects of light through colored glass and spent most of the morning trying to show me what she wanted. I am making three little screens for her, through which the light is to be thrown upon her and greatly magnified. I am rushing them and hope to have them ready for her first rehearsal Thursday night....

Clara attended one of the dancer's performances and expressed her astonishment at the compact physique of a woman renowned for her agility and grace: "When dancing she looks like a beautiful fairy spinning and floating in the air so my amazement was simply unbounded to see that she was a little fat, dumpy, short necked, middle aged woman, with most insignificant and plain little features." Nevertheless, Clara was suitably impressed by the dancer's knowledge of color: "She is certainly an artist and seems to know quite as much about color combinations as Mr. Tiffany...."[33] Indeed, during the 1890s, Loie Fuller's performances had sparked a veritable "rainbow craze" on both sides of the Atlantic.[34] It is interesting to speculate whether Clara derived any inspiration from her contact with the dancer and her groundbreaking experimentation with lighting and color. Fuller's innovations certainly parallel Tiffany's own experiments in glass.

Just months after her meeting with Loie Fuller, Clara encountered another pioneering female artist, the photographer Gertrude Käsebier (1852-1934). At the time Käsebier was a leading member of the Photo-Secession, an organization of Pictorialist photographers founded by Alfred Stieglitz (1864-1946) in 1902 to foster recognition of photography as an art. Stieglitz held Käsebier's work in high estimation, and devoted the first issue of his sumptuous journal *Camera Work* to her photographs. In addition to her Pictorialist work, Käsebier managed a thriving portrait business (fig. 82). Her studio, located on bustling Fifth Avenue between Twenty-ninth and Thirtieth Streets, attracted many clients from the city's artistic community. One was Louis C. Tiffany, whose eight-year-old daughter, Dorothy Trimble Tiffany, sat for her in 1899. In November 1903, Clara recorded sitting for her own portrait by Käsebier in

fig. 82
Under the Skylight, showing Gertrude
Käsebier and her assistant in her studio,
photographed by A. K. Boursault, from *The
Photographer*, May 7, 1904. Photograph
Collection, Miriam and Ira D. Wallach Division
of Art, Prints and Photographs, The New
York Public Library, Astor, Lenox and Tilden
Foundations.

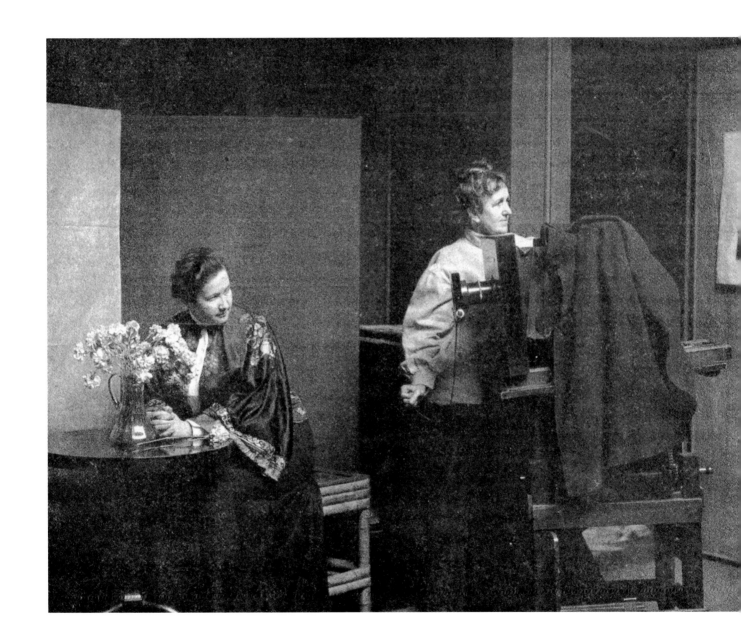

fig. 83
Metropolitan Museum of Art, photographed
by Frank Ingalls c. 1901-10. NYHS, Gift of Frank
Ingalls.

lively detail. She clearly admired and perhaps identified with the industrious photographer from the Midwest:

> She is a middle aged woman with funny black rimmed spectacles and most intelligent face. Her eyes are deep set and narrow and she squints a great deal, to get effects. She has a splendid ample body like Madam Schuman Heinck (not quite so large.) She has everything on rollers and moves the model stand with you on it, or the camera or the screens, constantly to get different effects.... She is a very clever and interesting woman and had the sense to find this way to apply her art and make an ample living rather than swell the ranks of the struggling artists.[35]

At the photographer's urging, Clara posed wearing a hat draped with a black gauze veil. Pleased

with the results, Clara sent a print home to her mother and sisters.[36] Käsebier, apparently equally pleased with her several portraits of Clara, displayed them in the sidewalk showcase in front of her studio.

> She had the smiling one in her case out on the street (all by itself) but has had this big one there ever since. She thinks it about the best thing she ever did. She said an Artist friend of hers, one of the "Photo Secessionists" to which she belongs, said to another one "Have you seen Käsebier's show case?... Well go and see it and then go home and pray to God that you may sometime be able to do as well."[37]

Clara herself dabbled in pictorial photography and experimented with manipulating portraits by painting the background with watercolor. She concocted a plan to have Alice Gouvy paint a background of summer blossoms in a photograph of her mother, and then have it rephotographed "in a soft brown and not too distinct."[38] Like Käsebier and others, Clara viewed photography as

a suitable career for women and even urged her sister Kate to consider the profession.[39]

Clara stayed abreast of New York City's art world, frequenting exhibitions, attending lectures, and drinking in the paintings at the Metropolitan Museum of Art (fig. 83). One June afternoon in 1898, she, the artist George Waldo, and Emma Dana took a street car uptown to the museum and "feasted our eyes while we wearied our backs and legs on the pictures... and also the collection of Michael Angelo's put in winter before last."[40] Clara also regularly attended art exhibitions with friends. Her letters recount viewings of the work of the Society of American Artists, shows at the National Academy of Design and National Arts Club, and an exhibition of Mary Cassatt paintings at the Durand-Ruel Galleries.[41] She also attended numerous lectures, including a "very fine" talk on the "Religion of Duty" given by Felix Adler (1851-1933), founder of the New York Society of Ethical Culture.[42]

Clara's letters reveal the Eurocentric culture of New York City's artistic community at the turn of the century. At 44 Irving Place, the boarders often read in European languages and even studied

fig. 84
Clara Driscoll, Parker McIlhiney, Agnes Northrop, and Louis C. Tiffany on deck of *S.S. Amerika*, September 13, 1907. Courtesy Michael Burlingham.

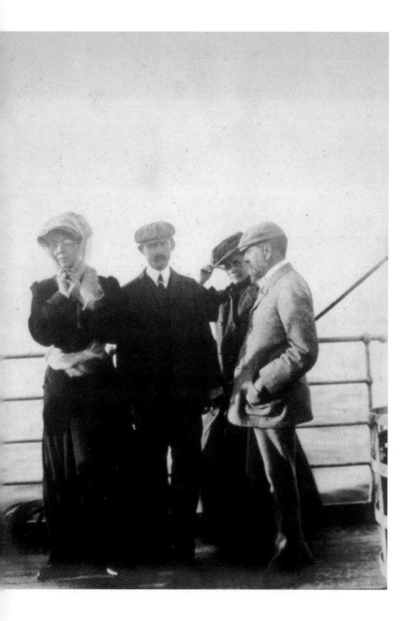

French together in the evenings. The language instruction was apparently well organized and well attended: "Mr. and Mrs. Trussell, Miss Bacon and I have an hour of the regulation beginning French down in the Trussell rooms. Then Miss Bacon and I go into an advanced reading class with Miss Griffin, Mr. Booth and Alice."[43] A number of Clara's artist friends, such as Dudley Carpenter and Henry McBride, had studied in Paris and taken the Grand Tour, and many who had not traveled aspired to go abroad for training.[44] Clara herself often expressed a longing to tour Europe, a desire that was finally fulfilled in the summer of 1906 when she went to Italy, France, and England with her friend Emma Dana. Clara often ruminated in her letters about suitable traveling companions and fretted about approaching Tiffany for time off.[45] In summer 1907, she embarked on a deluxe three-month tour of Brittany with Tiffany, Agnes Northrop, and Dr. Parker McIlhiney.[46] Intended primarily as a photography and sketching expedition, the tour is well documented by surviving photographs as well as a travel diary kept by Tiffany (figs. 84–86). The group traveled in grand style,

fig. 85
Clara Driscoll playing shuffleboard on *S.S. Amerika*, July 24, 1907. Courtesy Michael Burlingham.

shopping in Paris and touring the countryside in a flashy French automobile.[47] Clara's envious sister remarked: "You are certainly costing Mr. Tiff an awful lot, but I suppose it is a kind of relief to him to have some way to spend his money."[48]

THE STAGE AND CONCERT HALL

By the 1890s, New York City had become a hub for the nation's theatrical industry. Clara lived conveniently close to the heart of Manhattan's theater district, which was then concentrated near Union Square and just beginning its northward push to the streets around Longacre Square (later Times Square). Clara's letters reveal her as an active theatergoer and insightful critic. In February 1902, when a fellow boarder offered Clara good seats to Shakespeare's comedy *As You Like It* the day after she had seen a stage version of Paul M. Potter's *Notre Dame*, she capitulated to attending the theater two nights in a row and declared: "It is extremely difficult in New York not to be on the go all the time."[49]

Clara particularly enjoyed the plays of Shakespeare and she saw performances by many of the leading actors and actresses of the day in their

fig. 86
Clara Driscoll, Louis C. Tiffany, and Agnes
Northrop sketching in rue du Salle,
Quimper, August 20, 1907. Courtesy Michael
Burlingham.

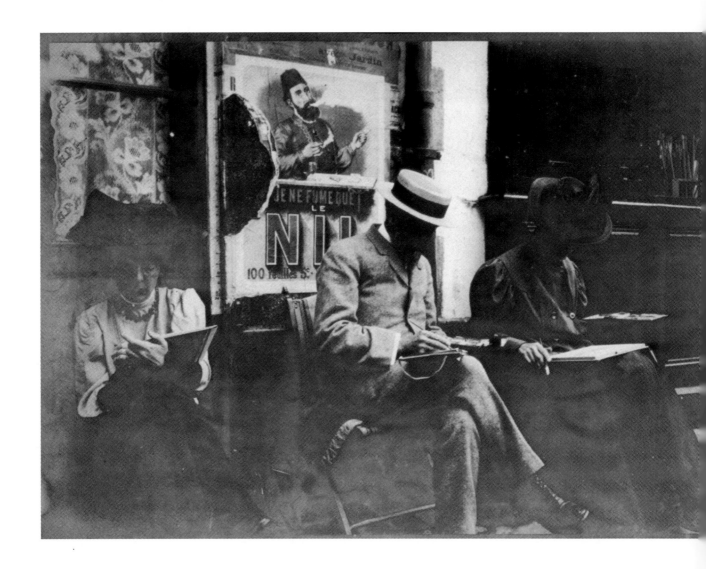

fig. 87
Edwin Booth as Hamlet, photographed by
Napoleon Sarony c. 1870-79. NYHS, Gift of
Harold Seton.

most famous roles. Her letters home abound with
accolades and occasional critiques, suggesting
that she closely followed these stars. Her family
shared her passion for the stage and they occa-
sionally compared notes on performances. In 1902,
Clara's mother and sister wrote about their plans
to see Sir Henry Irving and Ellen Terry perform in
The Merchant of Venice, and Clara replied competi-
tively that she had seen Booth and Modjeska
perform the same, and would love to know how
they compared.[50] The Shakespearean actor Edwin
Booth (fig. 87) was Clara's professed favorite,
though she named the English actor Forbes
Robertson (1853-1937) a close second.[51]

Clara also idolized several female leads, includ-
ing the Italian actress Eleonora Duse (1858-1924)
and the incomparable French performer Sarah
Bernhardt (1844-1923). In preparation for seeing
Duse perform the title role in Gabriele d'Annunzio's
melodrama *Francesca da Rimini* in Italian, she read
the play with friends.[52] In 1903, Clara "yielded to the
temptation" to attend a standing-room-only
performance of Duse in the title role of Hermann
Sudermann's *Magda*. After the performance, Clara

fig. 88
Metropolitan Opera House, photographed
c. 1897-98. NYHS.

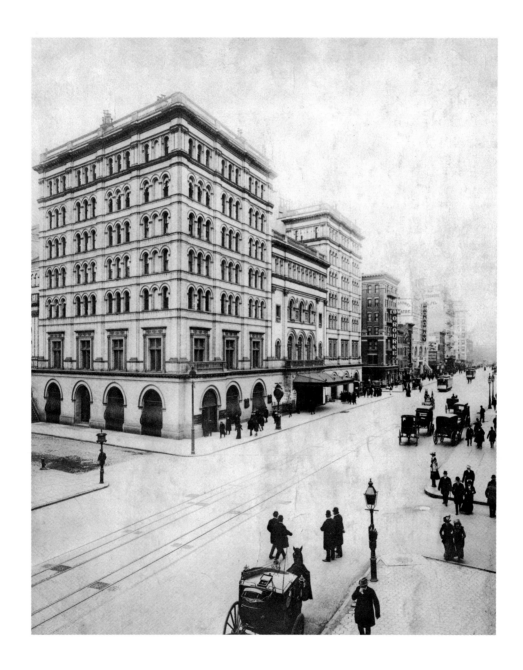

gave the ultimate praise: "She was so fine that our backs did not ache that much...."[53]

A highlight of the 1905 theater season was Bernhardt's performance in Alexandre Dumas's *Camille*, which Clara cited as the actress's "especial masterpiece." For the show at the Lyric Theatre, Clara was willing to pay for a $2.50 seat in the back row of the first gallery. "The house was packed and hundreds of people were standing besides. She is certainly a wonder. I believe she is sixty eight years and yet she acted with all the grace and spirit and charm of twenty... her clothes are works of art...."[54] That same month, Clara attended the first New York production of *Peter Pan*, a "perfectly delightful fairy story by Barrie" starring the American actress Maude Adams (1872-1953) as Peter, a role that became her signature.[55]

Clara's taste in music was as sophisticated as her interest in theater, and her reviews of performances suggest she was well informed about classical music and musicians. Thanks in part to the invitations of Henry Belknap, she regularly attended concerts by the New York Philharmonic and the visiting Boston Symphony Orchestra and heard many of the star soloists of the day, including the violinist Fritz Kreisler (1875-1962) and the pianist Ignacy Jan Paderewski (1860-1941).[56]

Although Clara enjoyed orchestral music, her true passion was for opera, which in Gilded-Age New York was a mainstay of the city's cultural and social life. In fact, the first Metropolitan Opera House (fig. 88) was erected in response to complaints from the city's socialites that the Academy of Music did not have enough boxes for all who desired them. Accommodating 3,045 people in its vast five-tiered horseshoe auditorium, the Metropolitan Opera had the largest hall of its type in the world.[57] Clara attended a range of operatic productions but, like Tiffany, had a distinct preference for the operas of Richard Wagner. After hearing Mozart's *Magic Flute,* she remarked: "All the best people sang and the music was beautiful, but the plot of the opera very silly. It doesn't seem to me to compare with the Wagner operas."[58]

In her taste for Wagner, Clara was joined by thousands of other middle- and upperclass Americans, particularly women, who thronged to

fig. 89
Ernestine Schumann-Heink, photographed
by Aimé Dupont c. 1900. NYHS, Gift of Henry
F. De Puy.

productions of his work with cult-like fanaticism.
Driving New York City's Wagner craze was the
magnetic European conductor Anton Seidl (1850-
1898), America's premier interpreter of the com-
poser. During the years of her Round Robin corre-
spondence, Clara attended numerous
performances of Wagner's compositions, particu-
larly of the *Ring* cycle, and also heard the Philhar-
monic perform his orchestral works. She described
an unforgettable performance of *Das Rheingold*,
featuring the famous contralto Ernestine
Schumann-Heink (1861-1936) (fig. 89): "It is
unspeakably beautiful and the music would go to
your soul. It was so memorable to see and hear
Schuman Heinc once more in her proper sphere—
Among the Gods."[59] The following week Clara saw
the third *Ring* opera, *Siegfried*, starring the Ger-
man tenor Alois Burgstaller (1871-1945), who was
particularly noted for that role. "The opera was
beautiful last night. Burgstaller outdid himself as
Seigfried [*sic*]. He looked like a God—bare legs,
Golden armour, beautiful shield and white winged
helmet." Clara was astounded to catch sight of the
divine Burgstaller later that evening in a German

restaurant on Fourteenth Street, red-nosed and ordinary-looking, downing quarts of beer and "making large inroads on a very plentiful supply of hearty food that was brought to him at once, by the admiring waiters."[60]

CITY LIFE: POLITICS AND LANDMARK EVENTS

Clara's correspondence also reveals an engagement with the larger world of local and national politics and landmark events in the city's inexorable progress toward modernity. Although unable to vote (and never intimating her views on women's suffrage), she held firm opinions on the state of political affairs in New York City and noted on election day 1903, "we are sick and sad here this morning in the face of the overwhelming victory for Tammany."[61]

During the 1905 election, one of the most contested campaigns in New York City history, Clara closely followed the re-election campaign of the New York district attorney William Travers Jerome (1859-1934), known for waging war against the corruption of Tammany Hall and the city government. She and her friends were "all sick at heart"

when Jerome's challenger, Thomas Mott Osborne (1859-1926), "that low down, drunken, Tammany-ite," pulled ahead briefly in the election returns.[62]

Clara did not voice opinions on national campaigns as ardently as she did about local races. Her male co-workers at Tiffany's firm, however, were active participants in the political process and particularly engaged in the presidential campaign of 1896, throwing their support behind the Republican William McKinley's "sound money" platform with its promise of jobs for blue-collar workers. Several weeks prior to the election pitting McKinley (1843-1901) against the Democrat William Jennings Bryan (1860-1925), the Tiffany workmen stretched a massive political banner over Fourth Avenue. Clara described the spectacle:

> We all got ready and went down in front of the building. One of the workmen stood on a tall box and made a speech which the roar of wagons going up and down the street entirely drowned except an occasional word or two. The only thing I heard was "shoulder to shoulder"—"sound money"—"fellow workmen" and

"McKinley and Hobart." When he finished the flag slid slowly across the street on a heavy rope stretched from the top of our building to the top of the opposite one. It was the American flag with this in large letters across the bottom. "Raised by the artizans of the Decorative Arts / McKinley and Hobart / An honest dollar and a chance to earn." At twenty minutes past four it was floating grandly and the men sent up three mighty cheers. Then we began to disperse our several ways.[63]

Clara's description of watching the election returns two weeks later vividly captures the mobbed streets, contagious energy, and raucous din of New York City on election night, all of which she relished. She watched the election returns in Herald Square two years later, when the war hero Theodore Roosevelt (1858-1919) was narrowly elected Governor of New York. She exhilarated in the "wonderful conglomerate mass of human noise and excitement" and thrilled to the election-night fireworks display in Madison Square.[64] By 1904, the locus of election-night festivities had shifted to the recently christened "Times Square," presided over by the city's newest skyscraper, the twenty-four-story Times Tower. Inching up Broadway with the crowds, Clara watched the bulletins flashing on the Times Tower, announcing Roosevelt's lead and ultimate victory.[65]

Just one week prior to Roosevelt's victory in 1904, New York City's citizens came out in force to celebrate an altogether different triumph: the opening of the subway, the city's first efficient urban transit system. Clara noted the city's frenzied excitement when the Mayor took the inaugural train ride from City Hall, accompanied by a shrill from "every whistle in the city and harbor."[66] Two weeks later, she reported her first ride on the new conveyance, marveling at its speed and affordability: "Took the wonderful subway at 14th Street and shot up to 125th on the West side only three minutes from the Fort Lee Ferry. This journey in times past has taken a full hour and cost ten cents, and now it is five cents in fifteen minutes." She also admired the bright, clean stations, "green and white tiled like a very expensive bathroom freshly scrubbed."[67] Clara

noted that the "Tiffany people feel pretty bad that 23rd St. is not to be one of the Express stations," perhaps because they thought that fewer customers would stop into the showroom.[68]

SPORTS AND THE OUTDOORS

Clara led a remarkably athletic life for a woman at the turn of the century. In addition to her daily constitutional to and from Tiffany's and her strolls in the city's parks, she also took up the sport of bicycling with great zeal. Her purchase of a "wheel" in 1898 and subsequent obsession with the sport coincided with the bicycling craze of the 1890s, unleashed by the invention of the Safety— a bicycle with wheels of equal size and a chain drive that made it easy for anyone to ride.

The Safety bicycle brought the sport within reach of rich and poor alike, but its liberating effects were felt most keenly by women. The cycling craze became intertwined with the women's movement of the 1890s, and in 1896 Susan B. Anthony (1820-1906) told the *New York World's* reporter Nellie Bly (1864-1922) that bicycling had "done more to emancipate women than anything else in the world."[69] The bicycle brought women a newfound sense of freedom of movement, at least in part because their attire had to allow it. Along with the purchase of her wheel, which probably cost around $40, Clara obtained a bicycle-friendly readymade linen suit for $5.20.[70] The writings of the suffragist Frances Willard (1839-1898), especially her 1895 memoir, *A Wheel Within a Wheel: How I Learned to Ride the Bicycle,* explicitly linked riding a bicycle with female empowerment and likened the conquest of learning to ride to the mastery women needed to achieve independence in the real world.

After an inauspicious beginning that included a collision with a lamppost near Gramercy Park, Clara became an intrepid rider. Her subsequent letters are filled with reports of her bicycle trips, first around the neighborhood, then to the northern reaches of Manhattan, and by late August as far as Brooklyn, Westchester County, and even Bergen County in New Jersey. Invariably accompanied by a male friend, typically Edward Booth, his brother ("Mr. Butterfly Booth"), or Mr. York, Clara and her escorts frequented many of the

popular biking areas of the city. On a gorgeous summer night in early August, she and "Mr. Butterfly Booth" rode up Madison Avenue, through Central Park, up Central Park West, over to "the Boulevard" (Broadway), and finally up Riverside Drive to Grant's Tomb (fig. 90). "Here there were thousands of wheels and it was a great sight."[71] By late summer she was bringing her bicycle on trains and ferries to explore areas north of the city such as Bronxville, New Rochelle, and Sleepy Hollow, and she ventured across the Hudson River to the Palisades in New Jersey. A favorite destination was Prospect Park in Brooklyn, which was linked to Coney Island by five and a half miles of twin cycle paths.[72] Although Clara's enthusiasm for biking trips in and around New York City waned along with the fading of the bicycle craze, she continued to enjoy lengthy rides during her jaunts to the Jersey shore.

POINT PLEASANT
Clara found refuge from the stress of her work at Tiffany's and the hectic pace of urban life by escaping to the quiet town of Point Pleasant, New Jersey. Located forty-three miles south of New York City, Point Pleasant's resort hotels and beachfront amusements had begun luring city dwellers in the 1870s. After New Jersey's Central Railroad extended its line to Point Pleasant in 1880, the town became more easily accessible and attracted weekenders fleeing the hot and crowded city. Clara was first drawn to Point Pleasant by her Tiffany colleagues Lillian and Marion Palmié, whose family maintained a large summer house there. After a visit to the Palmiés in August 1898, Clara became completely enraptured with Point Pleasant and mused to her family:

> Sometime when I am rich I am going to buy a little place down at Point Pleasant.... It is a beautiful place and I got more into those two days than I would have thought possible – a ride through woods and down to the beach on bicycles before breakfast. The birds were singing and everything was dripping with dew; two baths in the sea. I found I could swim a short distance and the cold salt water was exhilarating beyond anything I know. A camp fire and

supper on the beach, during which there was a double rainbow, a moon rise and a sunset; a sail on the river by moonlight and two others in daytime; a long walk; a long trolley ride by the sea, and a flower gathering trip. We put on our bicycle skirts as soon as we got there and did not exchange them for anything but night-gowns all the time we stayed.[73]

Clara was enthralled, and beginning the following summer she found her own accommodations in Point Pleasant. She corralled her boardinghouse friends to join her, and a group from 44 Irving Place pooled resources to rent Miss Fields's house for $75 a season. The arrangement must have been satisfactory, as the group returned for several summers. As Clara reported in 1902, the weekend-ers obtained board at the Palmiés' house for $5 a week and turned the kitchen of Miss Fields's cottage over to bicycle storage. Women slept in the upper-floor rooms and men downstairs.[74] After her marriage in 1909, Clara continued to return to Point Pleasant with Edward Booth, renting a small summer cottage in the pine woods back from the ocean and maintaining ties with friends from her days at Tiffany Studios.

———————————

Whether exploring on her bicycle, applauding her favorite performers on the stage, jostling with the crowds in Times Square on election night, or exchanging ideas with artists, Clara seized the many opportunities available to residents of the nation's cultural capital. Her upbeat descriptions of life in her adopted city and her perspective as a modern working woman offer a fascinating window onto a city that was undergoing extraor-dinary physical and cultural transformation. Clara Driscoll's enthusiastic embrace of urban life also presages the experience of subsequent genera-tions of career women and bohemians lured to New York City by its abundant business opportu-nities and thriving artistic community.

fig. 90
Bicycling on Riverside Drive
near Grant's Tomb, New
York, c. 1897. NYHS.

Appendix
THE WOMEN OF TIFFANY STUDIOS

Prior to the discovery of the Driscoll correspondence, scholars had identified relatively few female designers active at Tiffany Studios, and virtually none of the firm's glass selectors and cutters. Even those women whose work was recognized, such as Clara Driscoll, Agnes Northrop, and Alice Gouvy, remained shrouded in mystery, with little known about their backgrounds, artistic training, or careers. This compendium of more than sixty artists' biographies is intended to identify and recognize many of the women who contributed to the design and manufacture of Tiffany Studios objects, and to offer a starting point for future investigation of the many women workers there.

Since few official business records survive from Tiffany Studios, this roster was derived from a wide range of ancillary sources. In piecing together the biographies of the Tiffany Girls, Clara Driscoll's letters were a key source for identifying glass selectors and cutters working prior to 1908, while Mary Jeroleman's Glass Selectors Ledger offered additional names of women working in the Glass Cutting Department just after Clara's departure. Surviving photographs of the Tiffany Girls held by the Charles Hosmer Morse Museum of American Art offer some additional names and allow us to connect faces with at least twenty-four of these names. Some women who contributed designs for windows and other objects were identified through periodical references in journals and newspapers. The following sources are abbreviated in the references following each biography:

Census	United States Census Records (1880, 1900, 1910, 1920, 1930)
Falk	Peter Hastings Falk, ed., *Who Was Who in American Art 1564- 1975: 400 Years of Artists in America,* 3 vols. (Madison, CT, 1999)
Driscoll	Clara Driscoll Correspondence, Kent State University Library (1896-1897, 1902-1907) and Queens Historical Society (1898-1899, 1907)
Jeroleman	Mary Jeroleman's Glass Selectors Ledger, Charles Hosmer Morse Museum of American Art
King	Polly King, "Women Workers in Glass at the Tiffany Studios," *Art Interchange* 33 (Oct. 1894): 86-88.
NYCD	*Trow's City Directory* [New York]
NYT	*The New York Times*

fig. 92
Tiffany Girls (Mary McVickar, Theresa Baur, Nellie Warner, Alice Wilson, Annie Tierney, and Annie Boax) at New Rochelle, NY, c. 1905. The Charles Hosmer Morse Museum of American Art, Winter Park, FL.

THE TIFFANY GIRLS

ARNOTH, ANNA

(b. New York, NY, c. 1871)
Daughter of German-born parents living on Lewis St., Manhattan. Not cited by Driscoll. Photographed with Tiffany Girls c. 1904-05.
Ref. Census 1880.

BAUR, THERESA

(b. Brooklyn, NY, Feb. 1884)
Daughter of lithographer father and embroiderer mother. In 1900, lived with her parents at 200 North 6th St., Brooklyn, her occupation listed as "typist." Obtained position at Tiffany Studios in 1899 through her brother, an office boy to Edward Booth. First worked as a cutter for Anna Ring. Later cut mosaics for Joseph Briggs. Lived in Brooklyn with mother. Photographed with Tiffany Girls c. 1904-05. Making leaded-glass shades at Tiffany Studios 1909-10. Living in Brooklyn in 1910, occupation listed as "glass-artist."
Ref. Census 1900, 1910; Driscoll, Jan. 12, 1899, Mar. 2, 1905; Jeroleman.

BOAX, ANNIE L.

(b. New York, NY, Sept. 1878)

Not cited by Driscoll. In 1900, lived with mother at 163 East 33rd St., Manhattan. Her occupation listed as "art decorator." Perhaps already with Tiffany Studios. Photographed with Tiffany Girls c. 1904-05. Making leaded-glass shades in 1909-10.

Ref. Census 1900; Jeroleman.

BOOK, EDNA

(b. New York, NY, Feb. 1888)

Daughter of German-born parents. Lived with parents on East 27th St., Manhattan, in 1900. Not cited by Driscoll. Photographed with Tiffany Girls c. 1904-05.

Ref. Census 1900.

BYRNE, MISS

Cited as a glass cutter.

Ref. Driscoll, June 15, 1898.

DANA, EMMA K.

(b. Athens, OH, 1859–d. Martinsville, IN, Aug. 1934)

Daughter of Eliza and Joseph Dana. Graduate of Ohio State University. Lived in Boston. Exhibited at Boston Art Club in 1886. Painted china professionally and taught art in an elementary school in Montpelier, VT, by 1896. Became boarder at 44 Irving Place in 1898. Worked part time designing metal objects for Tiffany Studios. Taught in Cleveland 1899-1927, until she retired. Living in a boardinghouse in Los Angeles in 1930.

Ref. Census 1900, 1920, 1930; Falk; Driscoll, Oct. 13, 1896; June 15, 1898; Jan. 12, 1899; obit. *Cleveland Plain Dealer*, Aug. 21, 1934.

DE LUZE, GRACE SCHUYLER

(b. c. 1858–d. New York, NY, 1924)

Daughter of Charles Henry and Letitia Schuyler de Luze. One of six original workers in Women's Glass Cutting Department. Designed windows including memorial window for Cornell University, Ithaca, NY. Not cited by Driscoll. Lived in New Rochelle, NY, while maintaining a Manhattan residence at 42 East 43rd St. in 1902, and at 3 East 28th St. the following year. Became a ceramist.

Ref. King; *NYT*, May 26, 1900, Nov. 8, 1914; Falk; NYCD 1902, 1903; obit. *NYT*, Aug. 10, 1924.

DEMAREST, VIRGINIA BANKS

(b. Cleveland, OH, Oct. 8, 1872–d. Cleveland, Apr. 13, 1943)

Studied art in Paris and Florence. Worked at Rookwood Pottery, Cincinnati, OH, 1900-03. Hired at Tiffany Studios as a modeler in 1903. Photographed with Tiffany Girls c. 1904-05.

Ref. Census 1900; Voorhis D. Demarest, *The Demarest Family* (Hackensack, NJ, 1968); Herbert Peck, *The Book of Rookwood Pottery* (New York, 1968); Haverstock et al., *Artists in Ohio;* Falk; Driscoll, Mar. 21, 31, Apr. 2, 13, 1903; Feb. 23, 1905.

EFFIE *(family name unknown)*

Lived in Brooklyn with her family. Began work at Tiffany in Oct. 1902 but left the following month due to illness.

Ref. Driscoll, Oct. 19, Nov. 5, 1902.

EGBERT, ELLA E.

(Ella Egbert Van Derlip) (b. Prairie City, IL, Jan. 1865)

Daughter of John M. Egbert and Cornelia Leach. Attended school in Binghamton, NY, c. 1880. One of six original workers in Women's Glass Cutting Department. Executed several windows designed by Frederick Wilson and some for 1900 Paris World's Fair. Described as one of the best selectors; termed "the oldest girl" when she left Tiffany Studios in early 1899. On Jan. 27, 1900, she married George Mairs Van Derlip, the 67-year-old father of her former co-worker Anne Van Derlip. When he died in 1903, she returned to work. Photographed with Tiffany Girls c. 1904-05. Fired in Dec. 1907.

Ref. Census 1880, 1900; King; Driscoll, June 29, 1898; Jan. 27, 1899; Dec. 4, 1907; *The Watchman,* Aug. 6, 1903.

EULER, MISS

Not cited by Driscoll. Making leaded-glass shades in 1909-10.

Ref. Jeroleman.

FRANCIS, MISS

Hired as a draftsman and designer in early 1903; worked only half days.

Ref. Driscoll, Mar. 13, 1903.

GOBER, FANNIE MAGUEDA

(b. Memphis, TN, May 9, 1868)

Daughter of Rosella and Daniel Gober. Moved to New York from Chattanooga, TN, and studied at Art Students League in 1896-97. Lived then at 249 West 55th St. Working at Tiffany Studios by 1902, preparing watercolor renderings. Also worked as a selector. Left late 1906 to return to Memphis.

Ref. Census 1880; Art Students League Register, no. 563; Driscoll, May 14, 1902; Nov. 17, 1903; Jan. 18, Mar. 29, 1905; Dec. 13, 17, 1906; Apr. 22, 1907; Memphis directory, 1890-91.

GOUVY, ALICE CARMEN

(b. Cleveland, OH, c. 1870/75–d. Cleveland, Mar. 27, 1924)

Daughter of Charles P. and Helen L. Gouvy. Family lived at 30 Woodland Ct., Cleveland. Graduated from Cleveland School of Art in 1894. Moved to New York and may have worked then at Tiffany Studios. Lived with Driscoll in apartments at 438 West 57th St. and 5 West 63rd St. in 1896-97. Studied at Art Students League 1896-98. Returned to Tiffany in fall 1898. Driscoll's most trusted assistant. Shared summer cottage at Pt. Pleasant with Driscoll. By 1900 working in enamel and pottery departments at Corona but also designed bronze objects. Returned to work in Manhattan in 1903. Traveled to Europe in summer 1904. Became boarder at 44 Irving Place in Sept. 1904. Left Tiffany in early 1907, returning to Cleveland to live with her mother at 8303 Linwood Ave. and teach school.

Ref. Janet Zapata, *The Jewelry and Enamels of Louis Comfort Tiffany* (New York, 1993); Cleveland directories, 1907-08, 1923; Art Students League Register 1896-97, no. 115; Haverstock et al., *Artists in Ohio*; Driscoll, Oct. 13, 1896; Jan. 3, 8, May 4, Nov. 10, 1897; Sept. 19, Nov. 8, 1898; Aug. 19, 1899; Jan 9, Mar. 26, 1902; Apr. 2, Dec. 21, 1903; July 19, Aug. 23, Sept. 22, 1904; Jan. 4, 1905; Dec. 23, 1906; Apr. 22, 1907.

GRIFFIN, EDITH

(b. Canada, July 1864)

Came to U.S. in 1883, lived with family in Brooklyn in 1900. An elementary school teacher and cousin of a boarder at 44 Irving Place. Still in Brooklyn in 1904. Chosen by Driscoll as her replacement during her 1906 Europe trip. Designed some lampshades during her tenure.

Ref. Census 1900; Driscoll, May 5, 1903; Sept. 22, 1904; Jan. 4, Mar. 8, 1905.

GRIFFITHS, MISS
Described by Driscoll as "one of the best selectors."
Left prior to marriage in Hoboken, NJ, in 1902.
Ref. Driscoll, Dec. 27, 1897; Apr. 24, 1902.

HAWTHORNE, BEATRIX
(Beatrix Hawthorne Smyth) (b. England, Jan. 19, 1878–d. Armonk, NY, 1967)
Daughter of Julian Hawthorne and Mary Albertina Amelung, and granddaughter of author Nathaniel Hawthorne. Lived with her parents and five siblings at 216 West 138th St., Manhattan. Cutting glass at Tiffany Studios by 1903. Photographed with Tiffany Girls c. 1904-05. Left Tiffany just before Aug. 2, 1905, when she married Clifford Smyth, according to Driscoll a "literary man," who later founded and was the editor of *NYT Book Review*. She lived in Mount Vernon and reared three children.
Ref. Census 1900, 1910, 1920, 1930; Driscoll, July 6, Aug. 2, 1905.

HENDERSON, MINNIE
At Tiffany Studios by 1897. Modeled in wax and prepared some designs. Photographed with Tiffany Girls c. 1904-05.
Ref. Driscoll, Dec. 27, 1897; May 14, 1902; Apr. 13, 1903; Mar. 29, 1905.

HODGINS, ROBERTA
(Bertie)
Employed as glass cutter before mid-1898. Became engaged in late 1903 but did not leave immediately. Photographed with Tiffany Girls c. 1904-05.
Ref. Driscoll, June 15, Nov. 15, 1898; Dec. 28, 1903.

JEROLEMAN, MARY
Not cited by Driscoll. Perhaps supervisor of lamp department after Driscoll's departure. Kept Selectors Ledger from Oct. 1909 to Feb. 1910, now in Morse Museum, Winter Park, FL.

JUDD, MISS
Cited by Driscoll as helping to make metal clasps and hinges for a clock model.
Ref. Driscoll, July 26, 1898.

LOSEY, MARION
(b. New York, NY, Sept. 1877)
Daughter of Julia and William Losey. Lived with parents at 426 West 29th St., Manhattan, in 1900, occupation listed as "decorator." Perhaps already with Tiffany. Not cited by Driscoll. Photographed

with Tiffany Girls c. 1904-05. Married Andrew J. Dutcher on June 1, 1905, in Manhattan. Living in Jersey City, NJ, in 1920.

Ref. Census 1900, 1920.

MACCARTY, MISS

Not cited by Driscoll. Mentioned as having been with Louis C. Tiffany "doing metal work."

Ref. NYT, Mar. 14, 1910.

MAMIE *(family name unknown)*

At Tiffany Studios by 1896. Painted inscriptions on windows.

Ref. Driscoll, Nov. 4, 1896; Dec. 27, 1897; Mar. 21, 1899.

MCDOWELL, MARY E.

(b. Ohio, c. 1851)

Daughter of portrait painter and chair maker Daniel McDowell of Mount Vernon, OH. Active as a painter there c. 1880. Worked for Tiffany in early 1890s but left c. 1893 for Europe. Exhibited stained-glass cartoon at 1893 Chicago Exposition. Returned to New York in 1897 and shared Driscoll and Gouvy's apartment at 5 West 63rd St. Resumed work at

Tiffany Studios. Left Tiffany c. 1898 and married E. Boyd Smith. Intended to live in Europe.

Ref. King; Haverstock et al., *Artists in Ohio*; Maud Howe Elliott, *Art and Handicraft in the Women's Building of the World's Columbian Exposition* (New York and Paris, 1893); Driscoll, Nov. 10, 17, 30, 1897; Sept. 6, 1898.

MCNICHOLL, CARRIE

(b. New York, NY, June 1877)

Was at Tiffany Studios and tracing Driscoll's designs in 1898. Lived with her family at East 123rd St., Manhattan, c. 1900, profession listed as "clerk." Succeeded Anna Ring as bookkeeper for Driscoll. Photographed with Tiffany Girls c. 1904-05. By 1910 living in New Rochelle, NY, profession listed as "draughtswoman." Still there in 1930, working as a secretary.

Ref. Census 1900, 1910, 1930; Driscoll, July 26, 1898; Aug. 20, 1903; Mar. 2, 1905.

MCVICKAR, MARY

(b. Ireland, Jan. 28, 1878)

Daughter of Robert and Jane McVickar. In 1900, living in Mount Vernon, NY, with her sister and brother's family. Already working for Tiffany, her

profession listed as "artist in glass." Made mosaics. Photographed with Tiffany Girls c. 1904-05.

Ref. Census 1900; Driscoll, Oct. 22, 1903; Jan. 18, 1905.

MINNICK, LOUISE

(b. Pennsylvania, 1869)
Shared apartment with Driscoll at 438 West 57th St., Manhattan, by 1896. Left Tiffany Studios by early 1897 to marry George B. Dusinberre, and moved to Pennsylvania. Had two children. In 1920 and 1930 was living in Wellsboro, PA.

Ref. Census 1920, 1930; Driscoll, Oct. 1, 1896; Feb. 24, 1897; Sept. 23, 1902.

MITCHILL, EDITH

(Edith Mitchill Prellwitz) (b. South Orange, NJ, Jan. 25, 1864–d. East Greenwich, RI, 1944)
Studied at Art Students League and Académie Julian, Paris. Figure and portrait painter. Founder of Women's Art Club in 1889 (later National Association of Women Artists). One of six original workers in Women's Glass Cutting Department in 1892. Not cited by Driscoll. Married painter Henry Prellwitz in Manhattan on Oct. 6, 1894. Awarded prizes by

National Academy of Design, 1894; Society of American Artists, 1895; Pan-American Exposition, Buffalo, 1901. After 1913 moved to Peconic, Long Island.

Ref. Census 1900; King; *Annual Catalogue of American Artists* (1894); Falk; *NYT*, May 14, 1995.

NERGAARD OR NEIGAARD, MISS DE

(b. Denmark?)
Worked at Tiffany Studios prior to 1904.

Ref. Driscoll, Mar. 28, 1904.

NICHOLSON, MARY

(Mary Nicholson McGuire) (b. New York, NY, c. 1885)
Attended New York School of Applied Design. Not cited by Driscoll. Making leaded-glass shades 1909-10. In 1910, living with her family on East 27th St., Manhattan, occupation listed as "stained glass artist." Married John H. McGuire who became Street Commissioner of Passaic, NJ. After his death in 1933, she succeeded him in that position.

Ref. Census 1910, 1920; Jeroleman; *NYT*, Dec. 26, 1933.

OVERBECK, META

(b. New Jersey, c. 1880)

Daughter of German-born parents. Worked in Tiffany Studios enamel department by 1902. On friendly terms with Driscoll. Lived in "the country." Designed jewelry for Tiffany & Co. under Tiffany's direction; drawings by her are in archives of Tiffany & Co., Parsippany, NJ, and at Morse Museum, Winter Park, FL. By 1930 she lived with her mother at 333 E. 80th St., Manhattan; was single, her occupation listed as "designer and jeweler."

Ref. Census 1930; Zapata, *The Jewelry and Enamels of Louis Comfort Tiffany*; Driscoll, Apr. 7, 1902; Apr. 13, Dec. 28, 1903; Jan. 15, 1904.

PALMIÉ, LILLIAN

(b. Brooklyn, NY, c. 1871-74)

Daughter of Prussian-born parents Theresia and Edward Palmié, living at 171 Warren St., Brooklyn. At Tiffany Studios by 1897. Twin sister of Marion, who also worked for the firm. A close associate of Driscoll, who termed her one of the best selectors. Worked in enamel and pottery departments in Corona. Also modeled objects to be executed in bronze. Went to Europe with sisters Anna and Marion in summer 1903. Listed in 1910 as a "glass designer."

Ref. Census 1880, 1910; Zapata, *The Jewelry and Enamels of Louis Comfort Tiffany*; Driscoll, June 29, 1898; Jan. 9, Mar. 26, 1902; Mar. 23, 1903.

PALMIÉ, MARION

(b. Brooklyn, NY, c. 1871-74)

Daughter of Prussian-born parents Theresia and Edward Palmié, living at 171 Warren St., Brooklyn. Twin sister of Lillian. May have been at Tiffany Studios by 1899. Traveled to Europe with sisters Lillian and Anna in summer 1903. Worked as a mosaicist. Photographed with Tiffany Girls c. 1904-05. Lived at 44 Strong Place, Brooklyn. Listed in 1910 as a "glass designer."

Ref. Census 1880, 1910; Ledger 1999-066, p. 278, Charles Hosmer Morse Museum of American Art, Winter Park, FL; Driscoll, Oct. 14, 1899; June 9, Oct. 12, 1903.

PALMIÉ, THERESIA

(b. Brooklyn, NY, c. 1869)

Daughter of Prussian-born parents Theresia and Edward Palmié, living at 171 Warren St., Brooklyn. Older sister of Marion and Lillian. Noted by Driscoll as working on the mosaic of a *Cobweb* lamp base.

Ref. Census 1880, 1910; Driscoll, Oct. 22, 1903.

fig. 94
Tiffany Girls at Midland Beach, Staten Island,
NY, June 15, 1905. The Charles Hosmer Morse
Museum of American Art, Winter Park, FL.

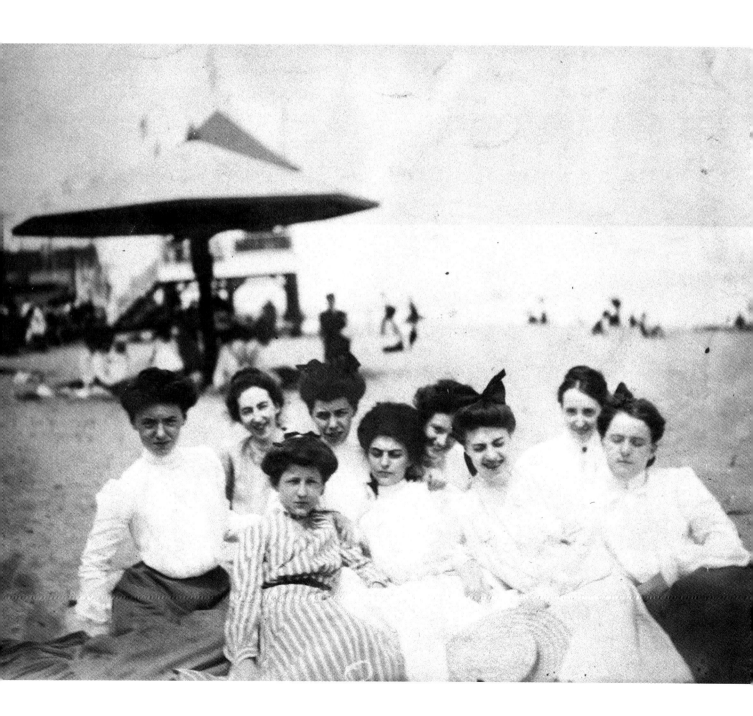

PEARSALL, EDITH
Not cited by Driscoll. Photographed with Tiffany Girls c. 1904-05.

PHILLIPS, MISS
Not cited by Driscoll. Photographed with Tiffany Girls c. 1904-05.

RING, ANNA
Considered one of the best glass cutters; served as Driscoll's bookkeeper. Photographed with Tiffany Girls c. 1904-05.
Ref. Driscoll, Mar. 2, 1904; Jan. 18, 1905.

SCHUMANN, MISS
Not cited by Driscoll. Making leaded-glass shades c. 1909-10.
Ref. Jeroleman.

STANLEY, EMMA
By 1902 was widow of Marcus C. Stanley. Lived at 56 West 97th St., Manhattan, 1902-06. Not cited by Driscoll. Photographed with Tiffany Girls c. 1904-05.
Ref. NYCD 1902-06.

STONEY, MISS
One of six original workers in Women's Glass Cutting Department, with "a recognized bent for flowers and all conventional designs." Not cited by Driscoll.
Ref. King.

TALASHEA, IRENE
Not cited by Driscoll. Photographed with Tiffany Girls c. 1904-05.

TATNELL, MAY
Not cited by Driscoll. Photographed with Tiffany Girls c. 1904-05. Making leaded-glass shades c. 1909-10.
Ref. Jeroleman.

TIERNEY, ANNIE
In 1902 living at 304 East 35th St., Manhattan. Cited once by Driscoll. Photographed with Tiffany Girls c. 1904-05.
Ref. NYCD 1902-03; Driscoll, Feb. 4, 1905.

fig. 95
Detail of Tiffany Girls on the roof
of Tiffany Studios c. 1904-05. The
Charles Hosmer Morse Museum of
American Art, Winter Park, FL.

fig. 96
Tiffany Girls at Midland Beach,
Staten Island, NY, June 15, 1905.
The Charles Hosmer Morse
Museum of American Art,
Winter Park, FL.

WARNER, NELLIE

Not cited by Driscoll. Photographed with Tiffany Girls c. 1904-05.

WHALEY, MISS

Painted faces for leaded-glass windows at Tiffany Studios.

Ref. Driscoll, Dec. 27, 1897.

WILHEMSON, AGNES

(b. Sweden–d. Brooklyn, NY, Sept. 7, 1898)
Began working at Tiffany Studios in 1894. Became engaged to a butcher in May 1897 and left work. After the engagement was broken, she committed suicide by drinking carbolic acid.

Ref. Brooklyn Daily Eagle, Sept. 8, 1898; Driscoll, Oct. 13, 1896, Sept. 12, 1898.

WILLIAMS, MRS. MARY VOORHIS SCHOFIELD

Designed windows at Tiffany Studios. A friend of Driscoll's, went bicycling with her. Often acted as general manager. Photographed with Tiffany Girls c. 1904-05.

Ref. Driscoll, July 19, 1898; Apr. 29, 1899; Oct. 19, 1902.

WILSON, ALICE

Began work at Tiffany Studios in early 1904, described as "Miss Borough's niece." In 1904 lived at 222 West 37th St., Manhattan. Photographed with Tiffany Girls c. 1904-05.

Ref. NYCD 1904-05; Jeroleman; Driscoll, Feb. 10, Mar. 2, 1904.

WINTERFELT, CAROLINE

Cited once by Driscoll.

Ref. Driscoll, n.d. (c. 1907), to Emily Wolcott (QHS).

ZEVESKY, JULIA

At Tiffany Studios by 1903, described as energetic but without "an artistic temperament." Photographed with Tiffany Girls c. 1904-05.

Ref. Driscoll, Mar. 6, 13, 21, 31, 1903.

OTHER WOMEN ASSOCIATED WITH TIFFANY STUDIOS

COMYNS, ELIZABETH

(Lizbeth B. Comins)

Illustrated books published by Louis Prang in 1880s and '90s. Three designs for china painting were published in *The Art Amateur*, 1892. Designed windows for Tiffany in 1890s.

Ref. King; Falk.

COX, LOUISE HOWLAND KING

(b. San Francisco, CA, June 23, 1865–d. Windham, CT, Dec. 11, 1945)

Studied at National Academy of Design and Art Students League. Married her teacher, painter Kenyon Cox, in 1892. Designed windows for Tiffany in 1890s. As a painter, specialized in portraits of children. With husband created murals for Liberal Arts Building at 1893 Chicago Exposition. Belonged to Cornish Art Colony in New Hampshire. Awarded medals at Paris World's Fair, 1900; Pan-American Exposition, Buffalo, 1901; St. Louis World's Fair, 1904.

Ref. King; Chris Pettys, *Dictionary of Women Artists: An International Dictionary of Women Artists Born Before 1900* (Boston, 1985); Falk; obit. *Willimantic Chronicle*, Dec. 12, 1945.

DODGE, OLIVE FAIRFIELD

(b. Beverly, MA, September 24, 1885–d. Douglaston, NY, December 16, 1938)

Trained in Boston and New York. In 1900 lived with her family in Queens, NY. Won a prize in 1906 at School of Applied Design. In 1920, lived with mother and brother at 223 East 17th St., Manhattan, occupation listed as "designer." Worked at Tiffany Studios in unknown capacity; lived at Allerton Hotel for Women.

Ref. Census 1900, 1920; *NYT*, May 20, 1906.

EMMET, LYDIA FIELD

(b. New Rochelle, NY, Jan. 23, 1866–d. New York, NY, Aug. 16, 1952)

Studied at Art Students League, with William Merritt Chase on Long Island, and in Paris with Adolphe-William Bouguereau, Joseph-Nicolas Robert-Fleury, and Frederick W. MacMonnies. Designed windows for Tiffany in 1880s and '90s, including one for Mark Twain house, Hartford, CT. Not cited by Driscoll. Painted mural for Woman's Building at Chicago Exposition, 1893. Received silver medal at St. Louis World's Fair, 1904. Part of colony of American artists in Giverny, France.

Ref. King; Falk; Pettys, *Dictionary of Women Artists*; obit. *NYT*, Aug. 18, 1952.

GAY, PATRICIA

(b. 1876–d. Mount Vernon, NY, May 8, 1965)
Daughter of landscape painter Edward B. Gay. Studied at Art Students League; New York School of Design; École des Beaux-Arts, Paris; Cragsmoor Art Colony, New York. Reputedly got position at Tiffany Studios through her brother Edward, an employee there. Not cited by Driscoll. Worked in enamel department by 1898 but left at unknown date, perhaps when department was absorbed into Tiffany & Co. in 1907. In 1919 was invited to take over re-opened enamel department. Retired c. 1925.

Ref. Falk; Koch, *Louis C. Tiffany, Rebel in Glass*; Pettys, *Dictionary of Women Artists*; obit. *NYT*, May 10, 1965.

GREEN, GRACE

(Grace Green Brown) (b. New Jersey, Aug. 1881–d. New York, NY, May 1965)
Studied at Art Students League. Designed leaded-glass windows for Tiffany. Not cited by Driscoll. In 1900, working as an artist and living on W. 82nd St., Manhattan. Later designed women's handbags and clothes. Was an interior decorator associated with Emily Peacock. Married well-known illustrator Arthur W. Brown.

Ref. Census 1900, 1910, 1920, 1930; obit. *NYT*, May 7, 1965.

LANTRUP, MISS

(b. Denmark)
Worked in Tiffany Studios pottery department at Corona. Became engaged to Danish man, left Tiffany; returned to Denmark. Her brother Carl Christian remained in Driscoll's circle.

Ref. Driscoll, Jan. 9, 1902; Mar. 28, 1904; Jan. 4, Feb. 15, 1905; interview between Julia Munson Sherman and Martin Eidelberg, Mar. 28, 1969.

MUNSON, JULIA

(Julia Munson Sherman) (b. Millington, NJ, 1875–d. Norwalk, CT, Feb. 2, 1971)
Attended New York School of Design, where she met Patricia Gay; took night classes at Walter Shirlaw's school, New York Institute for Artists-Artisans. Hired c. 1898 as a metalworker in Tiffany Studios enamel department under Patricia Gay. Left enamel department to become director of jewelry department. Traveled to Europe with Louis C. Tiffany in summer 1911. Left firm to marry Frederic Fairchild Sherman, founder of *Art in America,* on Feb. 3, 1914. Briefly pursued an independent career as enameler.

Ref. Driscoll, Apr. 15, 1903; interviews between Julia Munson Sherman and Martin Eidelberg, Mar. 28, Dec. 6, 1969; Falk; obit. *Norwalk Hour*, Feb. 3, 1971.

fig. 97
Detail of Agnes Northrop,
photographed by Davis & Sanford
c. 1896. Department of American
Decorative Arts, The Metropolitan
Museum of Art, New York.

NORTHROP, AGNES F.

(b. Flushing, NY, Apr. 20, 1857–d. New York, NY, Sept. 14, 1953)

Daughter of Professor Allen P. Northrop, an educator, and Emily Fairchild. Her maternal grandfather established the Fairchild Institute in Flushing, NY, in 1841; her father taught there. Reported living there in 1916. Reputedly began working for Tiffany in 1884. One of six original workers of Women's Glass Cutting Department, with "a natural talent for floral and conventional designs." Also designed silk fabrics and carpets, but primarily known for floral windows. She enjoyed a privileged status; her authorship of windows was often acknowledged; she had a private studio. Exhibited Chicago Exposition, 1893. Photographed with Tiffany Girls c. 1904-05. Frequently cited by Driscoll as a colleague, occasionally assisting her on projects, but they were not close friends. They traveled together with Tiffany to Brittany in summer 1907. Northrop stayed with firm until it closed, then with its offshoot, Westminster Studios. Resided in Gramercy Park Hotel. Remained active as designer of leaded windows until age 94.

Ref. King; Falk; *NYT,* Apr. 14, 1916, obit. Emily F. Northrop; obit. *NYT,* Sept. 15, 1953.

STURTEVANT, LOUISA CLARK

(b. Paris, Feb. 2, 1870–d. Newport, RI, May 3, 1958)
Studied with Frank Benson and Edmund Tarbell at
School of Museum of Fine Arts, Boston, and with
Lucien Simon, Jacques-Emile Blanche, and Paul Collin
in Paris. A landscape and mural painter, she also
designed embroideries and leaded-glass windows,
including some for Tiffany Studios. Not cited by
Driscoll. Active in Newport, RI. Awarded silver medal
at 1915 Panama-Pacific Exposition, San Francisco.

Ref. Pettys, *Dictionary of Women Artists*; Falk; obit. *NYT,* May 4,
1958.

VAN DERLIP, ANNE A.

*(Anne Van Derlip Weston) (b. New York, NY, Aug. 11,
1861–d. California, 1944)*
Natural daughter of Charles and Mary Dean,
adopted by George and Grace Van Derlip, also of
New York. Her adoptive father, an important art
collector and trustee of Metropolitan Museum of
Art, probably knew Tiffany. Attended Rutgers
Female College, New York, and began designing
windows for Tiffany c. 1880. Exhibited paintings at
National Academy of Design in 1886. Married John
Weston in 1888, moved to Duluth, MN, and had five
children. Continued to design windows for Tiffany,
among them the *Minnehaha* window exhibited at
Chicago Exposition in 1893. Not cited by Driscoll. In
1913 the Westons moved to California.

Ref. Falk; Wade Alan Lawrence, "The Tiffanys in Duluth: The Anne
Weston Connection," B.A. thesis, Univ. of Minnesota, 1984.

WHEELER, DORA

*(Dora Wheeler Keith) (b. Jamaica,
NY, Mar. 12, 1857–d. New York, NY, Dec. 27, 1940)*
Daughter of Thomas and Candace Thurber Wheel-
er, the latter a textile artist and Tiffany's partner.
Dora designed tapestries in association with her
mother; was also an illustrator. Designed windows
for Tiffany in 1880s. Studied at Art Students League,
Académie Julian in Paris, in Germany, and with
William Merritt Chase in New York. In 1890 married
Boudinot Keith, a lawyer and reform leader. Not
cited by Driscoll. Awarded gold medal at Chicago
Exposition, 1893. Painted dome in Capitol Building,
Albany, NY, but was primarily a portraitist.

Ref. Pettys, *Dictionary of Women Artists*; Falk; Amelia Peck and
Carol Irish, *Candace Wheeler: The Art and Enterprise of American
Design, 1875-1900* (New York, 2001); obit. *NYT,* Dec. 28, 1940.

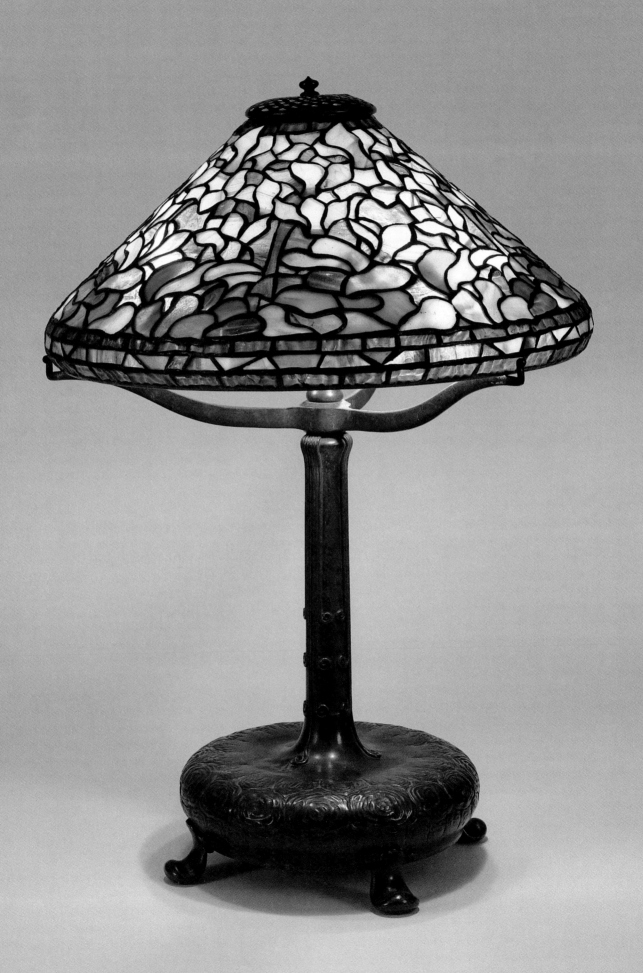

Notes

fig. 98
Cyclamen shade, probably designed by Clara Driscoll pre-1906, model 1452, 16 in. (40.6 cm) diam.; *Mud Turtle* base, designed pre-1903, model 365. NYHS.

INTRODUCTION

1 On Nash's contributions and the lack of credit given him, see Martin Eidelberg and Nancy A. McClelland, *Behind the Scenes of Tiffany Glassmaking: The Nash Notebooks* (New York and London, 2001).

2 Clara received a bronze medal and diplomas; see her letter of May 21, 1902, Kent State University Library, Kent, OH (hereafter KSU).

3 "Women Who Make $10,000 a Year or More," *New York Daily News*, April 17, 1904.

4 Both sides of Clara's family left Connecticut to settle in the Western Reserve in the early nineteenth century; see Robert C. Griffen and Mitchell R. Alegre, *Wolcott Genealogy* (Interlaken, NY, 1986), 284. See also Elizabeth A. Jones Yeargin, ed., "The Pierce and Wolcott Letters," photocopied typescript, 1993, KSU.

5 As Clara, the only married daughter, had no children, there are no direct descendants. All four women are buried with their parents in Tallmadge Cemetery.

6 Emily Wolcott to Charles Cutler, February 13, 1908, Queens Historical Society, Flushing, NY (hereafter QHS). Emily described visiting Cleveland and meeting with some of Clara's old teachers; see January 27, 1899, QHS.

7 Mary Sayre Haverstock, Jeanette Mahoney Vance, and Brian L. Meggitt, eds., *Artists in Ohio, 1787-1900: A Biographical Dictionary* (Kent, OH, and London, 2000), 962. The authors thank Dean Zimmerman of the Western Reserve Historical Society for his assistance. On Moses Ransom, see Paul Tucker, "Moorish Fretwork Furniture," *The Magazine Antiques* 167 (May 2005): 116-23. Clara is listed in the Cleveland city directories in 1886-87 and 1887-88. She was living with her relative Julia Tuttle, and her profession was recorded as "designer."

8 For more on the school, see "Industrial Art Studies," *New York Times*, January 8, 1880; also "The Metropolitan Art School," *New York Times*, October 9, 1887, and July 15, 1888. The school, established in 1880, offered courses in color, composition, drawing, sculpture, modeling, architectural draftsmanship, chasing, perspective, construction, industrial design, anatomy, window and wall decoration, and interior designing. It was run by John Ward Stimson and located at Third Avenue and Forty-ninth Street.

9 *Cleveland Town Topics*, March 10, 1888.

10 Yeargin, "The Pierce and Wolcott Letters," 27.

11 *Cleveland Plain Dealer*, June 5, 1888.

12 "Dun Reports," ms, Baker Library, Harvard University, vol. 388 (New York), pp. 1896, 2100 a/14. Both buildings were owned by the Goelet brothers, major New York City realtors and also clients of Tiffany's. Alterations to these buildings were made in 1889, including the insertion of an intermediate level between the fourth and fifth floors at the rear and additional windows.

13 The Tiffany Glass Company was founded on December 1, 1885, and incorporated in New Jersey. Louis C. Tiffany served as president, William Pringle Mitchell (1858-1900) as business manager, John Du Fais (1855-1935) as secretary, John Cheney Platt (1861-1932) as treasurer, and Benjamin F. McKinley was a trustee. Despite all the official changes of incorporation throughout his career, Tiffany and his business partners remained fairly constant. "Tiffany Studios" was the name commonly used to designate the Manhattan site, but it became a legal denomination for his company only in 1902; see Martin Eidelberg, Alice C.

14 Frelinghuysen, Nancy A. McClelland, and Lars Rachen, *The Lamps of Louis Comfort Tiffany* (New York, 2005), 21.

14 Almost none of the Wolcott family correspondence from this period has survived, but letters of a Tallmadge friend and cousin, twenty-year old Julia Alling, who lived in the same Brooklyn boardinghouse, were in the possession of Elizabeth A. Jones Yeargin (idem, "The Pierce and Wolcott Letters," 27) and they offer a glimpse into the women's lives. By the time that Miss Alling arrived, the Wolcott sisters had left Tiffany's employ. While Clara's engagement would explain her departure, less understandable is Josephine's, especially since it resulted in her having to return to Ohio, which she evidently did not want to do.

15 Mary Gay Humphreys, "The New York Working Girl," *Scribner's* 20 (October 1896): 511: "For married women to work in the trades is almost immoral; they should attend to their homes and their children. The severe labor, the long hours, the nervous strain on the growing girls exhausts their vitality and unfits them to be wives and mothers."

16 Mr. Driscoll had offered to support Josephine's continued education in art, allowing her to remain in the city. See Fannie Pierce to Clara P. Wolcott, October 8, 1889, KSU; also Yeargin, "The Pierce and Wolcott Letters," 30.

17 *Lain's Brooklyn Directory*, 1885-1886 through 1891-1892.

18 Griffen and Alegre, *Wolcott Genealogy*, 380. Driscoll's provision to leave one-third of his estate for a home for Methodist Episcopalian clergy was voided by the court; see *Brooklyn Daily Eagle*, March 23, 1893. Nothing else is known about the disposition of his estate.

19 New Building Docket No. 645, New York City Archives. A showroom was added to this building in 1893. The authors thank Christopher Gray for sharing this information.

20 Arthur J. Nash, who came from Stourbridge, England, was the head of the glass-blowing department. The company had $20,000 in capital and the directors were listed as Louis C. Tiffany, William H. Thomas, Parker C. McIlhiney, A. Stuart Patterson, William H. Holmes, and Arthur J. Nash; see *Trow's New York City CoPartnership Directory 1897*. For more on the opening phase of this firm, see Eidelberg and McClelland, *Behind the Scenes of Tiffany Glassmaking*, 7-8.

21 Polly King, "Women Workers in Glass at the Tiffany Studios," *Art Interchange* 33 (October 1894): 86. See also "Art Schools a Necessity," a letter to the editor written by Mrs. Stevenson Burke, in *Cleveland Plain Dealer*, May 31, 1896: "From this school [the Art School of Cleveland, successor to Western Reserve School of Design for Women] I can name many who are now doing very remunerative work.... Miss Wolcott has for several years been employed by Louis Tiffany of New York, as a designer and now has charge of a large department where women draw designs and cut the glass for his most beautiful work. Several girls from our school are employed there, receiving good wages for their work."

22 Unidentified newspaper clipping tipped into Joseph D. Hall, Jr., *The Genealogy and Biography of the Waldos of America from 1650 to 1883* (Danielsonville, CT, 1883), 2; see http://content.ancestry.com/Browse/BookView.aspx?dbid=14894&iid=dvm_GenMono002439-00002-0.

23 January 4, 1897, KSU.

24 April 11, 1897, KSU.

25 See Yeargin, "The Pierce and Wolcott Letters," 43.

fig. 99
Dragonfly shade, probably designed by Clara Driscoll pre-1906, model 1507, 22 in. (55.9 cm) diam. NYHS.

26 Her trip to Chicago is cited in her letter of June 29, 1898, QHS.
27 See Yeargin, "The Pierce and Wolcott Letters," 44.
28 February 12, 1902, KSU.
29 November 10, 1897, KSU.
30 Edward A. Booth was born in Gloucester, England, the son of Abraham and Elizabeth (Watts) Booth; see Griffen and Alegre, *Wolcott Genealogy*, 380. He arrived in the United States in 1893 (according to the 1930 census) and was listed in the New York City directories from 1896 onward.
31 Cited in "Married," *New York Times*, September 3, 1909.
32 Their move to Florida is registered in letters from Emily to Clara, dated November 4 and 7, 1930, QHS.
33 Emily Wolcott, "In Memoriam, Clara Wolcott Booth . . . ," printed pamphlet, QHS.
34 Louis C. Tiffany, "My Journal Through Brittany," unpublished ms, 1907, courtesy of a Tiffany descendant.
35 September 24, 1898, QHS. Clara herself generally wrote long letters; for example, her letter of April 5, 1905, is over thirty pages long.
36 The letters are also very much concerned with family affairs in Ohio, issues of refurnishing rooms, and obtaining dress material and wallpaper samples—topics outside our focus.
37 Clara and Josephine were living in Brooklyn, and Emily was in Baltimore.
38 This date is suggested by Fannie's comments in her letter February 14, 1897, KSU.
39 November 26, 1905, KSU.
40 November 18, 1898, QHS.

CHAPTER 1. DESIGNING FOR ART AND COMMERCE

1 He refused to let any of her assistants take her place; see February 15, 1906, KSU. On March 8, 1906, Clara wrote: "Mr. Tiffany insists on having some one whose work he likes and who is a good critic. . . ."
2 She reported that the glass cost $10 a pound, an exceptionally high price. For the normal cost of sheet glass, see note 71 below.
3 March 13, 1903 (misdated 1902 by Clara), KSU.
4 December 13, 1898, QHS. See also p.131.
5 April 26, 1902, KSU; see also May 4, 1897, KSU.
6 August 30, 1898, QHS.
7 June 15, 1898, QHS; see also May 4, 1897, KSU.
8 Ibid. Compilations of nature photographs intended as design aids were frequently used at the turn of the century, and Clara might have contemplated forming such a work herself.
9 August 18, 1898, QHS.
10 This window is now in the Charles Hosmer Morse Museum of American Art, Winter Park, FL.
11 For the birth and death dates of the women associated with Tiffany Studios, see the Appendix below p. 166.
12 King, "Women Workers": 87, referred to Northrop working in a studio but did not specify it was for her sole use. Clara mentioned Northrop's special studio when she explained that Alice Gouvy had been given use of it; see October 6, 1898, QHS. Artists like Emmet and Wheeler probably worked in their own studios at home.
13 King, "Women Workers": 86; see also "Mosaics Done by Women," *New-York Daily Tribune,* January 16, 1898.
14 These four women as well as a greater number of male painters were cited in "Stained Glass at the Tiffany Galleries," *New York Times,* February 27, 1897. It has been claimed that Northrop began working at Tiffany Studios in 1884, but neither her presence there nor her role is documented.
15 Wilson was appointed head of the Church Art Department when it was formed in 1899; see *New York Evangelist,* March 23, 1899.
16 King, "Women Workers": 87, cites the Gould window as a collaborative project.
17 July 27, 1899, QHS.
18 Clara did not describe the process in detail but a fairly full account was given by King, "Women Workers"; see also "Art and Architecture," *Current Literature* 36 (March 1904): 331. Although a decade separates the two articles, some portions of the text are worded similarly. Both may have been based on a common source, perhaps an otherwise unknown publicity release generated by Tiffany Studios. The later article is strikingly more specific on certain points than is the earlier one.
19 This attitude was also reported by the Tiffany enamel and jewelry designer Julia Munson Sherman in interviews with Martin Eidelberg on March 28 and December 8, 1969. Tiffany preferred her amateur beating of metal to the professional chasing of his trained British staff.
20 November 16, 1897, KSU.
21 King, "Women Workers": 86.
22 November 30, 1897, KSU.
23 King, "Women Workers": 87.
24 March 21, 1899, QHS.
25 September 23, 1902, KSU.
26 One wonders whether the Men's Department or the Women's was entrusted with the ten windows that Siegfried Bing commissioned from Tiffany in 1895. Designed by Henri de Toulouse-Lautrec, Edouard Vuillard, Pierre Bonnard, Paul Ranson, and other leading French painters, these were the most avant-garde windows executed by Tiffany Studios.
27 March 19, 1903, KSU.
28 Construction of the building was begun in 1892 and completed in 1894. A special exhibition at Tiffany Studios in February 1897 included part of this commission, said to be "more than half completed." See "Stained Glass at the Tiffany Galleries." In contrast to the women's anonymity, Holzer's name appears on the mosaic itself. The firm also supplied a rose window for the hall, but whether this was executed by the women or the men is not known.
29 November 28, 1899, QHS.
30 This was also expressed by the Tiffany Studios manager William H. Thomas, "Glass Mosaic—An Old Art with a New Distinction," *International Studio* 28 (March-June 1906): LXXVIII.
31 June 29, 1898, QHS.
32 March 16, 1905, KSU. Joseph Briggs, an Englishman who had come to the United States in 1891, seems to have assisted Clara mostly with the execution of mosaics. In 1905 he was appointed head of a men's mosaic department located within Clara's workroom. He later became the president of Louis C. Tiffany Studios, the firm that succeeded

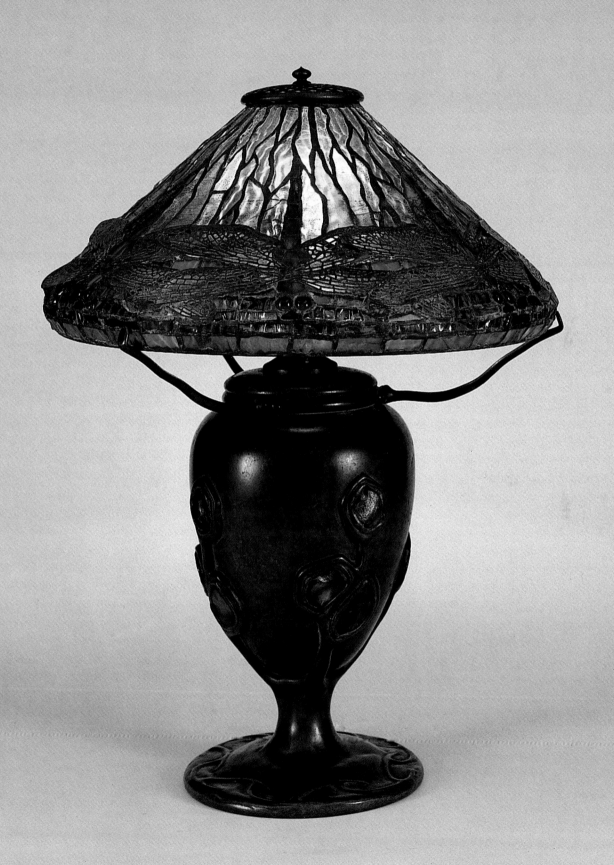

Tiffany Studios after it was declared bankrupt in 1932.

33 January 18, 1905, KSU.

34 June 22, 1905, KSU.

35 January 16, 1907, QHS; also John A. Offord, "True Expression of Industrial Art," *New York Observer*, January 20, 1910, who called a mosaic sample for this commission "a Byzantine design."

36 "Mosaic Workers at Their Tasks," *New-York Daily Tribune*, June 23, 1901.

37 Male dominance is also noticeable in the text, where the mosaicist is described as "he."

38 March 29, 1905, KSU.

39 Robert Koch, *Louis C. Tiffany, Rebel in Glass* (New York, 1961), 130, 134, claimed without documentation that many models were made under Driscoll's direction: *Ivy* (probably *Vine* was meant), *Pansy, Daffodil, Rose, Geometric, Leaf, Orange Petal* (the last three names do not conform to Tiffany's nomenclature), *Geranium*, and *Butterfly*. Authors such as Tessa Paul, *The Art of Louis Comfort Tiffany* (New York, 1987), 86, have attributed to Driscoll the *Ivy, Rose, Geranium*, and *Butterfly* shades.

40 For some of these earlier shades, see Eidelberg et al., *The Lamps of Louis Comfort Tiffany*, 8–14. Particularly relevant are the Lyceum Theatre wall sconces, which had chunks of glass and shells leaded together, and the small table lamp in Henry Havemeyer's library, which had a leaded shade of small glass tiles.

41 June 15, 1898, QHS.

42 In her letter of July 30, 1902, KSU, Clara reported that an order for twenty more of these shades had come in.

43 June 29, 1898, QHS.

44 April 6, 1899, QHS.

45 February 12, 1902, KSU.

46 September 17, 1903, KSU.

47 March 1, 1906, KSU.

48 April 29, 1899, QHS.

49 Clara's letters of September 1898 (letter XXV) and December 5, 1898, QHS.

50 April 6, 1899, and November 8, 1898, QHS.

51 March 16, 1905, KSU.

52 June 29, 1898, QHS.

53 About her design for a student lamp, she reported that "Mr. Tiffany made a criticism on it which necessitates some changing"; December 17, 1898, QHS.

54 April 29, 1899, QHS.

55 For the *Fern* lamp, see Eidelberg et al., *The Lamps of Louis Comfort Tiffany*, 36-37.

56 July 20, 1899, QHS.

57 June 29, 1898, QHS.

58 April 29, 1899, QHS.

59 October 14, 1904, KSU.

60 October 4, 1905, KSU.

61 Sold New York, Christie's, December 10, 2002, lot 150. Another example was sold New York, Sotheby's, June 11, 1997, lot 320. The citation on the 1906 Price List reads: "1418.14" ARROW HEAD, high cone.......[$]70.00."

62 The larger model also has an additional vertical level in the "sky" above, a leaf over the single blossom, and a row of triangles in the penultimate band at the bottom.

63 The citation on the 1906 Price List reads: "1427.14" DAFFODIL, high cone....... [$]60.00."

64 The citation on the 1906 Price List reads: "1562.14" GERANIUM[$]65.00."

65 Little is known about the geometric shades she designed. In her letter of January 9, 1902, KSU, she tells how she promised Mr. Cantrill, the man in charge of the Corona lamp department, "some good designs." She held their "cheap shades" in some contempt.

66 July 19, 1898, QHS.

67 February 1, 1906, KSU.

68 June 29, 1898, KSU.

69 April 29, 1899, QHS.

70 October 22, 1903, KSU.

71 A 1902 contract between Tiffany Furnaces and the Allied Arts Company (Tiffany's two companies at the time, the former making the sheet glass and the latter executing the windows and the lampshades) specified that light colors were 4 cents per pound, and dark colors were between 5 and 12 cents per pound. Special effects were relatively expensive: lustered glass was $2.50 per pound, lustered glass with linear decoration was $3.50 per pound, and glass with flower or leaf decoration was $4.00 per pound.

72 August 25, 1903, KSU.

73 March 16, 1905, KSU.

74 January 18, 1905, KSU.

75 August 11, 1898, QHS. Clara referred to "Annie," a new girl, assigned the task of cutting the copper foil.

76 October 28, 1902, KSU.

77 June 15, 1898, QHS.

78 Ibid.

79 July 19, 1898, QHS.

80 September 1898 (letter XXV), KSU.

81 October 22, 1903, KSU.

82 Only two mosaic bases continued in production after 1910, the *Dragonfly* oil and electric bases, model nos. 147 and 356 respectively. Both were still on the 1913 Price List.

83 March 19, 1902, KSU.

84 Inevitably there are exceptions to the rule, such as an awkwardly shaped inkstand clad in mosaic that bears the late mark of Louis C. Tiffany Furnaces, Inc.; see New York, Christie's, June 12, 2003, lot 78.

85 An example of this fish inkstand in the Louis C. Tiffany Garden Museum Collection, Matsue, Japan, has a patented Davis liner of the type described by Clara in her letter of March 19, 1902, KSU.

86 March 19, 1902, KSU.

87 Many examples of this desk set bear an early 20,000-range production number and the pre-1903 monogram of the Tiffany Glass and Decorating Company. In some early examples, such as a pen tray sold in New York, Christie's, June 12, 2003, lot 72, whole pieces of glass rather than small tesserae are used for each opening.

88 On the relationship between these men, see Martin Eidelberg, "S. Bing and L.C. Tiffany; Entrepreneurs of Style," *Nineteenth-Century Art Worldwide* (www.19thc-artworldwide.org) 5 (Summer 2005).

89 January 6, 1899 (misdated 1898), Emily Wolcott to Dear Ones (the salutation used by the family), QHS.

90 On August 13, 1902 (KSU), Clara wrote: "I must go to work on my ink well. This is at Tiffany's and I have been doing this [writing the letter] while my wax is softening in the sun."

91 March 19, 1902, KSU.

92 Ibid.

93 See, for example, two trivets, one with three dragonflies and the other with three fish, both illustrated in Alastair Duncan, *Louis C. Tiffany: The Garden Museum Collection* (Bridgewater, UK, 2004), 376. Both are impressed with the pre-1903 monogram of the Tiffany Glass and Decorating Company.

94 The trivet bears the pre-1903 monogram of the Tiffany Glass and Decorating Company.

95 Sold New York, Christie's, December 12, 1997, lot 161. The clockworks are by the French firm of Jappy Frères. Clara's interest in polished shells is recorded in her correspondence; see June 15, 1898, QHS.

96 See the mosaic clocks illustrated in John Loring, *Louis Comfort Tiffany at Tiffany & Co.* (New York, 2002), 192, 201.

97 Credit for the design of desk objects and lamp bases in bronze has in recent years been given to Alvin J. Tuck; see Robert Koch, *Louis C. Tiffany's Glass—Bronzes—Lamps* (New York, 1972), 90-91, 103-07, 119, 127-39; also Alice Cooney Frelinghuysen in *The Kogod Collection,* ed. Stephanie Rachum (Washington, D.C., 2004), 313.

98 October 6, 1898, QHS.

99 March 26, 1902, KSU.

100 August 5, 1898, QHS.

101 August 11, 1898, QHS: "The wild carrot things have not been begun at all. . . . "

102 For an example with the pre-1903 monogram of the Tiffany Glass and Decorating Company, see Duncan, *Louis C. Tiffany: The Garden Museum Collection,* 366.

103 *Exhibition of L' Art Nouveau, S. Bing, Paris,* exh. cat. (London: Grafton Galleries, 1899), 23: "32. Inkstand in metal, wild carrot, flower design."

104 March 26, 1902, KSU.

105 See the 1906 Price List, nos. 1306-08, 1318-20.

106 The example pictured here has a gilt base impressed with the early designation "26464." A comparable example is in the collection of the Museum of Modern Art, New York, inv. no. 120.1976.

107 February 27, 1902, KSU.

108 November 8, 1898, QHS.

109 February 27, 1902, KSU.

110 March 14, 1905, KSU.

111 Although it has long been recognized that Gouvy and Palmié were in charge of the enamel department, Clara's letters indicate they were also actively engaged in the pottery. This helps explain the ease of transference of forms and motifs between works in these two mediums. Gouvy's and Palmié's close relationship with Clara, as well as their joint participation in many of her projects, help explain the unity of subject matter and aesthetics within all the firm's different departments.

112 January 9, 1902, KSU.

113 Ibid.

114 March 26, 1902, KSU.

115 March 10, 1902, KSU.

116 His partner in this venture was Joseph H. Taft, an architect who in the 1890s had been partners with Georges Glaenzer (1847-1915). Glaenzer, in turn, was the employer of Clara's friend George Waldo. Belknap had left Tiffany's employ around 1901 to found this gallery, and from 1907 to 1909 he was the general manager of the Grueby Pottery in Boston. In the 1920s he was associated with the Essex Institute in Salem, Massachusetts.

117 March 19, 1902, KSU.

118 Alice Gouvy had very similar thoughts. She wanted to return to Cleveland and start an Arts and Crafts shop with her mother.

119 January 5, 1907, KSU; December [n.d.] 1907.

120 On the relation of Tiffany Studios and art industry, see Eidelberg et al., *The Lamps of Louis Comfort Tiffany,* 80.

CHAPTER 2. MANAGING AT TIFFANY STUDIOS

1 King, "Women Workers": 86.

2 New Building Docket No. 645, New York City Archives. A showroom was added to this building in 1893. The authors thank Christopher Gray of the Office for Metropolitan History for sharing this information.

3 *New York Times,* December 28, 1892.

4 King, "Women Workers": 86, reproduced professional photographs of the Tiffany Girls at work. After Tiffany's publication of *Glass Mosaic* in 1896, no known photographs of women are known to have been included in any company literature.

5 King, "Women Workers": 86.

6 June 29, 1898, QHS. Since 102 East Twenty-fifth Street was two stories higher than the adjacent building at 335 Fourth Avenue, as well as the one at 104 East Twenty-fifth Street, it was possible to have windows on three sides.

7 November 16, 1897, KSU.

8 November 10, 1897, KSU.

9 November 28, 1899, QHS.

10 July 26, 1898, QHS.

11 "Mosaics Done by Women," *New-York Daily Tribune,* January 16, 1898.

12 July 6, 1905, KSU.

13 February 1, 1906, KSU.

14 "Women Window Makers," *Boston Advertiser,* October 4, 1902.

15 This photograph can be dated to between early 1904 and mid-1905 based on the presence of both Alice Wilson who arrived at the company only in February 1904, and Beatrix Hawthorne who left before August 2, 1905.

16 Jennifer Thalheimer, Collections Manager of the Charles Hosmer Museum of American Art, believes that this photograph, along with other images of the Tiffany Girls, was donated to the museum in the 1980s by the daughter of Mary Voorhis Schofield Williams, one of the Tiffany Girls. Mrs. Williams stands beside Clara.

17 June 15, 1898, QHS.

18 Ibid. The contract system did not encompass cutting glass for lamps.

19 November 18, 1898, QHS.

20 January 12, 1899, QHS.

21 March 21, 1899, QHS.

22 January 23, 1902, KSU.

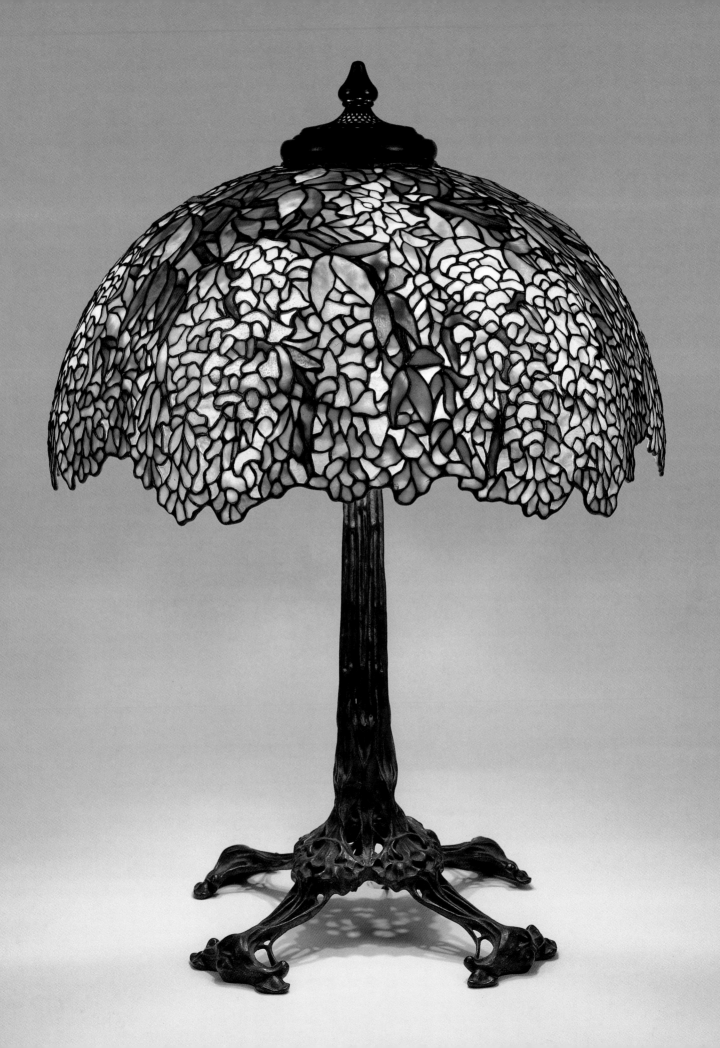

fig. 100
Laburnum shade, probably designed
by Clara Driscoll pre-1906, model 1539,
22 in. (55.9 cm) diam.; *Bird Skeleton* base,
designed pre-1906, model 422. NYHS.

23 Anna Ring initially had this job; January 12, 1899, QHS.
24 August 20, 1903, KSU.
25 September 24, 1898, QHS.
26 The letters abound with descriptions of headaches, by Clara, her mother, and Emily.
27 January 21, 1899, QHS.
28 October 6, 1898, QHS.
29 April 2, 1903, KSU.
30 March 13, 1903, KSU.
31 July 26, 1898, QHS.
32 March 29, 1905, KSU.
33 February 19, 1903, KSU.
34 March 31, 1903, KSU.
35 December 4, 1907, QHS.
36 The Stourbridge Glass Company even had a baseball team; see *Newtown Register*, May 17, 1900.
37 December 27, 1897, KSU.
38 The only known surviving print originally belonged to Agnes Northrop, suggesting that the women exchanged photographs as gifts.
39 January 1, 1902, KSU.
40 The Briggses subsequently had three more children. There were four daughters and one son in all.
41 See the letters of March 2, 9, and 14, 1905, KSU.
42 March 2, 1905, KSU.
43 Ibid.
44 Frank was allowed to make a section of a *Cobweb* lamp base; see October 22, 1903, KSU.
45 Ibid.
46 The first floor was devoted to the furniture and "bric-a-brac" of the Schmitt Brothers Furniture Company, a division of Tiffany Studios. The former theater on the second floor, including a mezzanine, was given over to the showroom, while the third floor housed the rug and textile departments. The rest of the building was used for the interior decoration department, studios, and offices. See "First Club, Then Art Shop," *New York Times*, October 21, 1905.
47 September 27, 1905, KSU.
48 June 22, 1905, KSU.
49 January 9, 1902, KSU.
50 Ibid.
51 March 15, 1906 (incorrectly dated 1905 by Clara), KSU.
52 March 14, 1905, KSU.
53 September 23, 1902, KSU. The windows were completed by October 8, 1902.
54 March 10, 1903, KSU.
55 Rheta Childe Dorr, "Making Glass Mosaics," *New York Evening Post*, January 6, 1904.
56 March 13, 1903 (incorrectly dated 1902 by Clara), KSU.
57 March 19, 1903, KSU.
58 September 17, 1903, KSU.
59 March 2, 1905, KSU.
60 November 23, 1905, KSU.
61 February 15, 1906, KSU.

62 Tiffany's sister Annie (1844-1937) married Mitchell's father, Alfred (1832-1911), in 1871.
63 June 22, 1898, QHS.
64 July 20, 1899, QHS.
65 November 8, 1898, QHS.
66 May 14, 1902, KSU.
67 Ibid.
68 January 12, 1899, QHS.
69 July 27, 1899, QHS.
70 January 23, 1902, KSU.
71 Ibid.
72 April 2, 1903, KSU.
73 "Women Who Make $10,000 a Year." The article states: "Mrs. Driscoll is one of the highest salaried women in New York and ranks with the $10,000 a year workers." Of the women profiled in this article, Clara Driscoll was the only one who was paid on salary.
74 January 16, 1902, KSU. This was after the contract system was no longer in effect at Tiffany Studios. She hoped to make more and wrote: "I feel that I must do something a little better than I ever have done—I want to earn $2500, and shall not be satisfied until I do." A payroll ledger in the collection of the Morse Museum records weekly payments of $35 from October 5, 1905, to March 21, 1906; Museum no. 1999-065, pp. 200-202. It does not appear that Clara got any raises between 1902 and 1906.
75 April 25, 1899, QHS.
76 January 16, 1907, QHS.
77 February 15, 1905, KSU. According to Clara, two of the old foremen had just been fired, the fourth firing in a year and a half. There were still two foremen at Corona who were employees when she began work at Tiffany's.

CHAPTER 3. EXPLORING NEW YORK CITY

1 Mary Gay Humphreys, "Women Bachelors in New York," *Scribner's Magazine* 20 (November 1896), 625-36. For a discussion of the New Woman in New York City, see Christine Stansell, *American Moderns: Bohemian New York and the Creation of a New Century* (New York, 2000), 27-34.
2 May 4, 1897, KSU. In 1897, her roommate Alice Gouvy was studying life drawing with Kenyon Cox at the Art Students League, several blocks east on Fifty-seventh Street.
3 November 10, 1897, KSU. Clara was living with Alice Gouvy and Mary Hackley, and they were joined by the Tiffany employee Mary McDowell.
4 June 22, 1898, QHS.
5 Charles Lockwood, *Bricks and Brownstone: The New York Row House 1783-1929* (New York, 2003), 266.
6 Classified ads, *New York Times*, May 29, 1857 and March 26, 1858.
7 Even after her marriage in 1909 and final departure from the firm, Clara continued to board rather than keep house herself.
8 The 1900 census documented seventeen boarders living at Miss Owens's two boardinghouses at 42 and 44 Irving Place. In addition, the houses accommodated seven female and two male servants.
9 October 22, 1903, and February 7, 1905, KSU.

fig. 101
Detail of *Cobweb* shade on *Narcissus*
mosaic base, designed by Clara Driscoll
pre-1902, model 146, 20 in. (50.8cm) diam.
NYHS.

10 October 20, 1904, KSU.
11 March 10, 1902, KSU.
12 Ibid.
13 April 26, 1902, KSU.
14 October 19, 1896, KSU.
15 April 15, 1903, KSU.
16 January 16, 1907, QHS. Clara noted being "much interested in looking at the new church, which we were working on here when I left."
17 January 20, 1903, KSU.
18 Carole Klein, *Gramercy Park: An American Bloomsbury* (Boston, 1987), 159.
19 December 13, 1905, KSU.
20 January 18, 1897, KSU.
21 December 13, 1898, QHS. See p. 131 for the full text.
22 February 10, 1904, KSU.
23 February 23, 1905, KSU.
24 January 8, 1906, KSU.
25 Ibid. The other designers and employees invited to Laurelton Hall included Alice Gouvy, Marion Palmié, and the chemist Dr. Parker McIl-hiney.
26 January 18, 1905, KSU.
27 June 25, 1905, KSU.
28 Cited in chapter 2, p. 103; October 8, 1902, KSU.
29 October 16, 1902, KSU.
30 January 30, 1897, KSU.
31 "Booth Memorial Window," *New York Times*, June 25, 1898.
32 June 22, 1898, QHS.
33 May 25, 1903, KSU.
34 See a report of her impact on Paris in the *New York Times*, April 9, 1893.
35 November 17, 1903, KSU. Ernestine Schumann-Heink was an operatic contralto of substantial fame in the early 1900s, and Clara was an admirer; see p. 158.
36 Clara recorded that at least a dozen shots were taken of her with and without the hat. Unfortunately, Käsebier's portraits of Clara have not been located.
37 Undated letter [March 20, 1907], KSU.
38 Ibid.
39 June 22, 1898, QHS.
40 Ibid.
41 For the exhibition of the Society of American Artists, see April 3, 1899, QHS; National Academy of Design, April 8, 1907, KSU; National Arts Club, January 30, 1904 and December 13, 1905, KSU; Mary Cassatt exhibition, November 7, 1903, KSU.
42 November 7, 1903, KSU.
43 January 8, 1906, KSU.
44 Carpenter studied at the Académie Julian in Paris in 1892. Henry Mc-Bride traveled to Europe regularly beginning in the summer of 1894.
45 January 25 and February 15, 1906, KSU. Clara and Emma's four-month tour included visits to Gibraltar, Naples, Rome, Perugia, Florence, and Siena, as well as stops in Paris, London, and the English countryside. May 3, 1906, KSU, and Edward A. Booth to Emily Wolcott, June 17, 1906, KSU.
46 Michael John Burlingham, "Louis Comfort Tiffany: Photographer-in-

Charge," *History of Photography* 4 (October 1980): 337-42.
47 Edward Booth sent Emily a clipping from the *New Jersey Herald* mentioning Mr. Tiffany traveling in a 40-horse power Darracq. Emily Wolcott to Clara Driscoll, August 5, 1907, QHS.
48 Emily Wolcott to Clara Driscoll, August 17, 1907, QHS.
49 February 27, 1902, KSU.
50 January 30, 1902, KSU.
51 November 17, 1903, KSU.
52 November 11, 1902, KSU.
53 January 15, 1903, KSU.
54 December 21, 1905, KSU.
55 December 13, 1905, KSU.
56 March 16 and April 20, 1905, KSU.
57 Joseph Horowitz, *Wagner Nights: An American History* (Berkeley, 1994), 75, and Robert A. M. Stern, Thomas Mellins, and David Fishman, *New York 1880* (New York, 1999), 681-82.
58 January 13, 1904, KSU.
59 Undated letter [March 20, 1907], KSU.
60 March 28, 1907, KSU.
61 November 4, 1903, KSU.
62 November 7, 1905, KSU.
63 October 19, 1896, KSU.
64 November 8, 1898, QHS.
65 November 3, 1904, KSU.
66 October 26, 1904, KSU.
67 November 10, 1904, KSU.
68 October 26, 1904, KSU.
69 "Champion of Her Sex," *New York Sunday World*, February 2, 1896.
70 July 19, 1898, QHS.
71 August 5, 1898, QHS.
72 Arthur Judson Palmer, *Riding High: The Story of the Bicycle* (New York, 1956), 113-16.
73 August 5, 1898, QHS.
74 March 10, 1902, KSU.

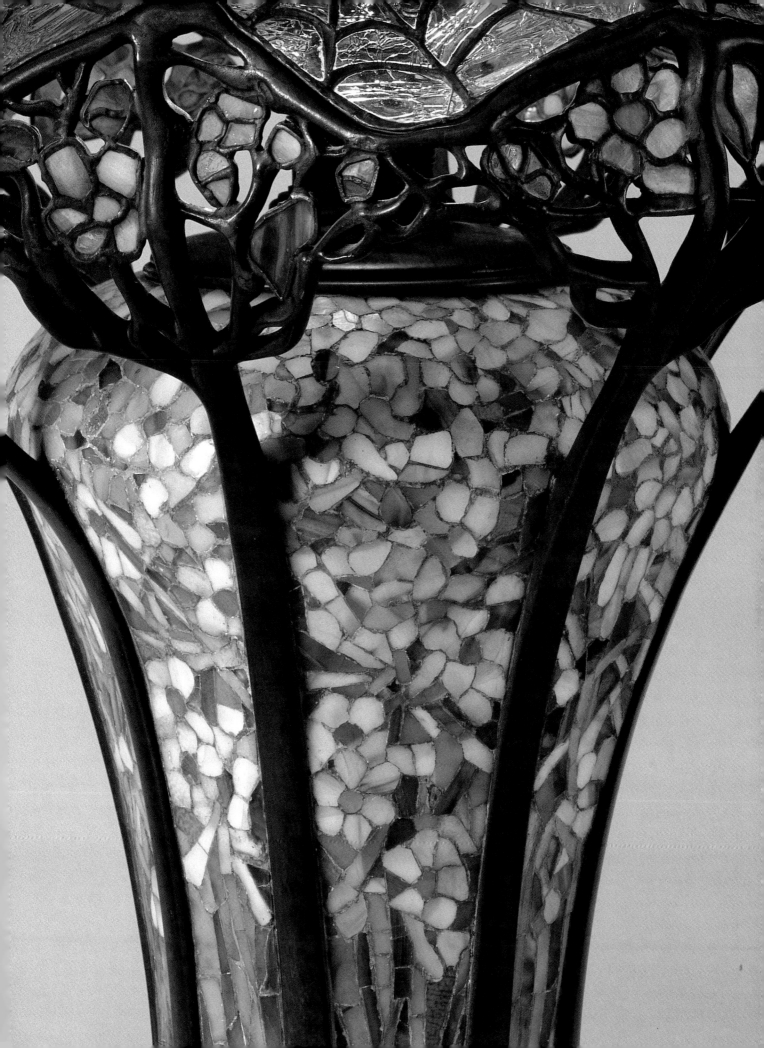

Photo Credits

Page 7 NYHS acc. no. N84.86
Page 8 NYHS acc. no. N84.131
Fig. 1 © The Charles Hosmer Morse Foundation, Inc.
Fig. 6 Image © The Metropolitan Museum of Art
Fig. 7 Photographed by Rudolph Blythe
Fig. 9 © The Charles Hosmer Morse Foundation, Inc.
Fig. 10 © The Charles Hosmer Morse Foundation, Inc.
Fig. 12 Photographed by John Jameson, Courtesy Princeton
 University Office of Communications
Fig. 13 Courtesy Lake View Cemetery Association
Fig. 17 NYHS acc. no. N84.87
Fig. 18 NYHS acc. no. N84.128
Fig. 19 NYHS acc. no. N84.130
Fig. 20 Courtesy Sotheby's, Inc. © 1995
Fig. 23 NYHS acc. no. N84.57
Fig. 24 Photograph © 1996 The Metropolitan Museum of Art (67.655.7)
Fig. 25 NYHS acc. no. N84.55
Fig. 26 © Christie's Images Ltd., 2002
Fig. 28 NYHS acc. no. N84.110
Fig. 30 Photograph © 1988 The Metropolitan Museum of Art (67.654.2)
Fig. 32 NYHS acc. no. N84.106
Fig. 34 Photographed by Katherine Wetzel, © Virginia Museum of Fine Arts
Fig. 35 © Christie's Images Ltd., 1994
Fig. 42 Digital Image © The Museum of Modern Art/Licensed by
 SCALA/Art Resource, NY (295.1960)
Fig. 43 © The Charles Hosmer Morse Foundation, Inc.
Fig. 46 © Christie's Images Ltd., 1997
Fig. 65 © The Charles Hosmer Morse Foundation, Inc.
Fig. 66 Image © The Metropolitan Museum of Art
Fig. 80 Photographed by George Obremski ©
Fig. 91 © The Charles Hosmer Morse Foundation, Inc.
Fig. 92 © The Charles Hosmer Morse Foundation, Inc.
Fig. 93 © The Charles Hosmer Morse Foundation, Inc.
Fig. 94 © The Charles Hosmer Morse Foundation, Inc.
Fig. 95 © The Charles Hosmer Morse Foundation, Inc.
Fig. 96 © The Charles Hosmer Morse Foundation, Inc.
Fig. 98 NYHS acc. no. N84.63
Fig. 99 NYHS acc. no. N84.52
Fig. 100 NYHS acc. no. N84.116
Fig. 101 NYHS acc. no. N84.128

Index

Page numbers in *italics* indicate illustrations.